The Art of Tattoo

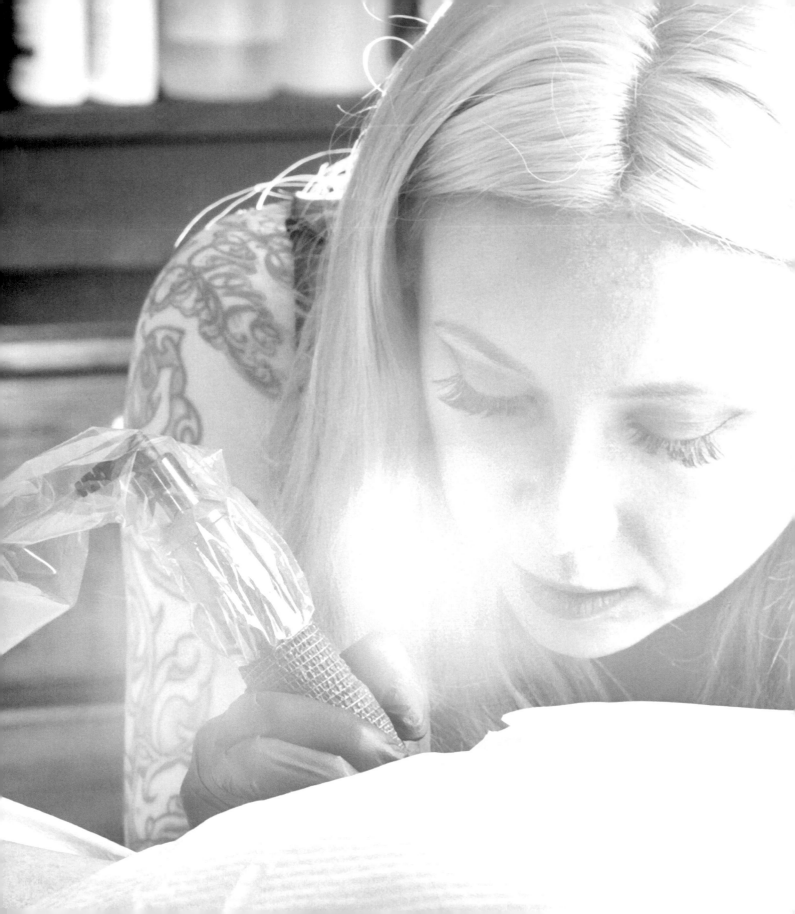

The Art of Tattoo

A TATTOO ARTIST'S INSPIRATIONS, DESIGNS, AND HARD-WON ADVICE

Megan Massacre

PHOTOGRAPHY BY LANI LEE

TEN SPEED PRESS
California | New York

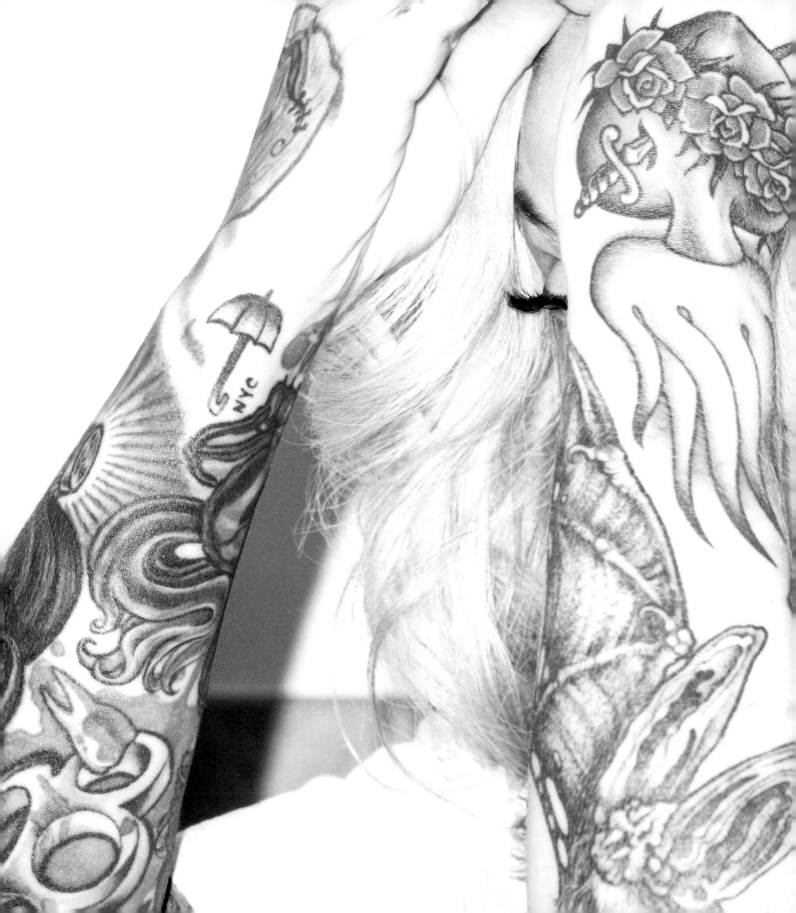

I'd like to dedicate this book to my family, friends, and fans for support-
ing my artwork. By doing so you have helped make it possible for me to
live a life that enables me to share my artwork with the world and use it
to help make the world a better place.

GRIT N GLORY

TATTOO BOUTIQUE

LOWER EAST SIDE

Contents

INTRODUCTION 1

PART ONE: LIFE AND CREATIVE PROCESS

1 Sources of Inspiration 48

2 Workplace 76

3 Artwork 96

PART TWO: TATTOOING

4 The Tattoo Process 122

5 Hall of Fame 156

6 Cover-Up Tattoos 210

APPENDIX: FAN ART 234

ACKNOWLEDGMENTS 237

ABOUT THE AUTHOR 238

INDEX 241

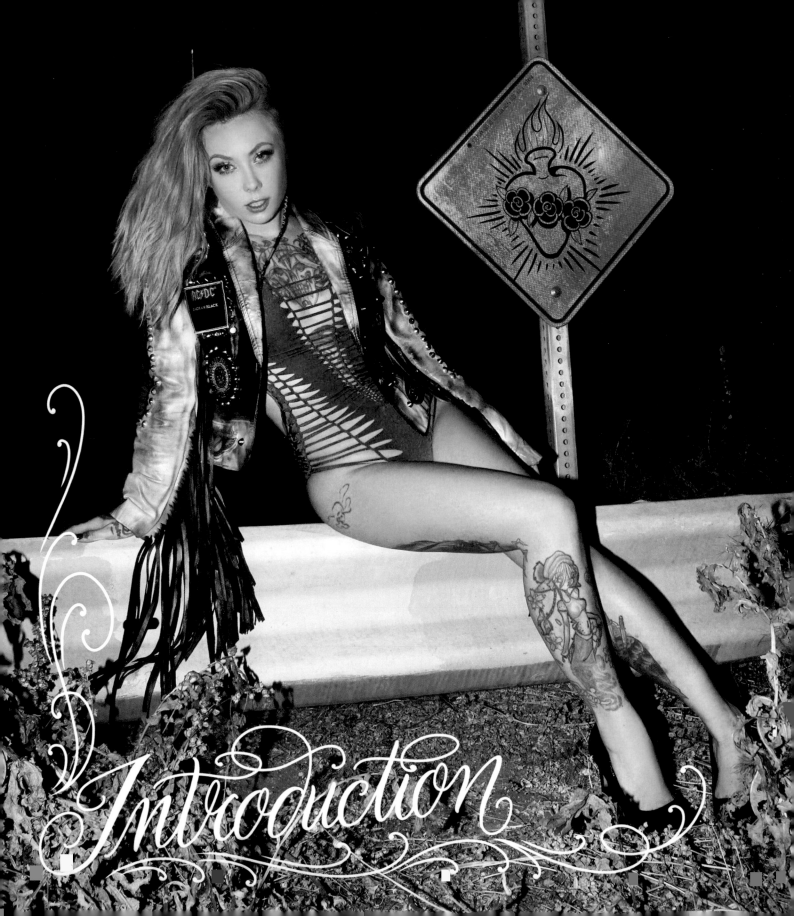

Introduction

Hi, I'm Megan Massacre, a tattoo artist based in New York City. I am best known for my roles in the tattoo reality TV series *NY Ink*, *America's Worst Tattoos*, and *Bondi Ink Tattoo*. I am an illustrator, clothing designer, model, now writer, and also owner of NYC tattoo studio and clothing boutique Grit N Glory. Basically, I do a lot of stuff. This wasn't always who I was, but I'll tell you how I got here.

If you would have told me when I started tattooing that I would end up on TV, let alone having millions of people follow my work, or even recognize my name, I would have laughed and thought you were crazy. Tattooing was a lot different at that time: there were no tattoo TV shows, and tattoos weren't glamorous. That really wasn't all that long ago. I've been tattooing for fourteen years now, which may seem like a long time to some, but in comparison to some of my peers and tattoo history as a whole, it's just a blip. I don't have all the answers; I don't feel like I've mastered anything. Honestly, I'm still learning and evolving along the way to try to be the best tattoo artist I can be. I think that feeling will last the length of my career. It's actually a bit difficult for me to write a book about my experience because there are so many people with way longer careers than mine. At the same time, tattooing is a creative art, and I believe that each person has something unique and different to contribute. So here I am doing it, happy to share with you my history and advice and hoping you can take something from it.

My Story

My interest in art began very young. I have drawings saved from as far back as age two. After seeing my interest, my family decided to send me to an art studio after my regular school day, whereas most other children went home to play or do homework. There I was introduced to many different forms of art. Whether it was painting, pastel, charcoal, photography, calligraphy—you name it—I wanted to learn it.

When I was in high school, I took every art class available to me. I was very lucky to have an amazing art teacher who, when I ran out of art classes to take, created independent study courses for me. One course I did was calligraphy, after which I actually ended up landing jobs as a calligrapher in high school, making things like wedding invitations and addressing envelopes.

I started tattooing in 2004, a few months after I graduated high school. At the time, I knew next to nothing about tattooing or the industry; all I knew was that I was an artist and wanted to learn how to translate my ability onto skin. The idea to learn how to tattoo, however, had come to me years prior. I have photos of me drawing tattoos on my mom as far back as age twelve. Mind you, the world of tattooing was much different back then. It wasn't on TV, and you didn't see many people walking around with any tattoos—let alone the sleeves and large-scale pieces people commonly get today. For my secluded, suburban little world, tattoos were uncommon. Most of my peers thought I was weird. Yes, I was a dorky art kid who was more interested in exploring the paths less traveled than trying to fit in and conforming to so-called normalcy or being cool.

One day, a ninth-grade classmate of mine came into school with a new tattoo. (Who was tattooing him that young? At this time we were about fourteen years old.) I took one look at it and thought, "That's so cool, but I think if I learned how to do that, I could do better." I went into a local tattoo studio asking about how one learns to tattoo. They told me I needed to get an apprenticeship, and said it cost a few thousand dollars. They weren't interested in offering one to me, but even if they did, at that age a few thousand dollars might as well have been a million to me. Looking back on it, I understand why no one wanted a young girl hanging around their shop. At that time, tattoo studios were much rougher places than they are today.

Fast-forward a few years, I was eighteen and newly free from the bonds of school, excited to move on to "real life." I had been waiting for this moment the entire time I was in school only to realize *I had absolutely no idea what to do with myself.* Looking back, I think it's kind of crazy to be pressured to figure out what you want to do with your entire life when you're only eighteen—you don't even know who you are yet! Most of my

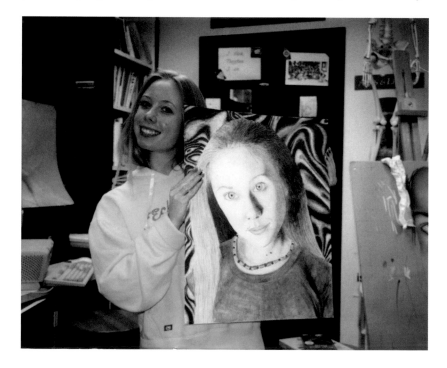

peers went on to college, so I followed suit. I didn't have much money saved, so I picked up a job at a local department store selling furniture to pay for some courses at a local community college. It didn't take long before I was *miserable* at my job. The store was going bankrupt, so there wasn't much for me to do. Let's be honest, selling furniture isn't the most exciting way to spend your time (though I appreciate the fact that I can now pick an excellent mattress). School wasn't feeling much better—the one elective art class available to me wasn't enough to get me through the drudgery of preliminary courses I had zero interest in. The only thing that kept my undivided attention was art. As someone who had been drawing ever since they learned how to hold a pencil, I was completely suffocating without any sort of creative outlet.

Then randomly one evening a coworker asked me to give her a ride to a local tattoo studio after work. She wanted to try out for a job as a body piercer. While there, I waited for her in the lobby, just checking out the tattoo flash on the walls. One of the artists came out to chat with me. "Your friend says you can draw," he said. I always sat at my desk and doodled all day at work, as there really wasn't much else to do, and apparently she had noticed. I told him I had been drawing a long time, and he said, "Oh yeah? Why don't you draw me some stuff now?" He handed me some paper and a pencil. I started to get a little nervous realizing this could possibly, finally, be a chance to show off my skills and get my foot in the door at a studio. "Sure, why not?" I said, trying to sound casual. "What should I draw?" He gave me a couple of options: a fish and a name hidden in a tribal design. Each time I finished a drawing, he would nod his head approvingly and ask for another. His final idea was an evil butterfly. I was a little stumped on this idea, but after looking over the tattoo flash on the walls I was inspired and took a crack at it. After checking out my drawing, he walked it over to the owner of the shop and said, "She's got it." The owner looked at me and asked, "Have you ever done a tattoo before?" Of course I replied no. "Wanna try?" he said. Shocked and nervous, but also realizing this might be my only shot, I blurted out, "Yes!"

That night the owner set up his tattoo station and walked me through my first tattoo, on the shop's very willing apprentice. It was of his name, Timmy. I started at the *Y*, which was pretty shaky, but by the time I got to the *T*, it wasn't half bad. Timmy then told me to go ahead and freehand a design on his leg. I chose an image of a crazy mushroom I used to draw all the time as a kid, very of the era. The owner then asked if I'd like to apprentice, and that was the beginning. It's funny, without that crappy furniture store job I would have never stumbled upon that path to tattooing.

. . . This is where most of my media interviews stop. While me walking into that first studio seems like an overnight success story, it was really the beginning of a very long and arduous journey. The interviews don't tell you how the apprenticeship I received wasn't thorough and ended too soon after just a year due to some very dramatic personal circumstances (let's just say dating your boss is a bad idea; eighteen-year-old Megan made a lot of bad decisions). The interviews also don't tell you about the years of jumping around to eight different studios, trying to learn bits and pieces along the way because for one crazy, dramatic reason or another, I was thrown out of or needed to leave the studios I worked in after relatively short periods of time.

However, no amount of adversity slowed me down. From the second I started tattooing I was completely obsessed, to the point that I didn't take a single day off my first year. I ended up actually moving into the first studio I worked in. I slept in the basement, rented a hotel room nearby for showers, and sometimes wouldn't do anything else but tattoo for weeks until friends would show up asking where in the world I had disappeared to.

At this time, being young and female in a heavily male-dominated industry, it wasn't always easy to get respect at tattoo studios. I've had instances where I was treated poorly by other artists, walked into the shop to find my machines in broken pieces, and had my things stolen. While I was advancing quickly artistically at each studio, it was clear that the guys weren't always happy for me. While sometimes I was being hired due to merit, it was clear other times I was hired just to "have a hot chick in the shop." There were also times when clients refused to get tattooed by me

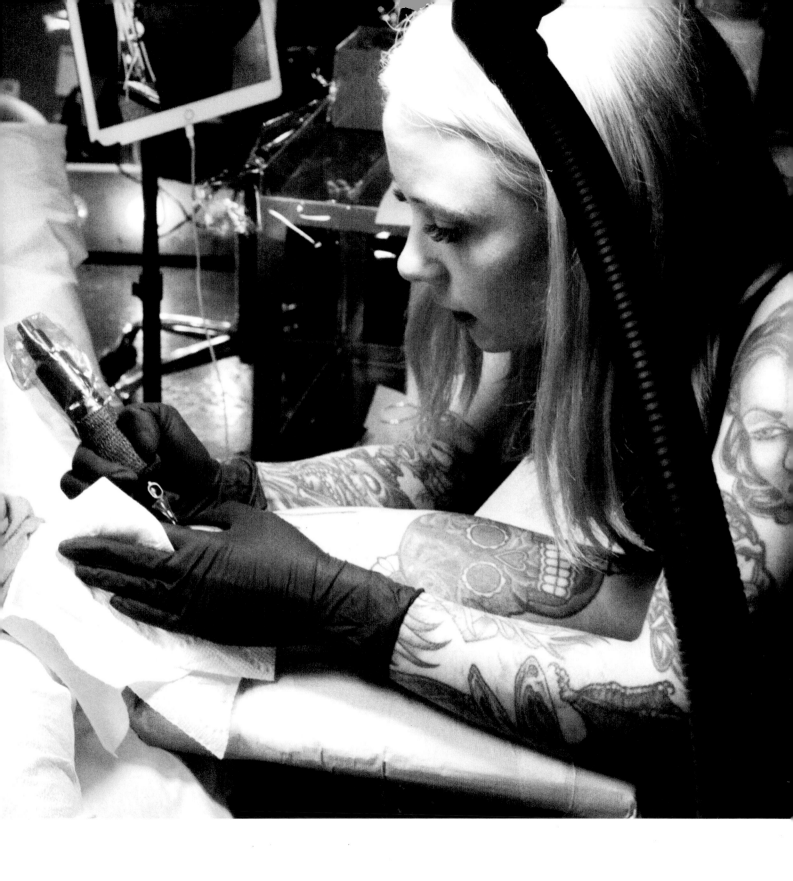

simply because I was a woman. Publicly some people treated me negatively as well about being heavily tattooed. I remember being out maybe grocery shopping or going about my normal day, and passersby would just walk up to me, feeling compelled to share their distaste for the way I looked. Telling me that I made a terrible decision to get tattooed, that I would regret it when I was older or a mother, that no one would want to marry me, that I ruined my life, and so on. I remember holding a door once for an older woman, and she refused to walk through it. She just looked at me and exclaimed, "You're covered in those terrible things!" It's funny, if someone gets a bad haircut, or is wearing an outfit you don't like, you wouldn't walk up to them and tell them, because it's considered rude. However, for some reason at this time people found it completely acceptable to talk to and look at heavily tattooed people this way.

That's why I was so surprised when tattooing appeared on TV. It was about a year into my career when the show *Miami Ink* first came out, and although it would take years yet, that's when I first saw the world begin to change. I still remember my very first positive, public experience. It was a few years later when I was waiting in an airport in Phoenix, Arizona, on my way to a tattoo convention. An elderly woman was sitting in a wheelchair by the gate and called me over to her. I politely did as she asked but was bracing myself for the typical insults disguised as "advice." Surprisingly, she made a different remark, one of positivity and actual happiness. "Oh! Your tattoos are beautiful!" she said, taking my hand and turning it over to see the rest of my arm. "I love the colors," she added. All I could do was smile and say, "Thank you."

After watching tattoo television for the first time, I knew that was something I would love to take part in. Not that I thought it would ever actually happen—I was just a green tattooer at the time and I knew I had light-years of learning to go before I would be able to get to that level. So I was shocked when only about a year later I was contacted about being on a tattoo TV show. However, their stipulation was that I do black-and-gray portraits, which is one of the more difficult styles of tattooing. As I was still inexperienced, and drawn way more to color tattoos at the time, I knew it wasn't the right time for me. I let the opportunity go. It was

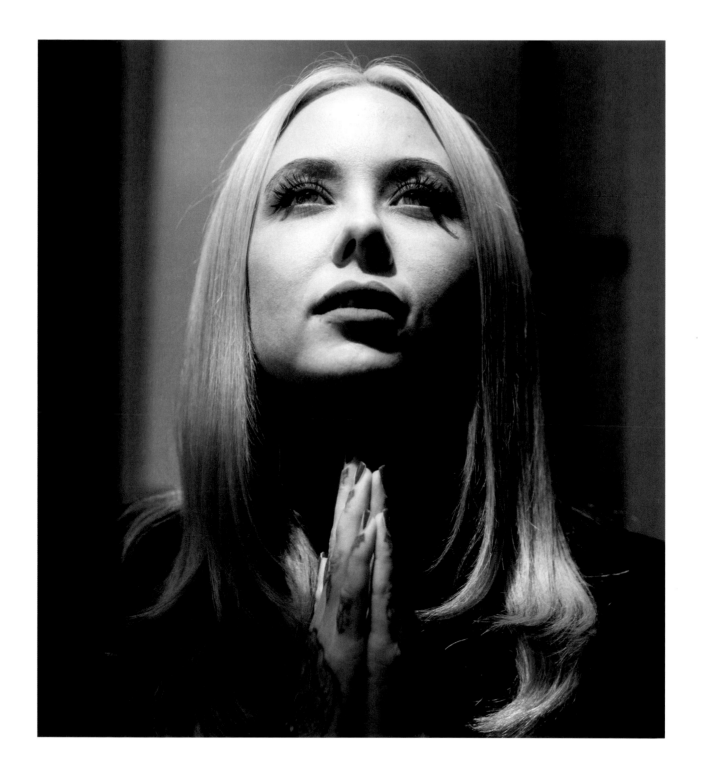

a very hard thing to do. Rarely does opportunity strike twice, but I knew it was the best thing for me artistically. I needed time to focus and hone my craft before showcasing it to the world. During the beginning of my career, new school–style tattoos were very popular, so I was very into tattooing this style. Over the years I went out of my way to try to learn many styles of tattooing, such as traditional, neo-traditional, and realism, both in color and black and gray. However, bright, vibrant color always seemed to stick with me the most.

Around this time, about 2007, is when I started alternative modeling. For those who aren't familiar with the term, alternative models fall outside of the model industry standards of around six feet tall and one hundred pounds. At five feet tall and covered in tattoos, I was definitely alternative. It began after I befriended another tattooed girl who had recently started modeling. She brought me to one of her photo shoots, which then became my first photo shoot. For a while we became shoot buddies, booking photographers at the same time to ensure our safety—let me tell you, there are a *lot* of creeps out there with cameras just calling themselves photographers. I got a lot of flak from other tattoo artists at the time, saying that I would never be taken seriously as an artist while I was modeling. I didn't listen to them. I knew to an extent they were right—I was receiving a lot of judgment—but modeling was something I loved to do and I wasn't going to stop for other people. I was determined to prove them wrong. My modeling has slowed down over the years as I've turned my time and attention toward shooting TV and running my own business. However, I still enjoy modeling for my clothing line and occasionally shooting for publications and brand collaborations.

This was also about the time I began to be known by my moniker Megan Massacre. Many people ask how I got this name, and I can assure you it's not because I've murdered a large number of people or because my hand is so heavy I tattoo to the bone (I actually like to think of my tattoos as feeling more like kitten snuggles). But for real, this name came about during a time where my friends and I were really into hardcore music. We were young and small in comparison to others in the scene, and there tended to be a lot of fighting and aggression at shows.

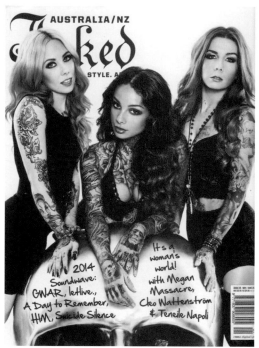

AUSTRALIA/NZ

Inked

STYLE. A

It's a woman's world! with Megan Massacre, Cleo Wattenström & Teneile Napoli

2014 Soundwave: GWAR, letlive., A Day to Remember, HIM, Suicide Silence

REBEL INK

Over 500 Tattoos!

RebelInk

20 Most Wanted Ink Slingers!

SPECIAL All-Artist Issue! Worldwide Talent!

Alex Rattray
Jose Perez
Dave Wah
Natalia Borgia
Ricardo Bottino
And More!

Megan Massacre
Raquel Reed
Burlesque & Ink Unite!

1553 FALL 2015
FACES PRESENTS
$5.99 US.
www.rebelinkmag.com
DISPLAY UNTIL 10/13/2015

TATTOOSOCIETY

GREAT ART FOR GREAT ARTISTS

ISSUE NUMBER #60

Realistic Portraiture At Its Finest
MICHAEL TAGUET

Photorealism Combined With Abstract Elements
THOMAS CARLI JARLIER

Dark-Themed Neotraditional Tattoos Standing the Test of Time The work of:
MATT CURZON

KOROUTEN
A Collaborative Art Exhibition by:
HORIYOSHI III & JESS YEN

MEGAN MASSACRE
Cover Girl Insert Poster

PLUS:
Mario Barth's Inked Out New Jersey

The Panama City Ink Fest
Panama City - Panama

December Jan / October and February 2018

$7.99US $7.99CAN

People belonged to "crews," so my friends and I gave ourselves tough-sounding names and formed our own mock crew after all the older, tough-sounding crews. (We used these same super-tough names for our bowling team, as we were on a league, just so you know how serious we were.) Long story short, lots of our friends ended up wanting to be a part of our crew, and with the bunch of us sticking together, the bullies left us alone. I never really meant for this to stick, but when my first magazine article with a cover came out, the headline read "Megan Massacre, Philly's femme fatale," and I knew then that was it. I will be sixty years old and people will still be calling me Megan Massacre. There was a time when I wasn't so sure I would keep it, but I've grown rather fond of it. If you met me, you would probably think I'm quite the opposite of my name. If you know me, you know that in the most phlegmatic way possible, I don't take anyone's shit.

It wasn't until about four years in that I felt I was able to make serious strides from being just a person who makes tattoos to an actual tattoo artist. It came from a change of environment. While working a tattoo convention in Baltimore, I met a tattoo artist I looked up to from Philadelphia named Paul Acker. He offered me a spot at his custom tattoo studio, Deep Six Laboratory (he's now the owner of Séance Tattoo Parlor). I was beyond honored and jumped at the opportunity, but I was then living far away in the small town of Exeter, Pennsylvania, and dealing with complications in leaving the studio where I was working at the time, so it took me about a year to make the move. Once I did, it made a huge impact on my work. Tattooing in a shop that was filled with talented and motivated artists was inspiring. I watched everything they did and listened to all the advice they gave me. I wanted to soak up every bit of it like a sponge. It was at this stage in my career that I started to be fascinated by realism. I learned a lot from Paul, who is so adept at color portraiture, and I began experimenting with it myself. I was beginning to understand three-dimensional art, shadows, and light. It was all coming together. This is also the time in my life where I started experimenting again with other art mediums, such as painting. I started working in watercolor, as the processes of color fades and line work are similar to tattooing. I painted a few pieces for

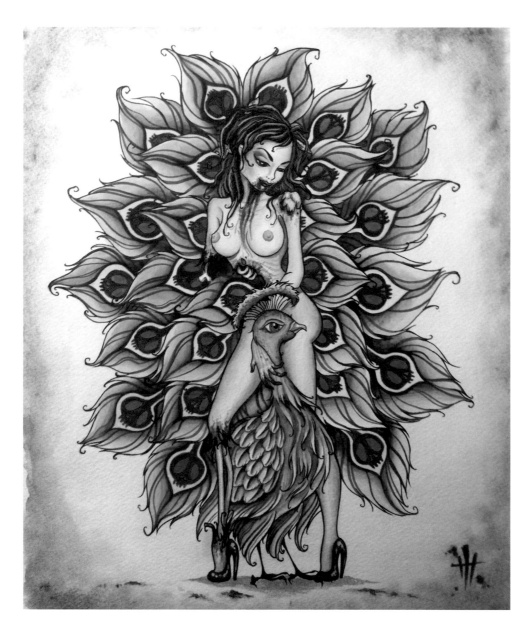

art shows, but with how busy I was getting with tattooing, it was hard to make as much time for other art as I would have liked. Around this time I also began working as many tattoo conventions as I could, stretching out into the world to meet, learn from, and be inspired by new artists, cultures, and places.

I was happy in Philadelphia, and I may have not moved on to a new place had another opportunity not presented itself. One day while working at Deep Six, I heard my manager get a strange phone call for me in the lobby. He was actually shouting into the phone. He then came huffing and puffing into my tattoo room to tell me about a client demanding to get tattooed by me that weekend without an appointment and insisting to speak to me. As I was booked out months in advance, this wasn't a reasonable request. Thinking he was talking to some sort of stalker, he was proud to tell them to get lost. I never have clients behave that way, so I was very confused by the whole thing. Later that night after logging into my Myspace account (the good old Myspace era), I saw a strange message. It said it was from the woman who made the odd phone call. She explained she wasn't looking to actually get a tattoo, but that it was just a cover to try to get me on the phone to talk about something else. She claimed to work for TLC network and said they were interested in interviewing me for a new TV show. At first I didn't believe her and thought it was some sort of spam mail. I took a risk and called her anyway, thinking that whatever this lady was trying to reach me about, it'd be interesting regardless. What I found out was that it wasn't a scam at all. Having gone through this process with TV people before, I told her right away I wasn't interested in being someone I wasn't. She replied that I was picked based on my work, and they just wanted me to be me. Hearing that, I was sold.

After a few video interviews, just a couple of months later I was on my way to New York to shoot the first season of *NY Ink*. It happened super fast. While it was an exciting opportunity, it wasn't easy. I had about a month to figure my life out: find someone to sublet my apartment in Philadelphia, find a new apartment in New York, and spend all my money on rent and moving, as New York is so expensive. I also didn't know anyone in New York. Moving to a whole new city and working in television for the first time were extremely intimidating. I felt very anxious. I was also feeling pressure within my industry. At this point in my career I had made a name for myself, developed a clientele, and made friends with many amazing tattoo artists. While some of them were thrilled for me, some were skeptical. They felt being involved in TV was selling out

or doing our industry an injustice by commercializing it and helping make it mainstream. I half agreed with them. I didn't like the inaccurate way tattooing was sometimes portrayed to the public, either. However, I didn't consider the idea of tattooing becoming mainstream to be a bad thing. The more popular tattooing became, the bigger our industry would be, and that's more work for all of us. It just had to be done the right way. I saw more purpose in taking part in a TV show to influence it in a positive way than just sitting back and letting other people do it.

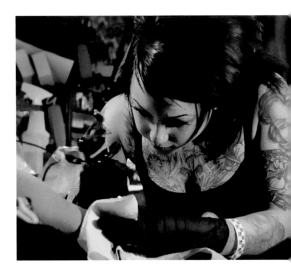

My first season of TV was a whirlwind. Walking onto set my first day was both exciting and nerve-racking. I had met only one member of the crew and none of the cast prior to the first day. When I got there, they put a microphone on me before I even walked in the building and sent me into a room filled with cast, crew, and cameras all around rolling on my reaction. I had never done anything like this before and it was extremely overwhelming, but I just went with it the best I could. Over the next few weeks I made friends with the cast and crew, but I couldn't quite get used to being on camera. I was way too inside my own head, so concerned with what I looked like, what I sounded like, what people would think and judge about the things I said. The hours were long and demanding. There were also periods where we had to sit and wait doing nothing for hours, going stir-crazy. While sometimes we had fun and it was lighthearted, there were also instances of tension and drama. While I was confident in my tattooing, I'd never had cameras inches away from me recording my every line before—it made me super nervous, and it was obvious. The producers told me if I didn't step my game up, I was at risk of being cut from the show. It was to the point where nights after shooting, I would cry to myself, thinking, "What the hell did I get myself into?"

Midseason we had a two-week break where I took time to reevaluate my situation. I had to really look at myself and decide if I had made the right decision. I ultimately concluded that I had taken on a responsibility and I needed to see it through. I was going to turn this situation around and not let it frighten me or get me down. I was going to enjoy it the best I could and be the best version of myself that I could be. I didn't want to be afraid to be myself or of what other people thought of me. As long as

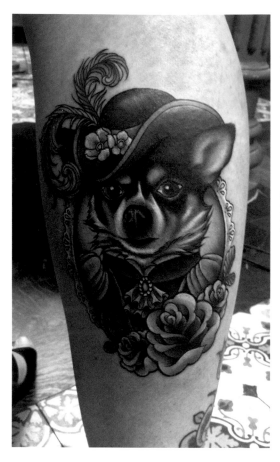

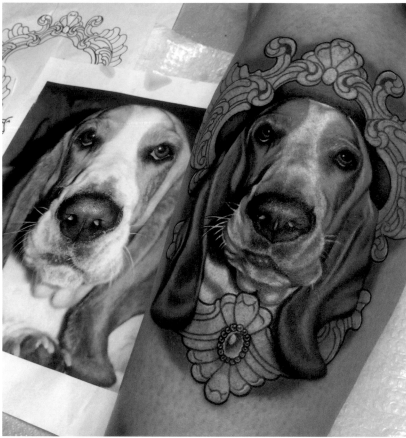

I spoke to how I truly felt, and was true to myself, that's all that mattered. This is when I learned not to bother doing something unless you're going to do it to the best of your ability. Dedicate yourself wholeheartedly to it or just don't do it. After that, the second half of the show went great. I was able to speak confidently in front of the cameras, let loose, and be more involved in the show, not taking anything too seriously. I then had the headspace to appreciate working with great artists I could learn more from and making great friends in both the cast and crew. I am really grateful to Ami James who built the shop and the show and gave me this great opportunity.

I believe most tattoo apprenticeships start with apprentices learning the basics of traditional tattooing. I didn't realize when it was happening

that my initial apprenticeship skipped over a lot of the traditional aspects of tattooing. I realized these were things I felt I really missed out on. I never had the opportunity to be around and learn from traditional artists until now, and I felt really lucky to have the opportunity years later. Both Ami James and Tim Hendricks helped me a lot in this direction. This was about seven years into my career, so I felt like, in a way, I was sort of learning backward. It's super important to be open to learning new things and to keep evolving, no matter where you are in your career. I found myself making simpler, cleaner tattoos. Having been focused on realism for a while, I wasn't accustomed to using much line work, but now I found myself looking for ways to incorporate more lines into my tattoos while still retaining my style. I really enjoyed the idea of combining multiple styles into one tattoo. A fun example of this was when I gave a friend of mine a tattoo on *NY Ink* of her pet Chihuahua dressed in a Victorian woman's clothes. It's a very early example of this, but the face was made to be more realistic, while the clothes are more traditional in style. That spawned a trend of many people coming to me to get their pets tattooed on them dressed as people. I absolutely love tattooing portraits of animals and pets in that way. For me, the fun is in finding new ways to combine different styles of tattoos. Over the years, I've experimented with combining other subject matter and tattoo styles as the trends have come and gone.

Originally when I first came to New York, I thought I would be there for only three months. Seven years later, I am still here—though things are a little different now. I worked at the tattoo studio where *NY Ink* was based, the Wooster Street Social Club in SoHo, for the first four of those years. After its first season, *NY Ink* was renewed for two more seasons, and then I did two seasons of another TLC tattoo TV series titled *America's Worst Tattoos*. Years later I am now currently in my second season of the Australian reality show *Bondi Ink Tattoo*.

Every show is a completely different experience to shoot. *NY Ink* will always probably be my favorite—it was the beginning for me. I made so many great friends and it really changed my whole life and opened up many doors. Each season took about three months to shoot—we're

talking super-long days, five days a week. By the weekend you're so exhausted you're just sleeping and trying to catch up on laundry. The most common question I get from people about shooting TV is whether it's weird to have cameras following me around or shooting me while I tattoo. At first, yes, of course, it was something I had to get used to. However, after a while, I didn't think of it as the camera; I thought of it as my friends on the crew just hanging out with me and watching what I was doing. Another interesting aspect is the fact that, because the cast were wearing microphones, people were always listening to us, so we had to be careful what we talked about. Needless to say, every time we went to the bathroom, we turned our microphones off or asked the sound guy to turn his volume down.

I started shooting the first season of *America's Worst Tattoos* around the same time I shot the third season of *NY Ink*. Both ended up airing at the exact same time. *America's Worst Tattoos* was originally meant to be filmed at Wooster Street too, but after some complications the location was moved to another nearby NYC tattoo studio, Sacred Tattoo. Its schedule was a lot more relaxed, with shoots only about once a week. However, these were easily the hardest tattoos I've done thus far in my career. When I was first asked to do a TV show that focused only on tattoo cover-ups, I wasn't thrilled. Cover-up tattoos are way harder than fresh tattoos and much longer to complete—which, in my mind, makes them not ideal for TV. I like a good challenge, though, so I decided to take on the job. Despite how difficult it may have been, it was all worth it to be able to hone my tattoo craft even further. Being able to cover up people's bad tattoos and transform them into things of beauty wasn't just helping with aesthetics. It was helping people, whether it was giving them confidence again, or changing a bad memory. The producers definitely didn't make it easy for me, though—they brought in some of the most challenging tattoos I've ever had to cover in my career, all on camera for everyone to see if I couldn't quite pull it off. In my mind, however, that

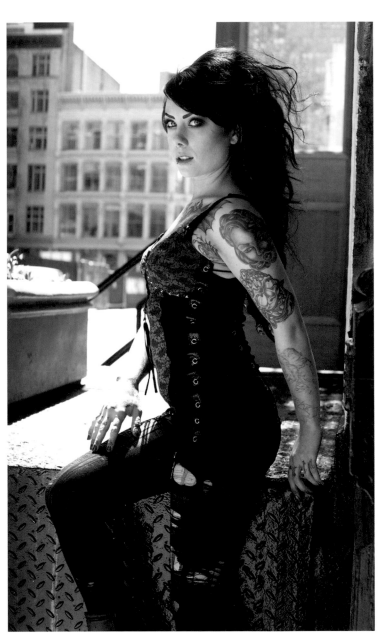

wasn't an option. I'm not going to lie: I took one look at some of the tattoos they brought in and thought they were completely un-coverable. That happens sometimes—not all tattoos can be covered, but we will look at that in chapter 6.

After the second season of *America's Worst Tattoos*, I had a couple of years' break from TV. At that point, TLC decided to step away from tattoo television. Meanwhile, there was an explosion of tattoo shows all over many other networks. While I was asked to participate in some, I unfortunately couldn't due to my TLC contracts. It was a bit of a bummer for me. However, once I was able to work again, I was lucky enough to be invited to Australia to participate in the *Bondi Ink Tattoo* reality series. The show took about a month and a half to shoot. It was super fun for me to get to spend that amount of time out of the country and experience new surroundings. Owning my own tattoo studio in New York makes it difficult for me to leave home for longer than a week, so it was a bit stressful balancing everything. Luckily, I feel I work best under pressure.

To me, tattooing is very special. It isn't my job—it's my life. Nothing else I have would exist without tattooing or the clients who get my tattoos. People aren't buying my artwork to hang on a wall; they are buying it to wear on their bodies for the rest of their lives. I am so thankful for that. Most people look at tattooing as permanent, but really it's probably one of the most temporary forms of art. While some painters, sculptors, and the like have works that exist for hundreds of years, tattoos last only a lifetime. One day my work will exist only in photos, and that makes it all the more special to me.

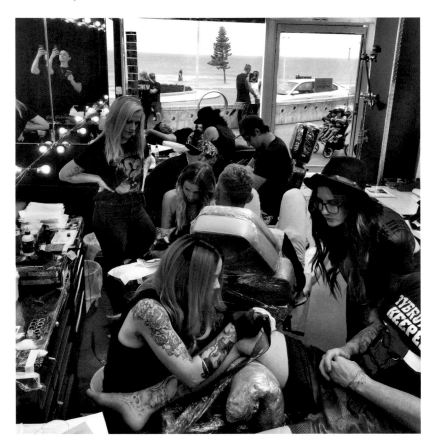

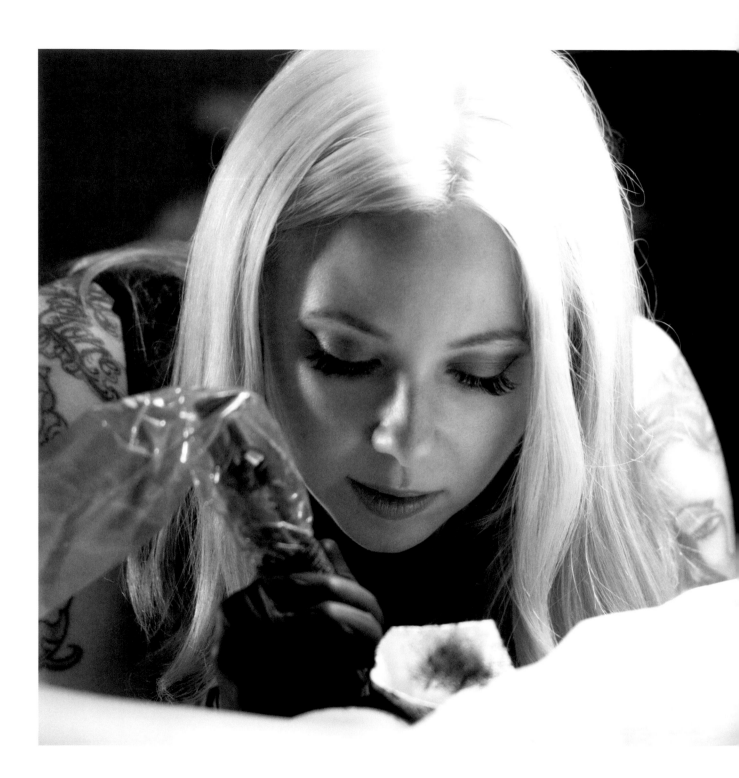

About this Book

In putting together this book, I wanted to create something that shared my hard-won experience and point of view on various aspects of the tattoo industry. While this is a collection of my tattoos and artwork from over the years, I wanted it also to contain information that professional artists, aspiring artists, and collectors could all relate to and pull something from. For the collector, I cover the basics of getting tattooed from the artist's perspective, and what we as artists need from you to give you the best artwork possible. There's also a special visual section on the whole tattoo process, step by step, from start to finish. For the aspiring tattoo artist, I include tips on how to get the most out of learning to tattoo. For artists and creatives, I share how I get inspired and how I approach brainstorming, drawing, and developing a style. Of course, this book would not be complete without some advice gleaned from my experience with cover-up tattoos and all the aspects that make them possible or not. Tattooing goes through trends, and that affects both artists and collectors. I want to share with you, all through my eyes, the best advice and experience I can give you.

I should mention, this book will not teach you to tattoo. No book can, because nothing beats the experience of working with someone who's been doing it for years. There are so many things that only someone who is experienced can know and show you. An apprenticeship is the most fruitful way to learn.

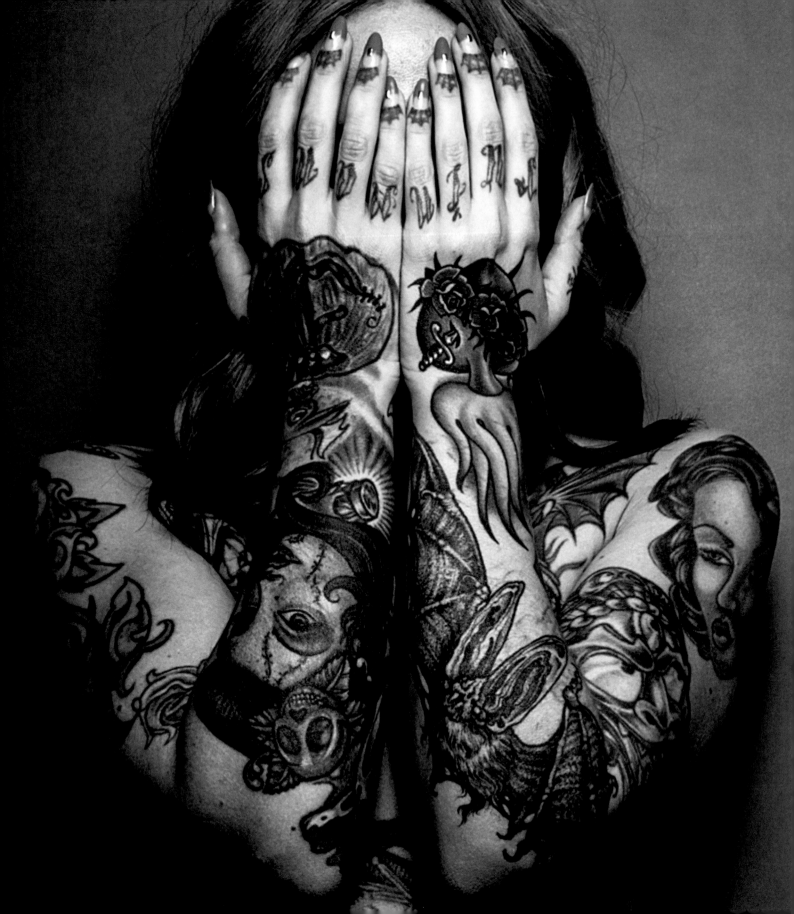

My Tattoos

I got my very first tattoo in 2004, about six months after I started my apprenticeship. Some may find it strange that I didn't have tattoos prior; the truth is I wanted them, but my mom would never sign off on it. At eighteen, I could finally, legally do it, but I had such a hard time deciding just what to get. To this day I always tell people, your first tattoo is the hardest to choose, but during your first one you'll already be thinking of the idea for your second, then soon after, your third, and you're totally hooked. That's what happened to me! The day I got my first tattoo I hadn't actually planned on doing it. My boss came into work that day and told me clients were too scared to get tattooed by me because I looked like a little kid. I did probably look about fourteen years old. Also, I had no tattoos. So, by the end of the day I had to pick something and he would tattoo it after work. There were no social media networks to sift through for photos back then, so for ideas I spent all day going through the hundreds of flash pages and dozens of tattoo magazines we had in the shop. At the time, there were sections in the back of some magazines where they would print tattoo flash submitted by artists. In one of those sections I found a colorful anime drawing of a lady cheetah, and something in my head said, "This is it!" Looking back now, I'm like, "What was I thinking?" However, eighteen-year-old me was super into video games and anime and I was stoked on it. That night my boss outlined it, huge, on my right calf. It was quick and easier than I thought. I was instantly hooked. When I got home, my mom *flipped* on me. Looking back now, I understand why: in the world where we existed at the time, it was a crazy thing to do. Eighteen-year-old girls in small-town Pennsylvania weren't walking around with huge tattoos. She exclaimed, "How will you ever wear a dress?" I simply thought, "I can still wear it!" She said absolutely no more tattoos.

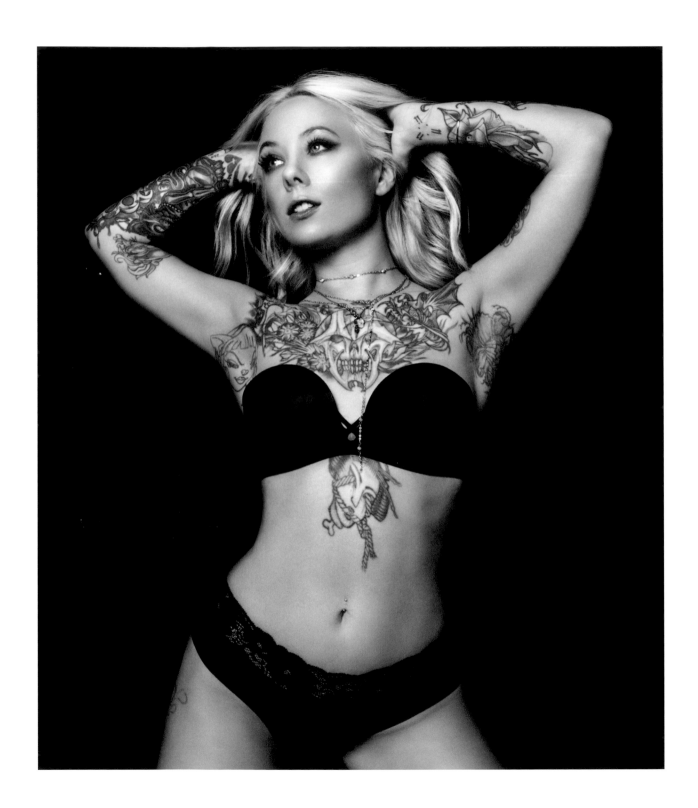

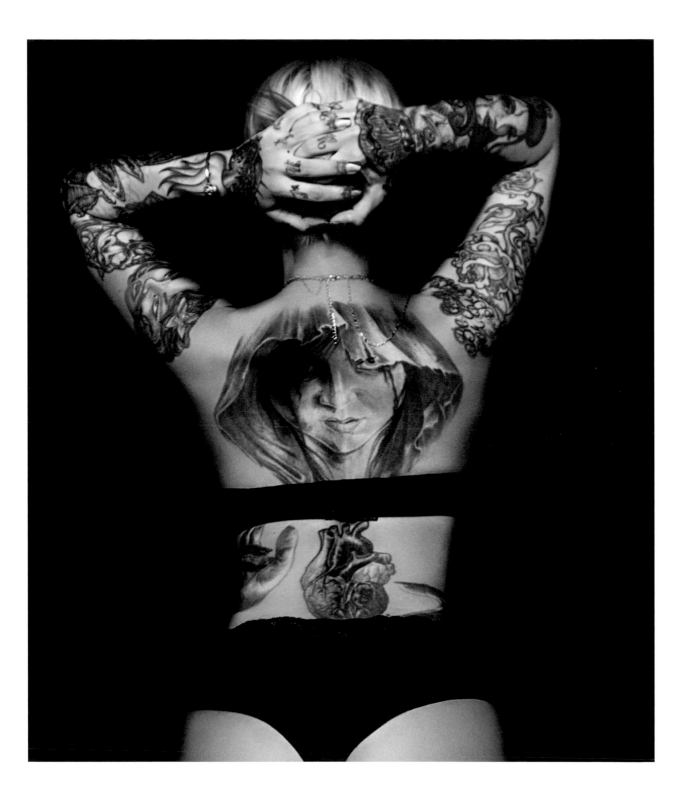

As the weeks progressed, I had the serious itch to get more work. I was looking for ways to get my mom to be okay with me getting more tattoos. First, I thought I'd let her help pick one for me. We looked through some new flash we had at the shop, and we both liked an image of a samurai woman with katanas and negative flowing hair. (For those who don't know, negative tattooing means the outside of the image is shaded instead of the inside, which is left blank skin color, and at the time it was *all* the rage.) I decided to add this to my inner right calf. Next, I decided to get a traditional-style pinup nurse, after my mom's profession, with a banner that said *Mom* on it. I put it on the back of my leg, and of course she loved it. Boom, just like that I had a lower-leg sleeve and I couldn't stop. For my next tattoo I decided on a geisha head with ropes through the eyes, done in a more traditional style. It's a dark image, but I like dark things. It isn't about anything negative; to me, tattoos are way more about the artwork itself than the meanings (even though TV will

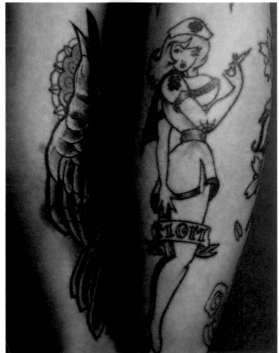

tell you to think otherwise). I knew my mom might not love this one, so I chose a spot I could easily hide from her—my sternum. At the time this wasn't a typical place to get tattooed, but I guess I got lucky that it's a very popular place today. Despite my efforts to hide it from my mom, she surprised me at the shop one day while I was walking around with my shirt rolled up. She walked in, shook her head, and said, "Okay, I understand that I can't stop you, just please don't tattoo your face!" While she was definitely worried about my getting tattooed when I was younger, I knew she had my best interests in mind, and she was the all-time biggest supporter of my tattooing—especially when no one else was. Some of my family members had a very hard time accepting my new life path and it took some years before everyone really understood that I was doing something positive. It's crazy to see how things have changed: just within the past few years I've been working on a large back piece on my dad and gave my little sister her not-so-little first tattoo.

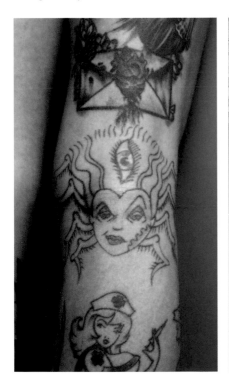
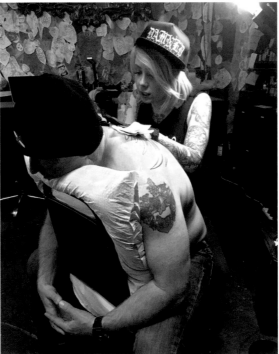

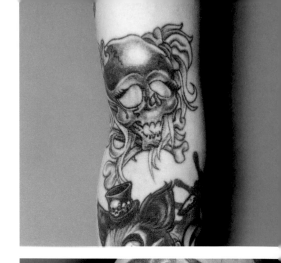

That first year I got a *lot* of tattoos. On my leg I added a bride of Frankenstein and some cherry blossoms, and I tried to tattoo a genie lantern under my first tattoo *on myself*, but that didn't work out so well because I couldn't really reach. It is typical for tattoo artists to tattoo themselves while learning, but it's a hell of a lot harder, so I prefer to leave it up to other people. I also started both arms within the following year. My very first arm tattoo, which felt like a huge deal, was by my boss's friend. He came to guest at our shop one day and my boss told me that his friend would give me my first arm tattoo, and to just let him do whatever he wanted, which was a little scary. I normally wouldn't just let someone I didn't know of well tattoo me like that, but I was young and inexperienced, and I had a lot of trust in my boss, who was also teaching me how to tattoo at the time. He did classic, neo-traditional-style roses.

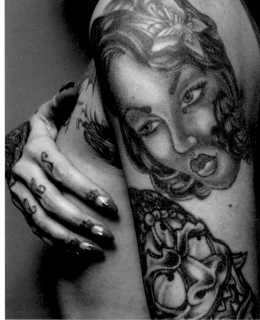

My boss did a bunch more tattoos on my arms. On my left forearm he did a koi fish; on my upper arm a traditional purple lady head and neo-traditional *hannya*-type mask. I distinctly remember being so drunk during the mask tattoo that I couldn't stay on the chair and fell off several times; great life choices. Do not do that! On the right forearm he did a pink cat and bride of Frankenstein. On my right ditch (tattoo slang for inner elbow) he tattooed a girly purple skull.

While at the shop I wanted to do my part to help others learn, as apprentice Timmy had once done for me, and I gave up some skin for one of the apprentices to learn. I made a terrible choice and had him tattoo my hip, with a three-liner (a group of three needles soldered together to create one of the smallest liner needles), which is way too difficult a place and too small a needle for a beginner. This was due to my inexperience, but hey, we have to learn somehow. It was a skull and crossbones, and today it looks like a pirate got it about a hundred years ago. That's what I get for not knowing what the hell I was doing. It's hands down my worst tattoo and an excellent representation of a "blowout," which means the needle went in way too deep and the line bled to a much bigger size. Weirdly, I don't hate it. I have a strange attachment to it and have yet to cover it—though, actually, I may never; I kind of feel like some of my older tattoos are just good stories on my tattoo timeline.

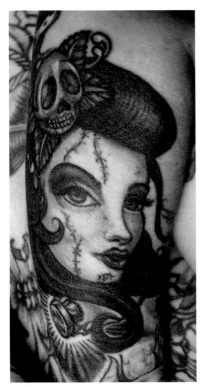

It is bad form to get a new tattoo before completing another, but I did this quite a bit. Unfortunately, I left my original shop before all my pieces were completed, and I walked around with some outlines for a little while. I had another local artist, Justin Bolonski, color my bride of Frankenstein for me.

After leaving my first shop and being in the tattoo industry for a few years by that point, I was starting to really learn about the art of tattooing and different styles, and I sought out a few of my favorite artists who specialized in certain styles. The first was a Philadelphia artist named Dave Fox. He has a unique neo-traditional style and I had him tattoo my chest. At first I wanted a Halloween-themed piece, but we chatted about how he was super into tattooing monsters at the time. I told him to go for it, and he created a vampire, skull, and bat–themed piece. However, I still couldn't get rid of the Halloween bug, so I sought another artist to do a themed piece for me. I really loved the cute characters made by the artist Gunnar, whom I asked to tattoo my right hand. He gave me the cutest jack-o'-lantern filled with candy corn and a little bat stealing a piece. Around that time I was really into hardcore music, so I decided to get the

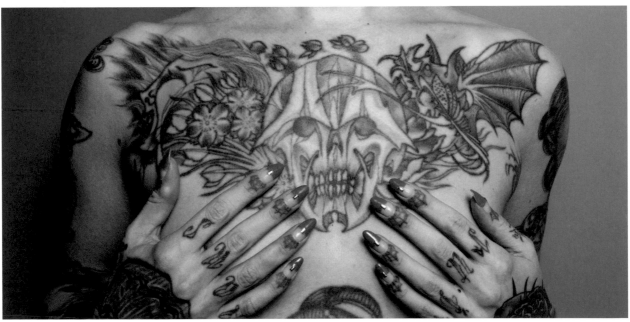

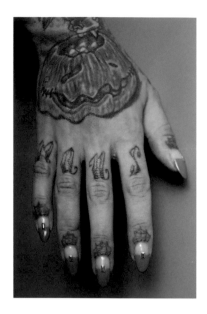

oh-so-super-tough and popular-at-the-time brass knuckles, blood, and teeth tattoo by a local artist close to my hometown named Justin Weatherholtz, who funnily enough now works just a few blocks away from me again in New York City.

Around this time I had a coworker, Rob Kells, tattoo my knuckles, and they are very tiny, so I know it was a tough job! I got *Mans Ruin* across my knuckles, inspired by the classic "Man's Ruin" tattoo. For those who don't know what that is, it's a classic traditional tattoo of a woman in a martini glass surrounded by gambling elements. It represents that women, alcohol, and gambling could ruin a man. In a way I felt like that girl, because I was currently scorned by my breakup with the owner of my first studio. Drama, I know, but perhaps we'll leave that for the future reality TV version of this book. I regret getting a tattoo with such a negative connotation. While I personally care more for the art than the meaning, I still believe tattoos should carry positive energy, not negative, and you definitely shouldn't brand yourself with something negative for life.

During this tumultuous time in my life, I also decided to tattoo my armpits. The decision actually came from a similar situation: I was in a terrible fight with my ex, he pulled some serious shit, and I was angrier than I had ever felt (when I was young I also had a really bad temper). I needed something to stop me in my tracks from going to burn his house down, so I asked my boss at the time, Jason Strunk of Colorwheel Tattoos in Reading, Pennsylvania, if he would give me the most painful tattoo I could think of—the armpit. The truth is that it wasn't bad at all! If you can believe it, I actually laughed through some of it because it tickled. He did a traditional purple peony tattoo from start to finish. This made me decide a few months later to get the other armpit done, thinking it would be no problem. However, things were different this time around. I was now happy again, and getting the tattoo *from* the ex in question who I was then back together with again (man, I was complicated), and this time it hurt like all hell. It was so painful that I didn't go past the outline, still haven't, and probably never will. I guess I'll never really know if it was that I was happier and that made it hurt more, or if he was tattooing me heavier because he was probably upset with me, but I'm not about to try again to find out.

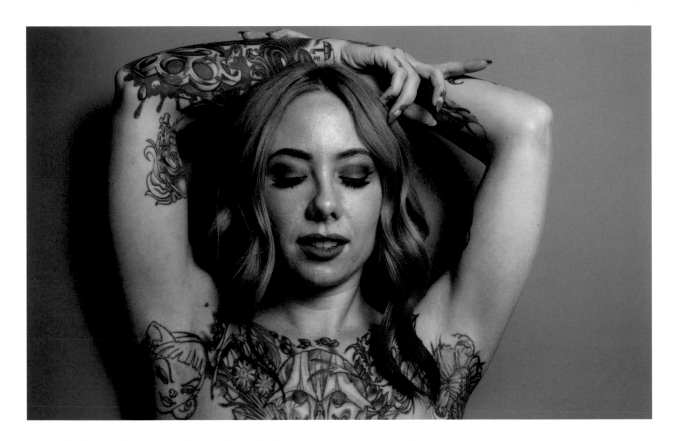

I also hadn't learned my lesson from the first apprentice tattoo and decided to get another, this time from my current boyfriend and body piercer at the studio, Zach. I walked him through this wild-looking zombie tattoo I was inspired by from a tattoo magazine, and it sort of came out looking like a wiggly alien. He was a beginner and that's no fault of his; again, I just wasn't using my best judgment. After that, I finally learned my lesson. (It may seem crazy to some, but while there is fake practice skin available for artists to learn to tattoo on, and some people even tattoo on fruit, the best way to learn to tattoo is just on people. There really isn't anything like the real thing.)

I stopped getting tattooed for a few years, realizing that I had gotten a lot of tattoos, really fast, and before I really knew what a good tattoo was. I loved some of them, but there were a bunch I really disliked, and that made me a little depressed. Around 2006 I started working in Philadelphia

at the shop Deep Six for my friend Paul Acker, whom I mentioned earlier. Working with him and the rest of the team there, I really felt I began to grow artistically and my taste in tattoos was changing. Paul started a full back piece on me—the idea was that it would be a darker, creepier, version of a Virgin Mary. I grew up Roman Catholic as a child, and while I don't practice religion, I do visually appreciate the artwork and the symbolism. We did about three sessions; the first was about seven hours on the head of the Virgin Mary at a tattoo convention in Richmond, Virginia. If you've been to the old Richmond conventions, you know how wild they get; if not, you'll just never know. Let's just say after seven hours of getting tattooed, at 3 a.m. we went up to the hotel party to have a drink and I passed out on a pile of strippers. Our next session, of the heart, was some time later and took about four hours I think. The final session, of the hands, took four to five hours. There is a lot more to do, but life happened, and with me moving to NYC and both of our busy schedules, I have yet to get it finished all these years later. At this point, who knows if I ever will, but hopefully it will happen eventually (wink-wink, Paul, if you're reading this). That being said, I'm gonna say do as I say and not as I do. If you're going to start a large piece, you should try to finish it in a timely manner; otherwise, you're just going to end up constantly redoing the older parts to match the newer parts and waste tons of time, pain, and money.

I was tattooed by a couple of other people at the studio as well. An artist named Pastor did the little spider webbing around my cuticles, one of my favorite tattoos to this day. This was hands down the most painful tattoo I have, and it took only about a half hour, but, man, was it brutal! I remember I had to put my hand on the hard counter because my fingers vibrated too much on the cushioned armrest. The sound was so low-pitched (you know, that *bone* sound) that it made everyone else in the studio cringe and they felt compelled to wait outside till it was over. Trust me, when the first hand was done it took a lot of courage to go through the second. Weirdly, when my fingernails grew out, some of the little webs were visible on them, meaning the tattoo went through that thin skin around the cuticle onto the actual nail. Gross!

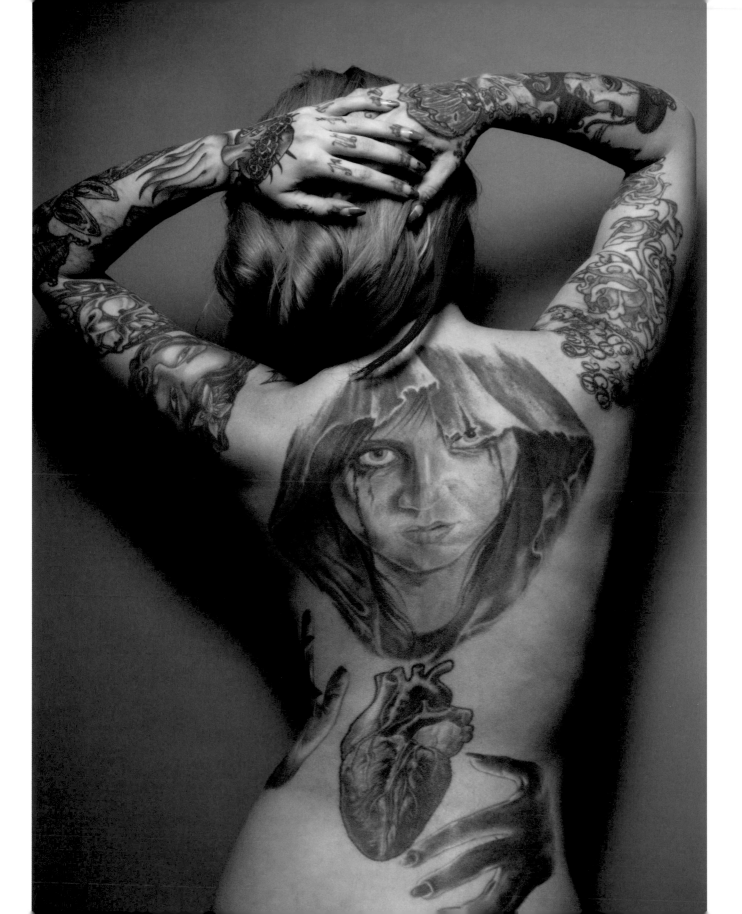

Another tattoo I got around this time was my classic "lucky 13" tattoo (no, it wasn't done on Friday the 13th like most other people's, but it's still cool, whatever). My artist friend Shlak did this one, and I had him put a spiral swirl and bats behind it that remind me of the old *Scooby-Doo* cartoons.

During this time period, I was good friends with a Pennsylvania-based band called Motionless in White. During the time I modeled, I was in a few of their music videos. I went with them on Warped Tour one summer to help them sell merch and I brought my tattoo equipment. I had no idea what I was getting myself into, one-hundred-degree weather, fifteen-hour days, and the most heinous of Porta-Potties. However, it was also a blast, and at the end of the tour we all got the tattoo I have on my left thumb. It stands for "wing crew," and "7" and "14" indicate the number of chicken wings I think? I tattooed everyone's wing crew tattoos, and I had each of them do a little piece of mine (funny enough, I was a vegetarian at the time and did not eat chicken wings, but I got it anyway as part of the group). Another music-themed tattoo I have is by a good friend of mine, artist and musician Davey Suicide. On a trip out to Los Angeles I tattooed a huge script tattoo on his back; I thought it fitting he tattoo one of his heart designs on my wrist.

While working at Deep Six, I had some tattoo removal done as well. At the time, Jack Morton traveled all over the country to different tattoo studios to do laser tattoo removal, so I took advantage of his time in our studio as much as I could handle. Let me tell you, getting laser is next-level painful! However, it's so fast and yields such great results it is totally worth it. I got the koi fish on my upper arm lightened just enough to cover, but didn't know quite what I wanted yet. After years of being bummed out on having some subpar tattoos, I really wanted to take my time with this.

In 2010 when I moved to NYC, my tattoo tastes started to change again, inspired by my environment. I was working around traditional tattoo artists and learning more about that style. My first tattoo in New York was a matching tattoo with my boyfriend at the time, Joe Letz. Now I *never* recommend relationship tattoos (again, do as I say, not as I do);

they just aren't worth the risk if the relationship ends. However, if you're swept up the way I was and throw caution to the wind, I recommend doing it the same way I did. Instead of getting something like each other's names, we went for a matching tattoo that had meaning independent of our relationship. It is three elevens on our wrists, because in numerology a reoccurring pattern of ones is a reminder to keep your thoughts positive, as they are powerful and currently manifesting in your world. We also got this on the calendar date 11/11/11, by my artist friend Guy Waisman. This way, even though we've since split up, it's still a positive, cool tattoo to me. It also helps that we are still friends.

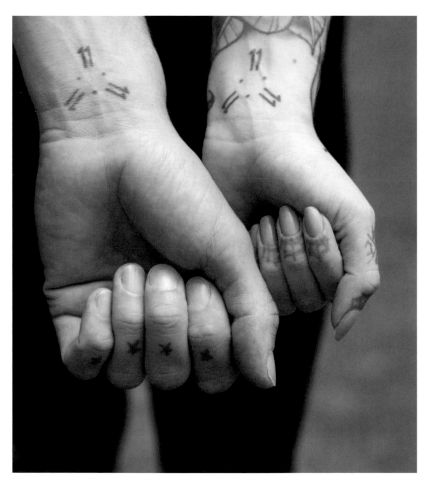

Those of you who watched me on the TV show *NY Ink* may have seen my next tattoo. A couple of us from the Wooster Street Social Club went out one night to the oldest bar in NYC, McSorley's. We got "white girl wasted" according to my friend Lee Rodriguez. They had a sign on the wall that said "be good or be gone," and this phrase really resonated with me and the group; it was a great night. Afterward, we all got it tattooed by artist Ross Nagle. Another tattoo surrounding my *NY Ink* experience was a little umbrella I got tattooed on set by artist Billy DeCola from the series. We all got the tattoo that day, dedicated to the fact that it literally wouldn't stop raining while we shot the show.

Next, I sought out a tattoo of a hand, rose, and flames on my left forearm from artist Dave Tevenal. This covered my old, lightened-up koi fish partially. This tattoo really had no meaning; I just loved Dave's artwork. I was ready to begin some other cover-up work as well. As some of you may have seen on my tattoo cover-up TV show, *America's Worst Tattoos* (which is America's worst tattoo show name), I had my friend who

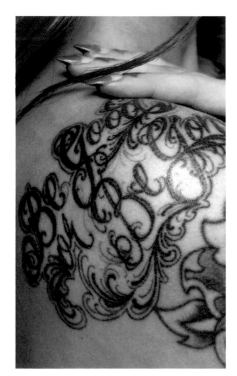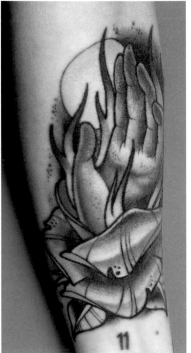

accompanied me on the show, artist Tim Pangburn, cover up the zombie on my leg for me. He did a raven and swords, simply because I just really love ravens; they're very cool-looking birds. I also started to have some of my older tattoos reworked. I had artist Tim Kern bring new life to the bride of Frankenstein on my right arm and turn my once bright pink cat into a creepy, cute bone kitty. After this, my life started to take a couple of turns and I took another little break from getting tattooed.

At the end of 2015 I started a new adventure, my own tattoo studio, Grit N Glory, in NYC. I was way too busy at this point to even think about getting tattooed, but an opportunity presented itself. I went back to my hometown, which I hadn't had the chance to visit in forever. My artist friend Justin Weatherholtz, who was also from this area, started a tattoo convention there called Pagoda City (we have a very large pagoda on a hillside in my town) and I couldn't miss it. Upon arriving, I saw my friend, artist Tim Hendricks, whom I worked with on *NY Ink*. I was so surprised and happy to see him—it had been so long! I had always wanted to be

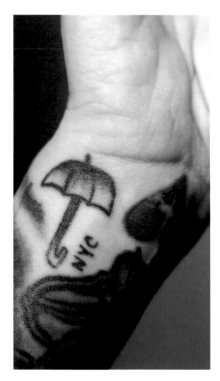
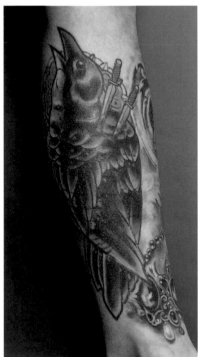

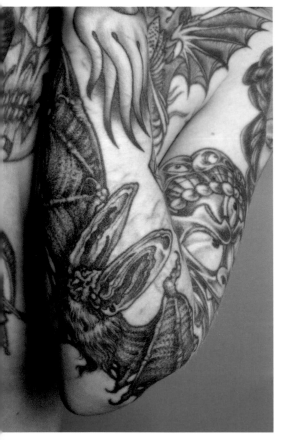

tattooed by him, and the chance to have this tattoo done in my hometown was even more special. I also always wanted a sacred heart tattoo as well (I think they're beautiful and I collect sacred hearts from Mexico and various other places I travel). So he tattooed one on my left hand at the convention. Hands are a big-deal placement for a tattoo artist; I had been saving that spot for a long time.

My next tattoo was the very first and so far only tattoo I've gotten in my own studio. I had worked the Cezanne tattoo convention a few months earlier in Aix-en-Provence, France. While there I met an artist, Jeanchoir, whose artwork I was instantly drawn to. A few months later, he completely surprised me in New York and gifted me with the most beautiful drawings. I was floored he traveled that far. (My boyfriend, however, wasn't amused.) While he was in town I just had to get a tattoo. He completed covering up my old koi fish on my left arm with a super cool and dark bat.

That brings me to my newest addition. During my travels I met a lovely Australian artist named Teneile Napoli. I visited her all-women tattoo studio in the Gold Coast, which was a big inspiration behind why I wanted to open my own place. She came to visit my studio and to attend the nearby United Ink tattoo convention in 2016, and I had to take the opportunity to get tattooed. I thought it would be something smaller, but she surprised me and ended up covering my whole outer left calf: under the knee to the ankle in seven hours! She is fast and light-handed but, man, getting tattooed that long at a convention is brutal. It was well worth it, though, and one of my favorite tattoos. Now, unfortunately, this tattoo bares a scar from an unfortunate accident years later (sorry, Teniele!), but lucky for my tattoo, it can be mended.

You can see the story of my life written through my tattoos. It might not be the most perfectly placed, beautiful, high-quality version, but it's raw and it's real. Sometimes people say online that they don't understand why I have such "bad" tattoos. This makes my brain want to explode a little. It's just a matter of perspective. But really it takes a simple understanding of my time in the tattoo industry to understand why I don't have a body full of perfectly planned-out, well-executed, vibrant, new tattoos. First, a lot of my tattoos are over ten years old, and yes, all tattoos age with time. I started getting a massive amount of tattoos before it was the accepted cool thing to do, so the bar of quality wasn't as high and the technology and techniques weren't as developed as they are today. Second, as many of us do, I started getting tattooed before I knew what a great tattoo was (thinking that I did). Many people go through this stage. I spent this period of my life *in* a tattoo studio learning how to tattoo. I was just so excited and obsessed with tattoos, I got them without a whole lot of thought, and a *lot* of them. Third, what's in style now wasn't cool back then, and vice versa. Yes, when I started tattooing, the tattoos I was getting were all the rage. New school and neo-traditional were the new exciting things.

There's a saying within the tattoo industry: "Beware the tattooer with all great tattoos," implying the better tattoos an artist has, the worse their own work is. Is this always true? I'm sure it's not, but it's something to think about. Over time I have lasered off some old pieces and gotten some cover-ups (more for getting rid of reminders of my ex-boyfriends than work I didn't like, but it was an added bonus). I do sometimes fantasize about getting all my old tattoos removed and replaced with beautifully placed, gorgeous new pieces. Then I think about the amount of time and pain that would take and say, maybe not! Who knows, maybe my mind will change again one day. For now I wear my tattoos as badges in honor of the time, experiences, and people throughout my tattooed life.

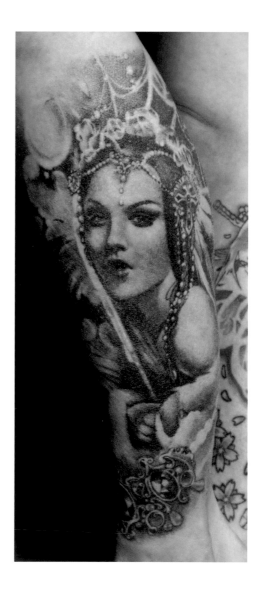

part one

LIFE
AND CREATIVE
PROCESS

Chapter One

Sources of Inspiration

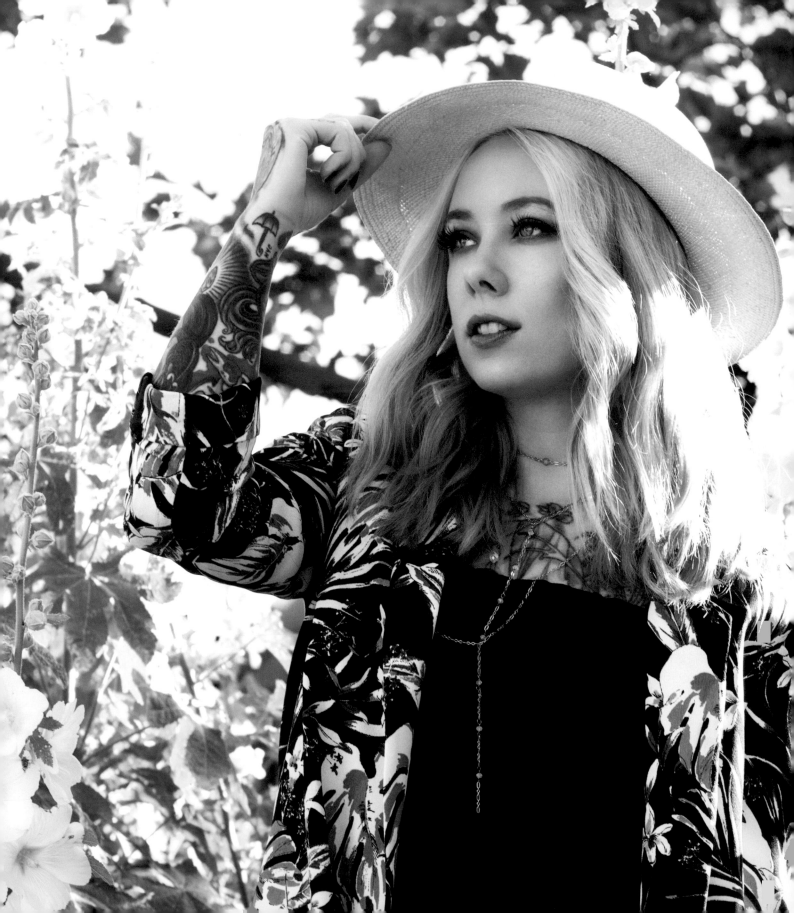

Making art is more than just picking up a pencil and deciding to draw something. It takes being inspired with an idea to know where to start. Inspiration works differently for everyone; it isn't something you can just turn on and off like a switch. Sometimes it flows naturally, but how do you discover inspiration when it doesn't? Each artist finds her or his own ways of learning how to encourage inspiration when needed. I personally find inspiration from the world around me—from my home in New York City to far-off destinations—and from all the animals, objects, and colors that surround me every day.

Travel

One of the things I love the most about being a tattoo artist is being able to travel. Tattoo artists are pretty migratory—it's common for artists to move around and work at different shops and tattoo conventions all over the world. Traveling is valuable for work and play, but also being away from home leaves my brain free from everyday stresses and distractions to allow inspiration to freely flow in. Traveling also provides an opportunity to have new experiences and to see new things from different perspectives. Now, we can't always just hop on a plane whenever we're in a lull, although we may wish we could. This can be done in simpler ways. During the spring and summer I try to hike once a week, each time at a

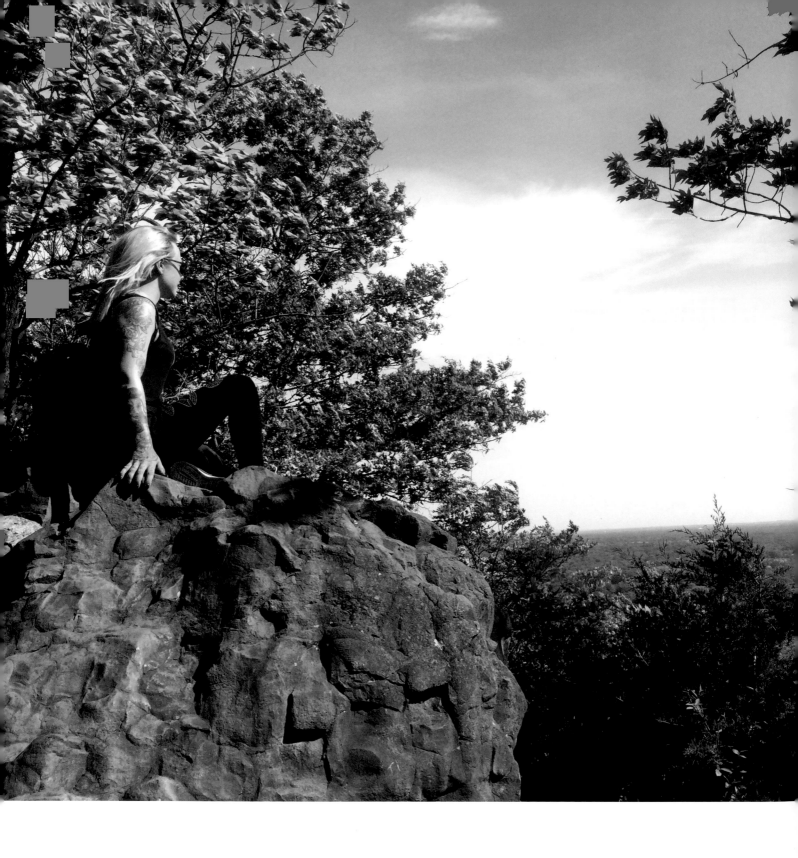

different mountain, park, or nature reserve all within a couple of hours from home. I always bring my camera and take tons of photos along the way (between scaling giant boulders). Even just being out in nature, with great weather and feeling peaceful, really sets my mind at ease to let the inspiration flow in. Make sure you always have your phone or a notepad with you to jot down ideas, because if your inspiration works anything like mine, it can be fleeting. Sometimes ideas will come pouring in out of nowhere and be gone just as fast.

Favorite Places

Outside of my own home sweet home of New York City, there are many places I have visited and fallen in love with and found truly inspirational. Here are just a few, and I hope to keep adding to this list as the years go on. Different regions of the world have different things to offer inspirationally. Culture, architecture, religion, animals, plants, textiles, art, and geography are just a few examples.

Mexico

The colors, music, food, and culture of Mexico make it one of my favorite places. You can see its influences through my sugar skulls (see page 177) and Day of the Dead girls (see page 173) inspired by the Mexican holiday Día de los Muertos, which celebrates loved ones who have passed. It is believed that for a span of days over this time, the souls are allowed to reunite with their families. One of my favorite trips to Mexico was a trip to Mexico City with my business partner Veronica to visit her family there. On this visit, we climbed the ruins at Teotihuacan. It was an exhausting and awesome experience. I also got a wicked sunburn after climbing the temple of the sun . . . coincidence?

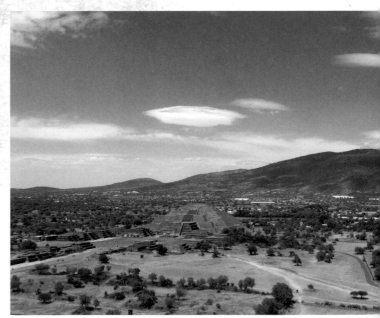

Guatemala

Guatemala has been a huge source of artistic inspiration for me, as well as a lovely place to visit. I have been going back yearly to attend the Expo Tattoo Guatemala in Guatemala City, find new experiences, and explore. I find a ton of color inspiration here, from the color combinations of buildings and their hand-painted lettering, to the local handcrafted items, the very colorful garb of the native people, and intricate patterns and embroidery of the textiles. There is an endless amount of colorful plants and animals to be found in Guatemala, and its jungles offer a rich history of ancient Mayan culture as well.

Brazil

Brazil is a wonderful, vibrant, and alive country. I first came to São Paulo to work an event with Spotify, and again to visit the Tattoo Week tattoo convention. This is a place where I've made many great friends and found a ton of color inspiration.

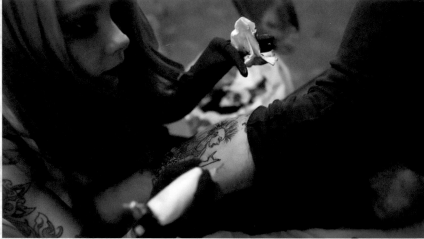

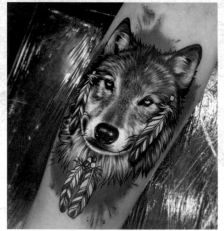

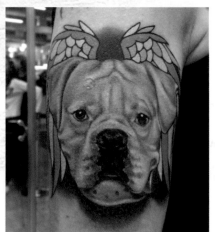

Chile

I've gone to Chile for a couple of years to visit the Summer Ink tattoo convention in Valparaiso. I'm always joyously overwhelmed by the amount of support I get from my fans every trip. One of my favorite experiences in Chile is visiting the charming local vineyards. Two of my favorites are Viña Indómita and Casas del Bosque. Getting to view the whole process from grape to wine is a really cool and inspiring experience. The tasting is a perk.

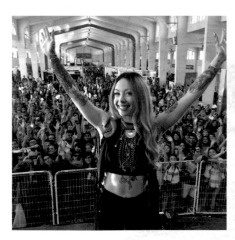

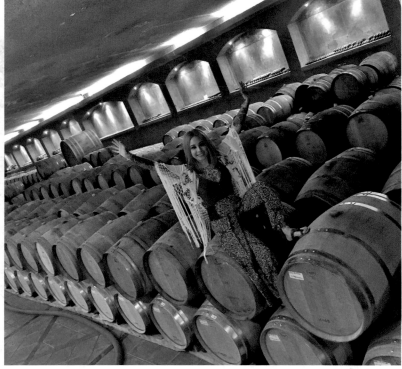

Ecuador

A year ago I traveled to Quito, Ecuador, to visit the Mitad del Mundo tattoo convention, where I did the tattoo on page 200. The most inspiring part of this trip for me was visiting the Galápagos Islands. I've never been to a place teeming with so much interesting and unique wildlife—giant tortoises, manta rays, colorful fish, sharks, and hordes of sea lions. I was lucky enough to be there during the sea lion birthing season and see lots of little tiny new pups wobbling around.

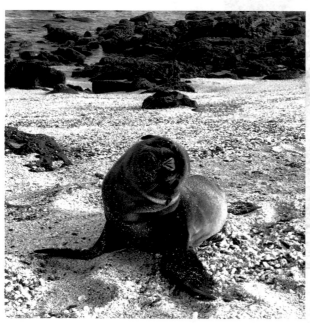

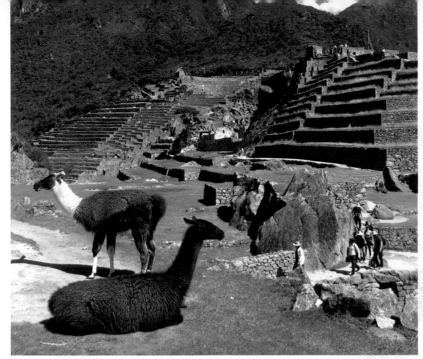

Peru

I traveled to Lima, Peru, for a tattoo convention, and I decided to stay a few extra days to visit the grand ruins of Machu Picchu, high up in the Andes mountains. A constant diet of coca-leaf tea and candies helps keep the elevation sickness at bay. First we traveled to the ancient city of Cusco, where I experienced local customs, food, and culture. I found particular inspiration in the way the people colorfully decorated alpaca and lambs walking around the city. I was lucky to be there during a large festival and saw many musical and dance performances. I also bought textiles with the beautifully woven patterns and colors of the region to take home. I also took the train to the Machu Picchu ruins. I hope to go back one day to hike the way. Despite the droves of tourists, you feel like you're transported back to an ancient time, with nothing but giant, tree-covered rolling mountains stretching off into the distance.

Costa Rica

One of my favorite aspects of Costa Rica was all the wildlife. As I love using nature as artistic subject matter, I sought it out and took tons of photos of animals, birds, insects, and plants. The monkeys were particularly naughty, stealing snacks from bags onshore while people swam. The highlight for me was the sloths. I had a couple of sightings; once I looked up into a tree to find one hanging and looking straight down at me! I also found them ever so slowly making their way down the power lines in a small beach town, taking a little nap every few steps.

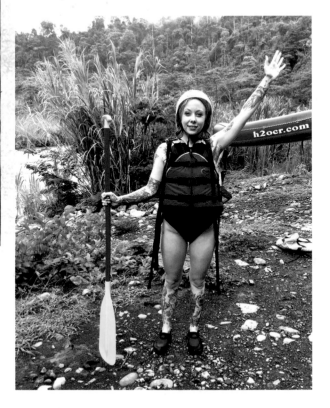

Australia

I've spent a good amount of time in Australia. Some of you have seen the TV program *Bondi Ink Tattoo* I shoot there in Bondi Beach. I started visiting years before that to visit tattoo conventions and friends' tattoo studios. To me it is one of those feel-good places: beautiful weather, friendly people, a place I can really relax and enjoy the beaches and sunshine. I also got my latest tattoo here! (See page 45.)

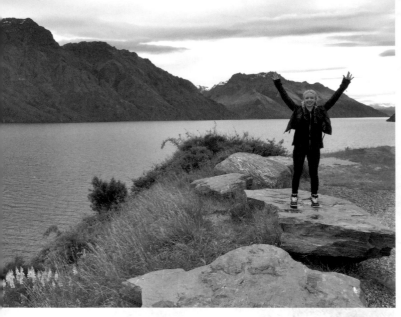

New Zealand

I've been to New Zealand a couple of times to visit the New Zealand Tattoo & Art Festival in New Plymouth. I spanned the North and South Island, from Auckland to Queenstown, absorbing all its beauty along the way. From luminescent glowworm caves, to immense sprawling mountains, to the unique plants and animals, there's no shortage of inspiration. The Maori culture of the region has a deep and ancient tattooing culture.

France

I've been to France a few times, but one of my most inspiring trips was to a small city in the south called Aix-en-Provence to attend the Cezanne tattoo convention, where I did the tattoo on page 198. I went on many hikes while there, one on the mountain Sainte-Victoire made famous by the painter Cezanne, and another to a magical coastal area called Cassis, where we climbed across bluffs that jutted out into the ocean. Standing on a sheer cliff so high above the sea makes you feel as though you could fly.

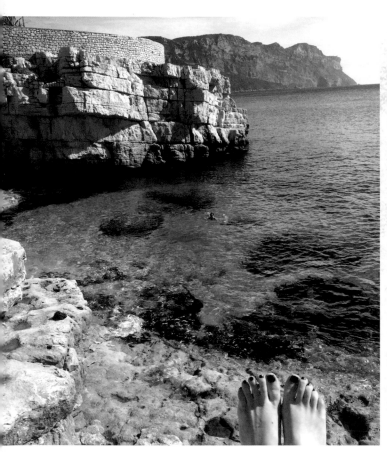

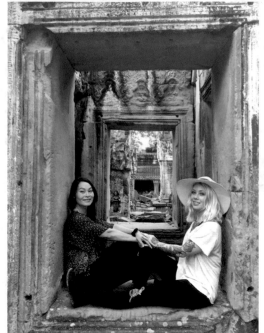

Cambodia

I took a family trip to Vietnam with my sister Melissa and stepmom Mimi, who is originally from there. I had a lot of wonderful experiences on this trip, but the top for me artistically was when we took a few days to visit the epic ruins of Angkor Wat. I honestly saw so many temples I lost count, but they were all awe-inspiring: grand in stature, covered every inch by gorgeously intricate carvings, all framed by the filigree-like overgrowth of the jungle (which inspired the black designs framing the wolf tattoo on page 200). It's a place I hope to visit again.

Hawaii

I've worked the Pacific Ink and Art Expo in Hawaii for a few years now, and every trip is better than the last. Every day looks like waking up in a post-card. I've found a huge amount of inspirational colors here, from the vibrant flowers and plants to the infinitely diverse wildlife. There is also a strong Polynesian tattoo history.

TATTOO CONVENTIONS

A great way for a tattooer to see the world is by working tattoo conventions. It's a perfect place to meet other artists and learn about tattoo artwork and culture from that area, as well as from other tattooers who congregate from all around the world. I have some amazing friends that live thousands of miles away from me, but we get to see each other relatively often because we visit the same conventions.

What is a tattoo convention? For those who haven't attended one before, it is a gathering of tattoo artists, working in booths, usually in a convention center or large hall. It is a special opportunity for patrons to come learn about their local artists or get tattoos from artists from around the world. I have been to tattoo conventions with as few as five booths and as many as hundreds. Tattoo conventions also usually offer a wide array of entertainment. This sometimes includes live music, burlesque, suspension, and freak show acts. They hold tattoo contests where artists compete to win awards for their work—there are many different categories, and every convention is different. They usually include large and small tattoos, body placement, color, black and gray, and each particular style of tattooing. Contests are also usually split up between male and female clients. The majority of the tattoo contests are for completely healed, previously done tattoo work. However, they have a couple of contests, "Tattoo of the Day" and "Best of Show," which are specifically for tattoos done at the convention.

I have been working tattoo conventions for as long as I've been tattooing—first all across the United States, then, about five years in, outside of the country too. In my early years, conventions were a different kind of outlet for me. I used to travel mostly to party with friends, meet

new artists and, of course, tattoo. As I've gotten older, and as working in TV has changed a lot of things for me, my dynamic at tattoo conventions has shifted. I no longer have the luxury of staying up all night drinking with my pals and rolling onto the convention floor at 5 p.m. to then tattoo till 3 a.m. Now, I have a lot more people counting on me: fans waiting to meet me, press engagements, and much more intricate tattoo sessions. I now get a good long night's sleep, rise early, and then it's work, work, work. I miss parts of the old party days, but these new circumstances are great in different ways. I've also realized it's good to take the time after the convention to experience the great places I am visiting and gain inspiration, whereas before I would never usually see the outside of the convention center.

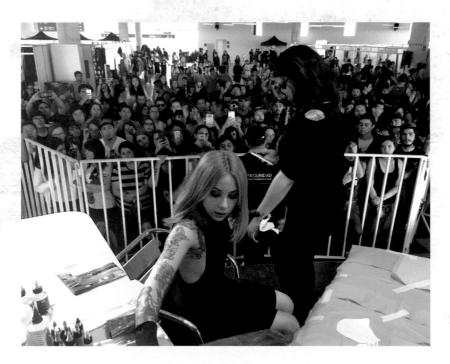

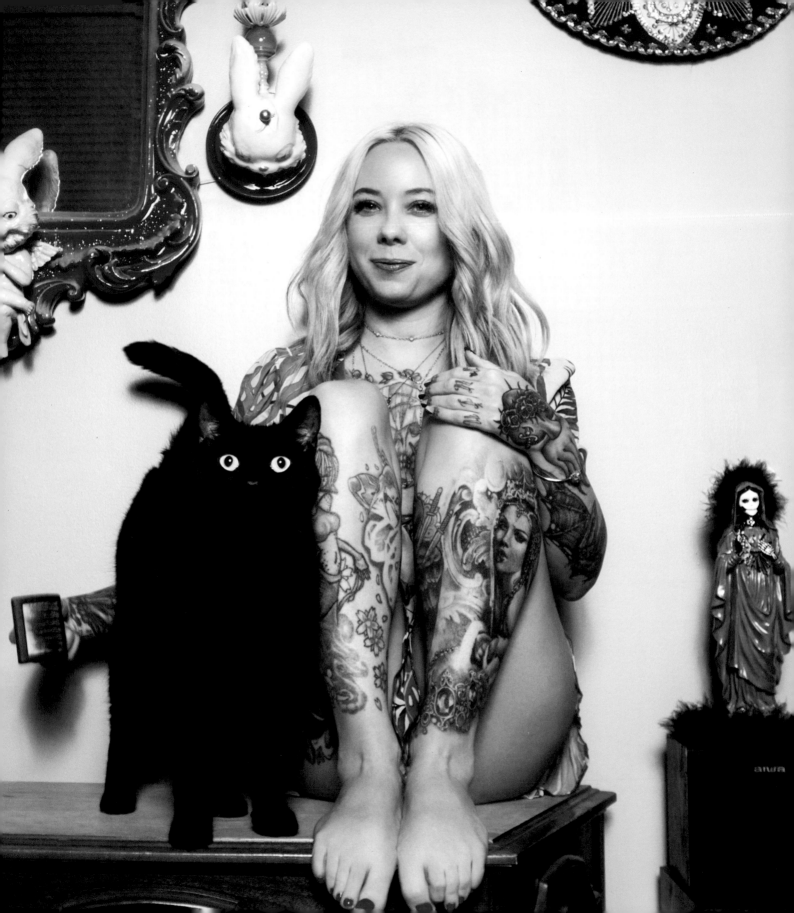

Home

As I mentioned earlier, you don't always have to leave home to find inspiration. Sometimes it's all around you; you just have to look. In my home, I have dozens of pieces of artwork and decorative items I've collected from all over to surround myself with. These things keep me constantly visually stimulated, even if subconsciously. At work I do the same, covering the walls with inspiring artwork and items. Making your own creative nest is key.

Outside of my walls, there is an entire bustling city filled with inspiration. In New York City we have so many neighborhoods, with so many aesthetics and types of people living here. The fashion, unique architecture, street art, charming parks, and grittiness of the subway are all just a handful of things I see every day that have inspired me at some point. During holidays I love going up to Fifth Avenue to check out all the elaborately decorated store windows for inspiration. There are also amazing museums I love to visit, such as the Met and the American Museum of Natural History. I realize New York City is a unique place, but there is inspiration to be found in every area. Go outside—check out your city or town to see what visual inspirations it has to offer.

Color

As a visual person, I soak up whatever environment I'm in like a sponge, and it shows in my artwork in different ways. For example, I really love to tattoo in color—bold colors, muted colors, pastels, earth tones, all of it. When I'm looking at the world around me, I'm focusing on the naturally occurring color patterns I see. It could be the deep blue of a lake next to a canary-yellow field of flowers, the vibrant feathers of a parrot, the subdued metallic tones in the subway, even the latest fashion trends. To me the world is teeming with color inspiration; you just have to take the time to look around and see it. In particular, I really love sunrises and sunsets. Although I am *not* a morning person, I drag myself out of bed at the crack of dawn some mornings to take advantage of seeing the sunrise in different environments all around the world. Every single one is different, each displaying a unique array of colors and patterns and interacting differently with the surrounding environment. Sunsets are a lot easier for me to catch and also have the same effect. I always try to take pictures of them to remind myself of these colors, but unfortunately a camera is sometimes not able to grasp their grandeur in reality.

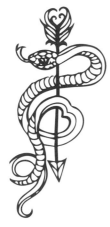

TAKE PHOTOS!

Photos are a great way to record your inspirations. I take hundreds of photos recording all the little inspirations I see—buildings, animals, flowers, artwork, anything I come across that inspires me to create. It's great to have these photos for reference material, whether for color, shape, light, mood, or dimension. If you're having an artistic lull and your normal tricks for inspiration aren't working, sifting through your collection of reference photos can be a great way to kick it in.

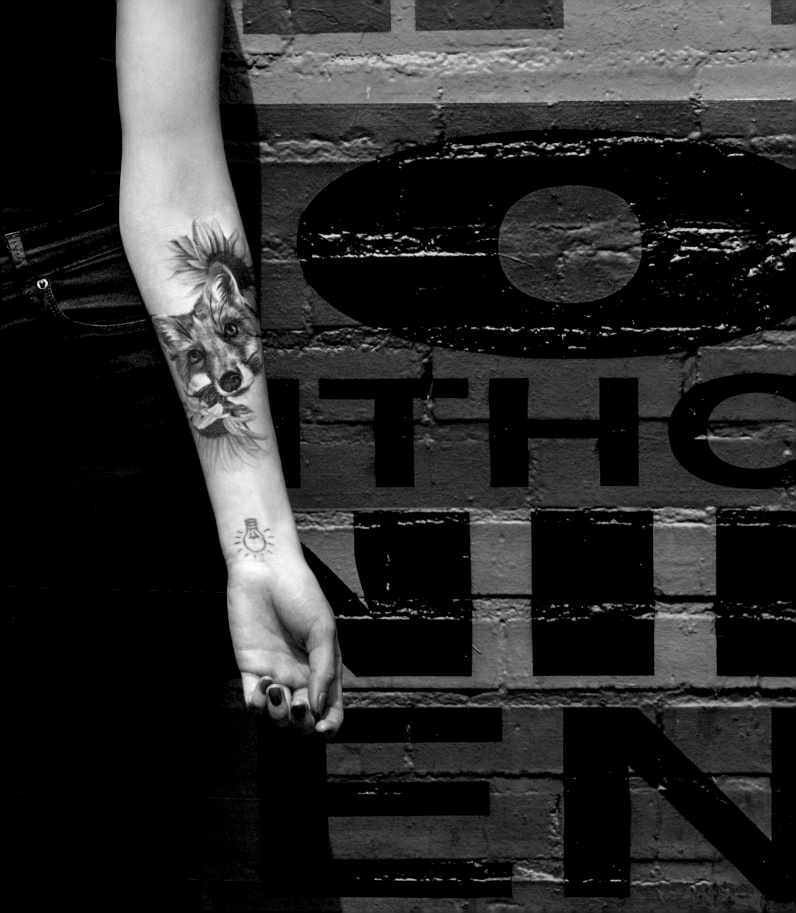

Subject matter

Everyone is inspired to draw different subjects: people, locations, animals, flowers, buildings, ideas, or maybe things that just are made up out of their heads. Once you figure out what you like to draw, if it exists in real life, it's great to get yourself some reference material. Personally, when I tattoo realistic roses or other flowers available to me at the local bodegas in New York, I'll often go buy them and take my own pictures. If you can't get the real thing you're looking for, consider buying models. I own a few skull replicas I use for my art. I would love to own a real one, but honestly I think I'd be too freaked out; I get nightmares really easy. In my tattoo studio I have an entire wall-size bookshelf dedicated to books, models, and items that are all used for reference and inspiration.

The Internet is also a great tool. At the tips of your fingers you can find thousands of photo references. Just be aware that many other people are also using these same references as well, which can make tattoos look and feel less original. Often when I see a wolf or fox tattoo, I instantly recognize common references that many people use from Google.

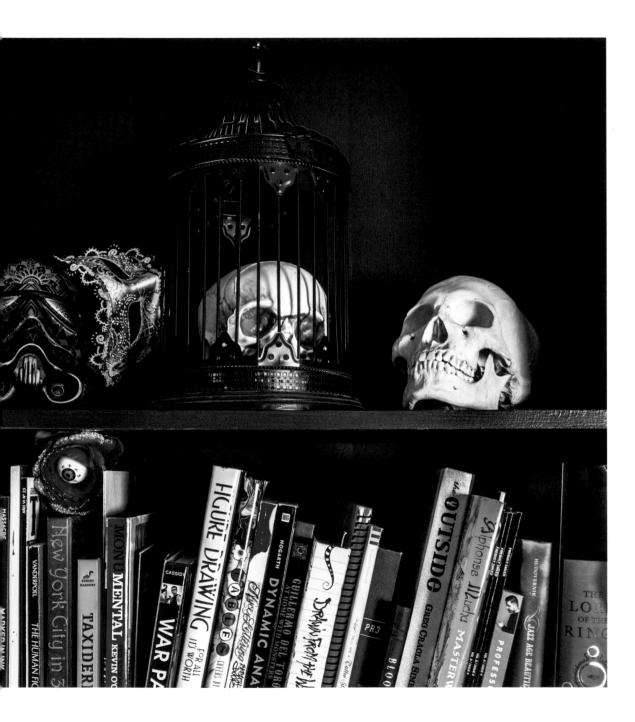

Animals

Making artwork and tattoos of animals is very close to my heart. I have always been an animal lover, having pets of all different sizes since I was a kid: dogs, cats, reptiles, fish, and about twenty birds all named David. I also worked on a farm for many years in my youth, tending to horses and chickens. I would actually bring fertilized chicken eggs home and incubate them in my jewelry box up close to my bedroom light. My grandmother was not thrilled, but impressed. I even buried my pets in a special little graveyard my family made for me, in boxes that I colorfully painted, with decorative hand-painted headstones and flowers growing around them. Morbid, I know, but my pets meant so much to me that I celebrated them in life as well as in death. These days, I love being able to help someone commemorate their undying love for their furry friend. I still have pets, an adorable black cat named Fernet that I adopted from a friend after she rescued him from the New York City streets, and a little crested gecko named Mavis, who was given to me as a "tip" after I tattooed a gecko on a gecko breeder. We're one big happy family. I wish I could have even more pets, but it's so hard with how much I work and travel. It has been a longtime goal of mine to retire on a farm one day and have lots of space to bring otherwise unwanted animals to live out the rest of their days.

That brings us to why I find these guys so inspirational. On the surface, animals make great subject matter for art due to their complex, varying types, colors, textures, and patterns. Beneath the surface, you can also capture emotion and personality. When someone asks me to tattoo a pet's portrait for them, I ask them about their pet's personality. What was their favorite toy? Game? Pastime? I also ask for multiple photos (a true pet lover has hundreds) so I can really get a feel for their expressions. It's important that you're not just tattooing an image of their animal, but capturing their personality as well. On the technical side of this, I really pay close attention to the eyes first, then the nose and mouth to capture these traits.

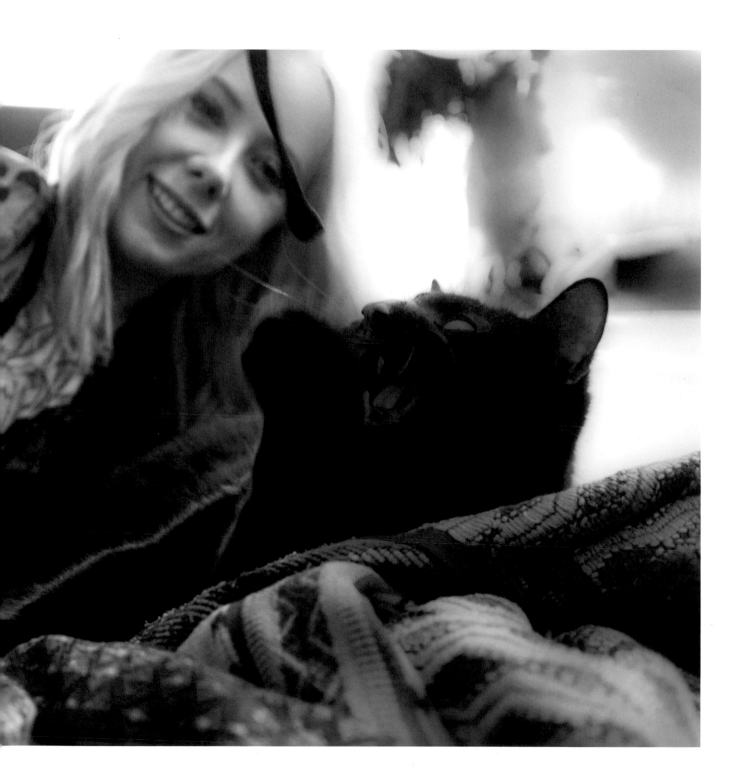

Chapter 2

Workplace

I spoke earlier in the book about my history of learning to tattoo and some of the shops I was in. I've worked at a total of eight studios in my career (not including guest spots). Some were long engagements, others short, but I learned something at every place I worked, whether it was what to do or what not to do. Toward the end of 2014 I decided to open my own studio. Now, Grit N Glory is my home away from home and a new source of inspiration in my life.

In the past I always said I would never open my own place. I felt I loved tattooing too much to take on the burden of running a studio. I just wanted to tattoo. But years into my career the idea came about surprisingly naturally. Around 2013 I was working at the Wooster Street Social Club, and things were great there. As the show *NY Ink* had ended, the shop was going to move locations. At the time, I had made friends with the women who owned a local clothing brand and store in the Lower East Side called Grit N Glory. It was just a few blocks from my apartment, and my then-boyfriend Joe Letz and I would DJ evening events there with our DJ project "Letz Massacre." The women, my now business partners Emily Conley and Veronica Mallo, had a really cool rock 'n' roll style. We all shared a similar taste and aesthetic, which is important. (As someone who has tried a few times to start a clothing line, I realized the fault had always been not seeing eye to eye or having the same vision as the people I was working with.)

Emily, Veronica, and I became friends. I then began to model and eventually design some clothing with them. I spent so much time at the store that I joked one day that I wished I could just tattoo there. That

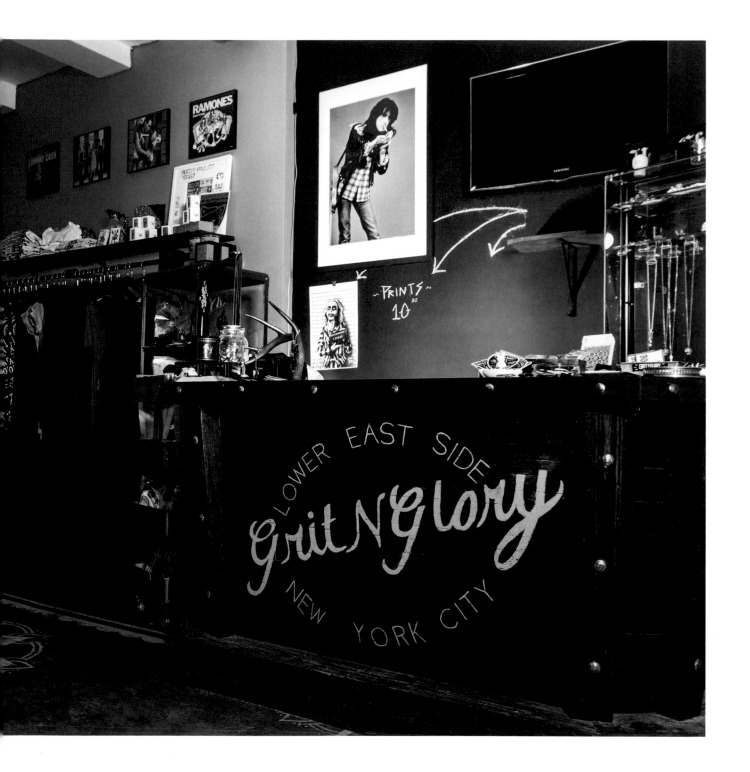

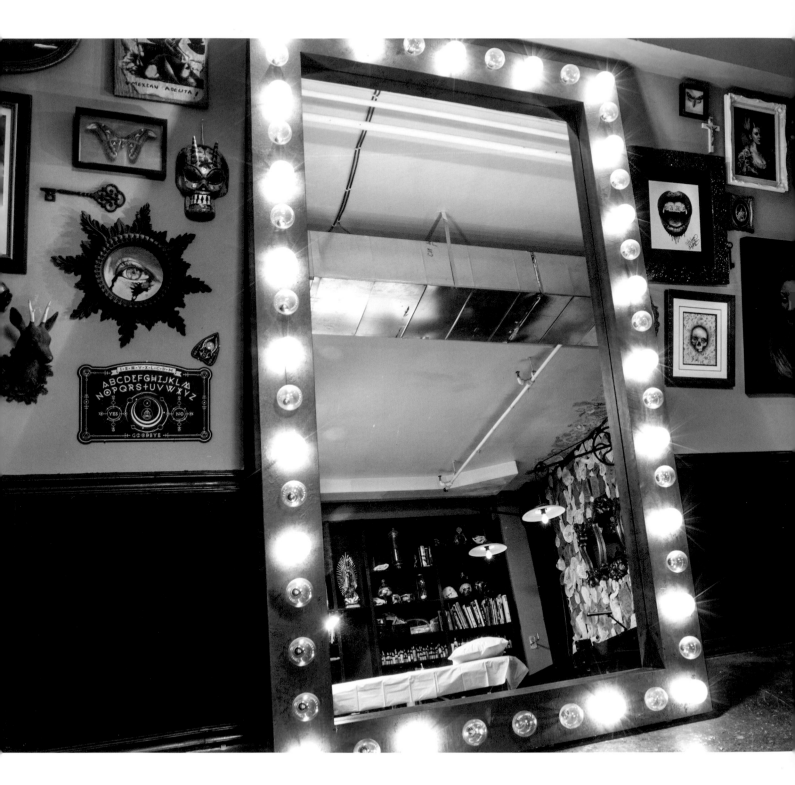

sparked the idea, and the more we talked about it, the more we liked it. That's when I decided that when Wooster Street moved, I would take the plunge. It was a hard decision to make, but I felt it was time to work for myself. It was also pretty scary. I had never set out on my own like this before and had no idea what to expect, but I did what I always do and just jumped in. We turned Grit N Glory into NYC's first tattoo and rock 'n' roll boutique. Running a business in New York City is hard, expensive, and with something like three hundred other tattoo studios in the city, rather intimidating. I was lucky to have two great business partners to go through this with.

Grit N Glory was a fully functioning clothing boutique and brand when I joined the team and decided to expand it into a tattoo studio as well. While making the plans to open the studio, we decided to gut the whole store and start over fresh. This was a giant project, especially for just us three women and a handful of friends to help. We ripped everything out from the walls, repurposed or removed the old furniture, tore the cosmetic walls down, and piled everything up in the center of the store while we repaired the walls. It looked like a war zone. The three of us sanded, spackled, and painted the walls, and with the help of friends installed cabinets, bookshelves, light tables, fixtures, and my giant lighted mirror, which is my favorite thing in the tattoo studio. I commissioned my friend Jasin Cadic to create this for me, as I had a particular vision in mind and could find nothing like it that already existed. I wanted clients to have a grand place to view the brand-new completed tattoos they had spent so much time, pain, and effort to get.

Because our store's shape is long, we decided to place the clothing boutique in the front and the tattoo studio in back. I wanted to imitate how most older tattoo shops had to operate out of the back of another business, because tattooing had only relatively recently (1997) been legalized in New York City. All in all, it took us only about two weeks to reopen the boutique side of the shop, and another couple of weeks to complete the tattoo studio. The studio started with just little ol' me. When a few friends of mine came to town, they asked if they could guest spot with me, and of course I said yes. A few guest spots turned

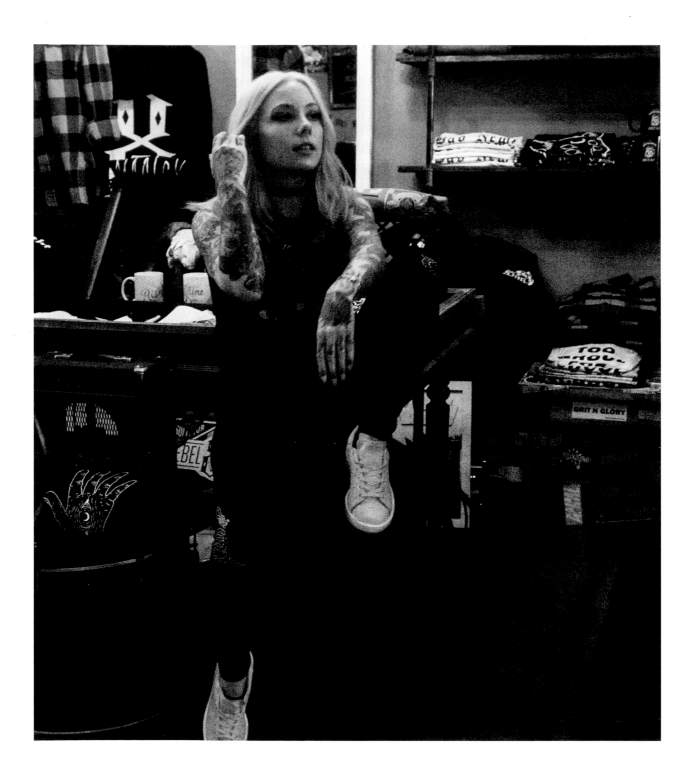

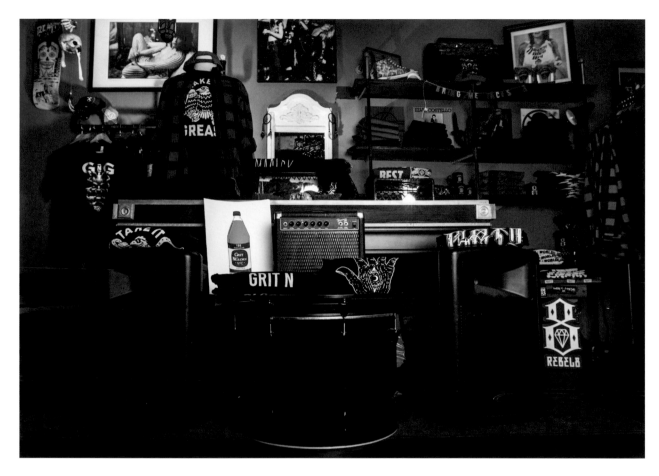

into a few artists working with me full time, to now, a couple of years later, a full team of artists and many guest artists from around the globe. While I think it's very important to have well-specified goals, I think it's also important to leave room for whatever project you're working on to develop naturally into whatever it will become.

I really love working for myself. I have to be honest, though; running your own business is tough. No one else will care as much about it as you do, and you will put in an endless amount of time and energy only to keep working harder. However, the success is hopefully the grand prize for all your hard work. I am lucky to have a hardworking team that helps me get everything done. It wasn't easy to find them, but after much trial and effort I found the best team I could ask for.

A popular event we have at the studio is walk-in tattoo day. This is common at many tattoo studios. For us, as a mostly appointment-based studio, it's more of a special event. It's an opportunity for our clients to just walk in and get an affordable tattoo from our artists who are usually booked out months in advance and at a much higher rate. They always have a theme, sometimes based on a holiday like Halloween or Valentine's Day, sometimes based on pop culture like *Star Wars* and other movies and TV shows—really, whatever we think is fun. Every year the events get bigger and bigger. In the beginning, it was just me tattooing at these events, struggling to get as many done as I could on my own. Now, I'm thankful to have a team of five working our butts off all day.

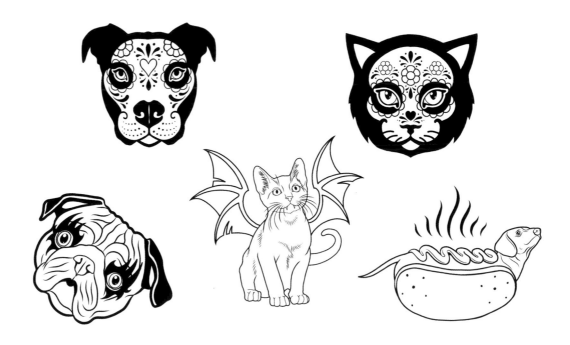

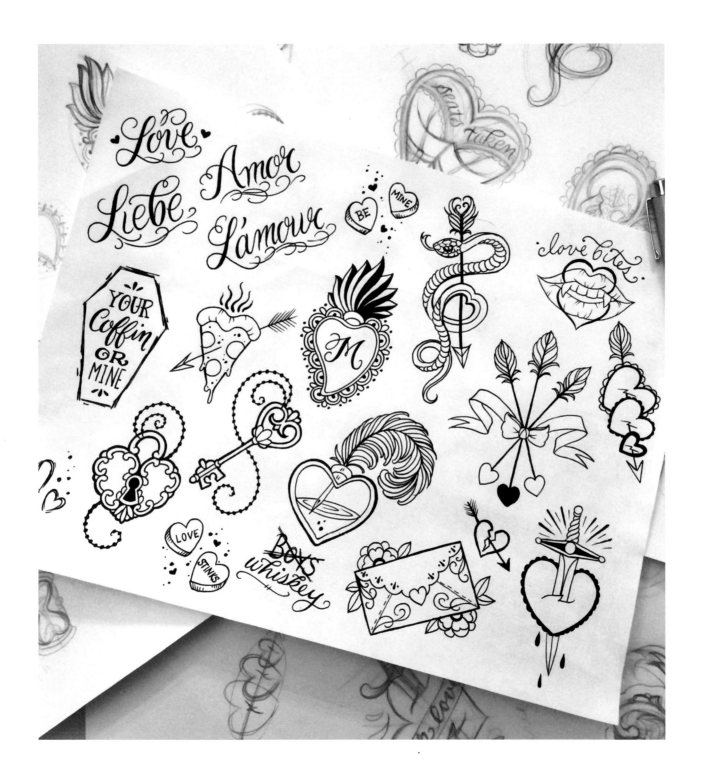

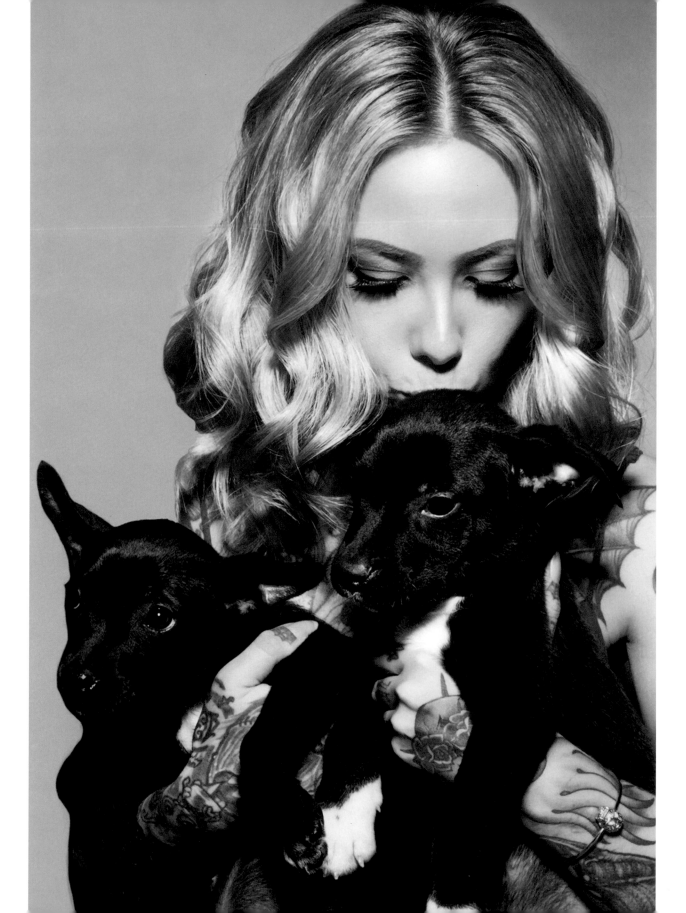

Sometimes these walk-in days are extra special. I wanted to be able to use my own personal success and the success of my business to help others who can't help themselves. As an animal lover, I decided to use my newfound television fame to spread awareness about animal cruelty. I paired up with Peta2 to do ads and tutorials for cruelty-free makeup and products and do an animal-themed walk-in day.

For those who don't know what *cruelty-free* means, it describes a product that contains no animal products or was ever tested on animals. I worked with the ASPCA to do a special walk-in tattoo event at my studio called Tats N Tails. At these events we have animal-themed tattoo flash, special Grit N Glory–brand dog- and cat-themed shirts, and other donated products for sale. All profits went to the ASPCA to help find good homes for dogs and cats in need. We've had three successful events so far, each one better than the last, and I hope to have them for years to come.

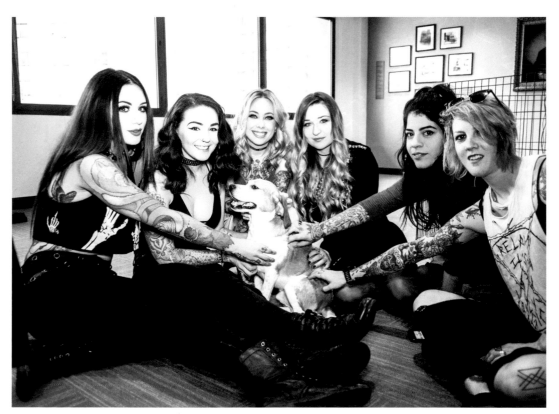

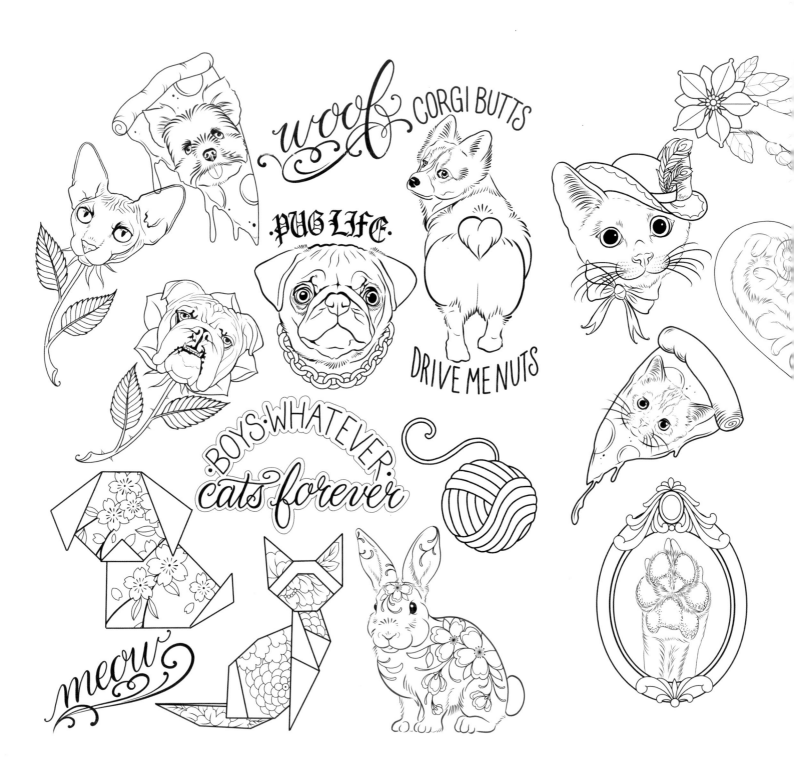

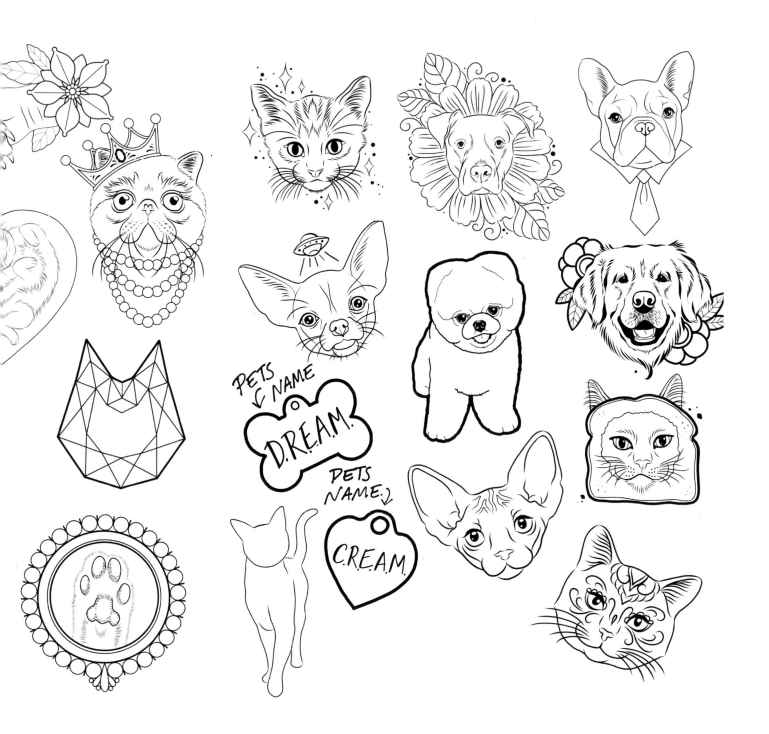

PETS NAME

D.R.E.A.M.

PETS NAME

C.R.E.A.M.

Clothing Line

Not only is Grit N Glory my tattoo studio, but it is also a rock 'n' roll–styled, free-spirited, and all-women-owned-and-operated clothing brand. The other artists and I design all of our shirts and print the majority of them in house. What I like best about our brand is its authenticity. It caters to music lovers, pop culture buffs, tattoo enthusiasts, and those fascinated with the occult. What makes our brand authentic is that we *are* those people. We aren't a company of suits sitting around in a room trying to figure out what our demographic is into, because we are our demographic. We create the things we want to wear and we believe in our product.

The artwork that I design for our clothing brand is a different aesthetic from my tattoo style, for a couple of different reasons. Although I love to create beautifully intricate and colorful works of art, the way I prefer to dress is different. Fashion-wise, I personally like to dress in many different styles. I am forever changing my makeup; style of dress; hair color, cut, and style. (They say women change their hair when they've gone through something, so I guess this shows I've gone through a lot of sh*t.) I almost feel like a chameleon. For our clothing brand, however, we've chosen a more simple, edgy, and to-the-point style that can be rocked by many different kinds of people. Here are some of my designs:

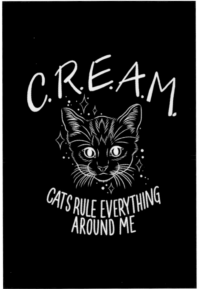

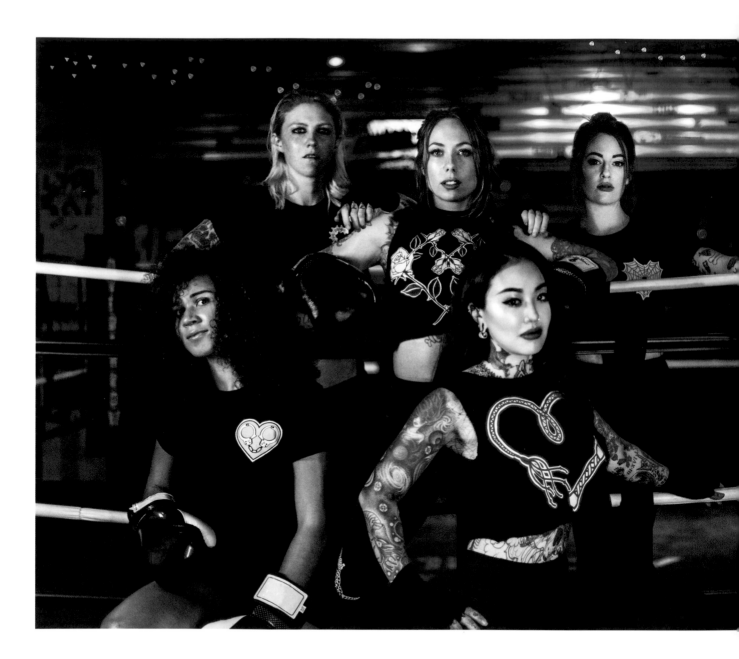

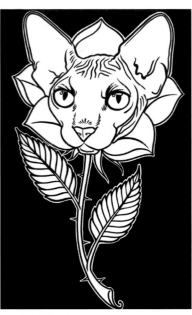

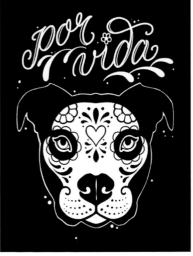

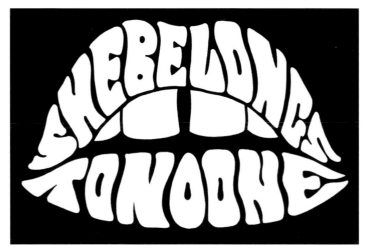

Chapter 3

Artwork

I spent many years before my tattoo career painting, drawing, and working in calligraphy, photography, and other mediums. Once I started tattooing, I became busy very fast. That, combined with my obsession to learn to be the best tattoo artist I could be, left very little time for me to create outside artwork for much of my career. Add in working in TV, tattoo conventions, running a shop, designing a clothing line, and making books, and it's even harder to find the time. In slow moments, and (funny enough) almost always when I take sick days, I find the time to express myself through other mediums.

In the beginning of my tattoo career I started drawing some tattoo flash. I was inspired by the new-school style at the time. These were outlined in ink and colored in with colored pencil. Unfortunately, I made these so long ago, I was able to salvage only the line work versions of some of my old flash. (See how I still signed my name *Megan Woznicki*? That means it's ooooold.)

A few years in, I began experimenting with watercolors. I mostly painted creepy-looking girls. Most of these pieces were created specifically for art shows. I didn't date a few of them, but I believe they are all from between 2007 and 2010.

After this period I became interested in creating more realistic and precise pieces. I started experimenting with a mixture of Copic markers and Prismacolor pencils, with a little bit of watercolor as well.

I realized over time that I prefer to work in more controlled mediums; for me, they are the most similar to tattooing. I watch friends who are able to paint and tattoo in much looser styles and am envious, but to me, looseness is utter chaos.

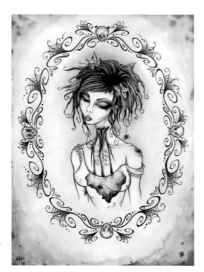

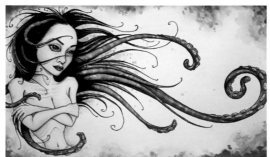

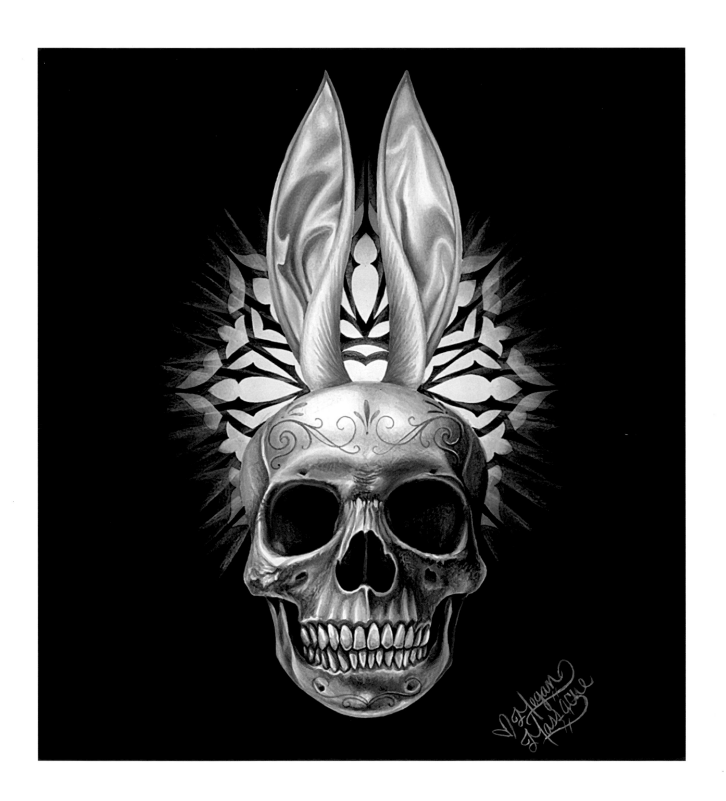

After this period I started working with other companies, collaborating on art for different projects. One really fun part of these projects was that the canvases were 3-D objects, and the process was like designing tattoos for a sleeve or other body part, only on those particular shapes.

Working with other companies is fun, but it also can be tough. Not unlike the tattoo process, your vision needs to also match the requirements of the company. Sometimes they may love your design upon first draft, but many times they ask for changes and sometimes a lot of them. It can stretch the boundaries of what you feel like defines your personal style.

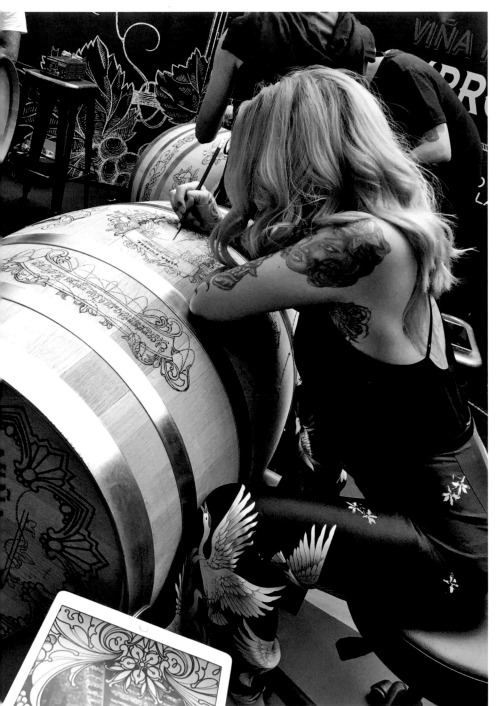
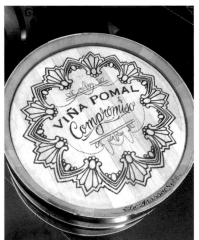
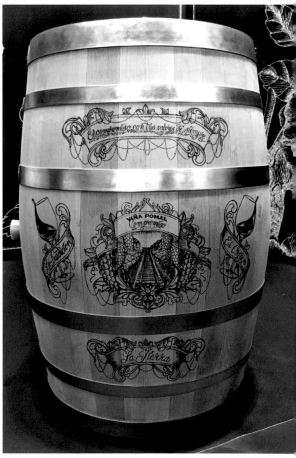

The Harley-Davidson x Sailor Jerry project was interesting because it required more simplified designs than I'm used to making. Depending on the project, I have to use my best judgment. While I feel like I want to go over the top with some designs, it's important to keep all the elements of the situation in mind, such as time frame, art medium, canvas, and branding. There can be a lot of pressure in these types of situations, but it's important to remember to try to have fun with it.

To explain my process of making my art pieces, here's an example.

First, I decide on subject matter. In this case, I decided I wanted to draw a Day of the Dead–style girl. My next step is to find reference material. Whenever I'm drawing people, I try to take photos of people as the reference. Usually I use my friends and, when no one else is around, myself. I can't tell you how many times I've tattooed my own hands on people.

For my reference, I asked a lovely friend and colleague at Grit N Glory, Cally-Jo, to model for me. I start by finding a good place to take a photo, with a good light source that complimented the look I was going for. I usually take a bunch of photos of different positions and angles. Later I go though them and narrow down the perfect photo. It's usually just based on taste. If it's for a particular project, I would keep in mind the

shape of the canvas and any other elements that may need to be added in the future, like branding.

Next I lay a piece of tracing paper over the photo on a light table. This allows me to draw right over the photograph. I start creating the skull makeup of the Day of the Dead girl, as well as other new elements of the drawing. I draw everything at this stage in red pencil; doing so allows your eye to freely see different shapes in a typically messy sketch. I use this technique of drawing in red when designing tattoos as well.

In the case of this drawing, I'm adding a lot of things that I typically draw—the roses, filigree, and hair. I am just freehand drawing these items. As you can see with the roses in the sketch on the opposite page, I first start with a general shape like a circle. I then sketch in the rest of the details from memory.

Now the entire red sketch is complete. As you can see, there are now a bunch of elements to the drawing. I had drawn the mandala in the background on a separate piece of paper, laid the drawing of the girl

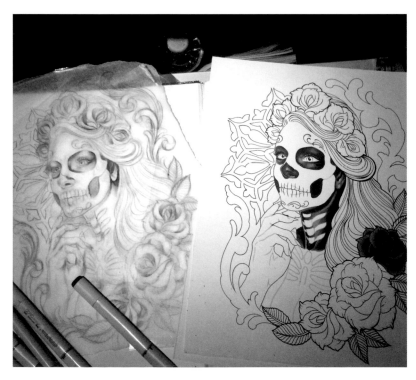

on top of it where I wanted the mandala to lie, and traced the mandala onto the girl drawing. For the hand, I took a photo of my own hand in the position I wanted, sized the photo appropriately, and traced it onto the drawing with the girl. Now that everything is mapped out, it's time to create the hard line drawing.

The next step is to create the outline. For this I usually use a few different sizes of Micron pens. I like to use line weight to make the drawing more interesting, using thicker lines on the outside of the different elements, and thinner ones on the inner details. For realistic drawings, I will sometimes leave out the bold outline and use a subtle, light guideline instead that will be colored over with other mediums used to fill in the colors of the piece. This creates a more realistic appearance. After the outline is complete and dry, I start to color. Sometimes I work dark to light, and sometimes I don't really have a specific order, I just go for it. A lot of it depends on your medium. In this case, I am coloring in the drawing with Copic marker and colored pencils. I start with the marker first. I will say with marker, if there are a lot of very dark areas, it's best to start with light colors first, as the darker colors could bleed into a nearby area if the page becomes too saturated. I blend the markers together from color to color, also using a blending marker to blend further. I go over the whole image with the markers. Then I go back and color over it with colored pencil. I don't recolor the entire image; I am mostly focusing on shadows, highlights, and small detailed sections. The tip of a colored pencil is way more precise for these small areas, and the addition of light and dark with the pencils lends depth and dimension.

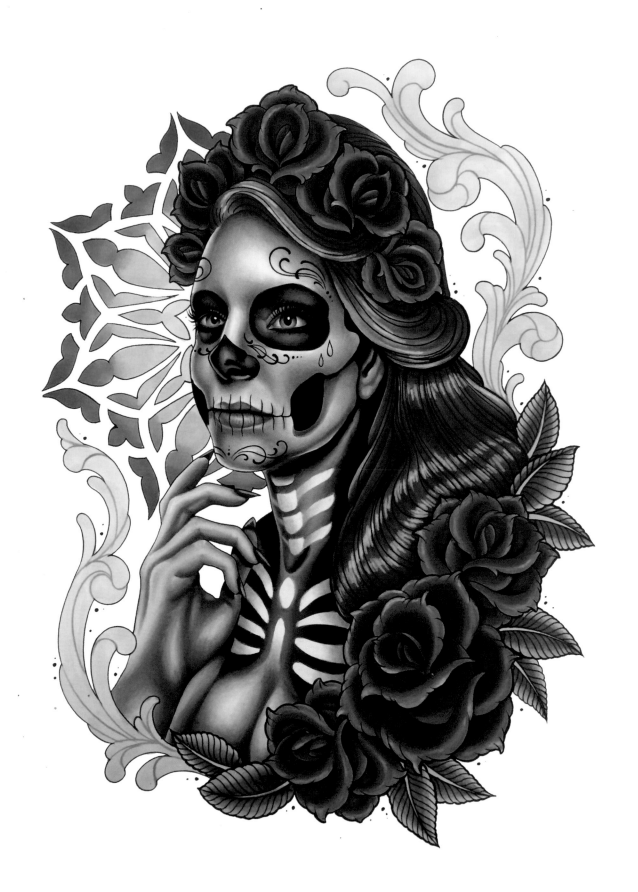

For the cover of this book, I actually experimented with using tattoo ink to create a painting. I don't actually use tattoo ink in all of my artwork, and it's not something I would do regularly, as it's really difficult and not made for use outside of tattooing, but I like the idea of using tattoo ink in mixed-media art and I think it ended up having a really unique effect.

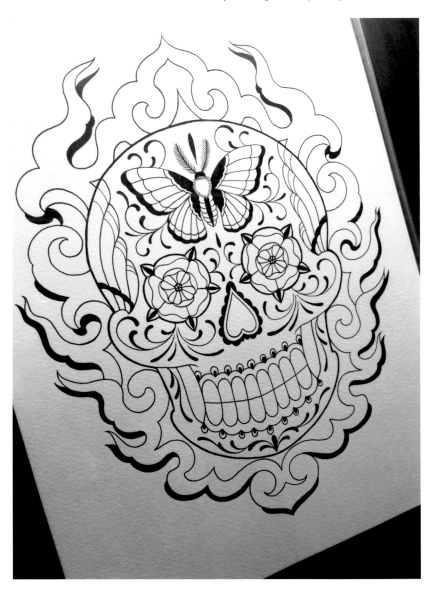

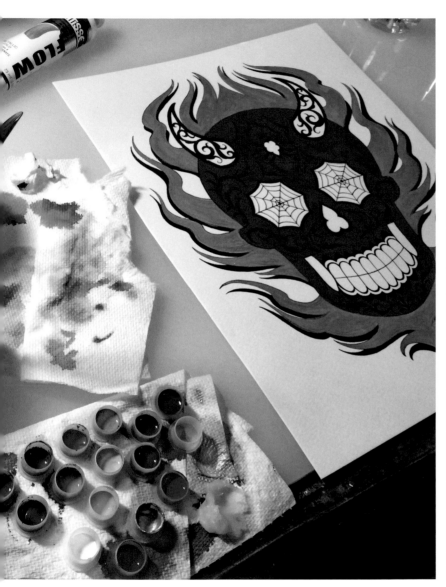

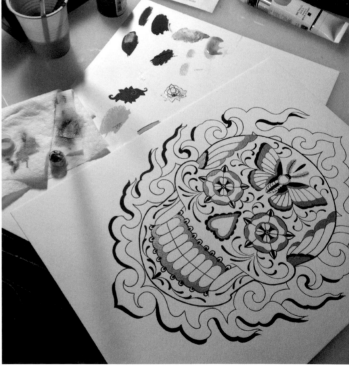

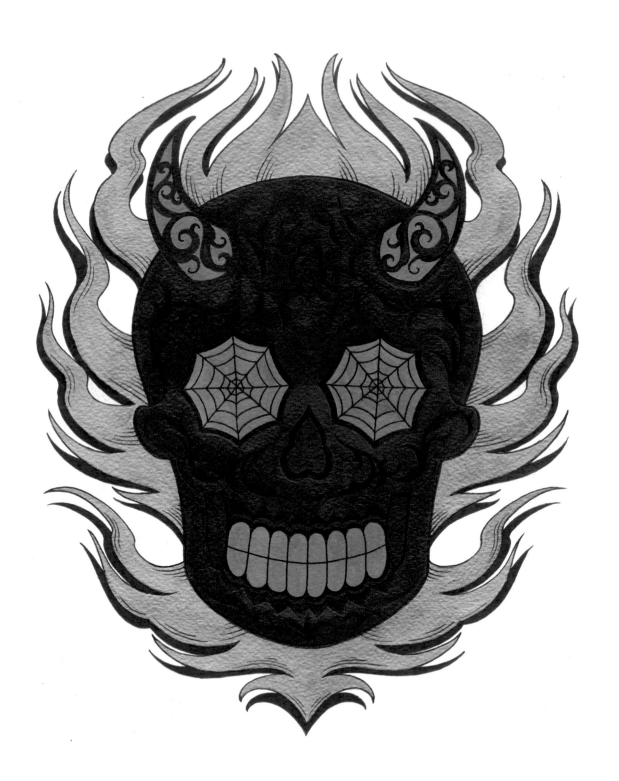

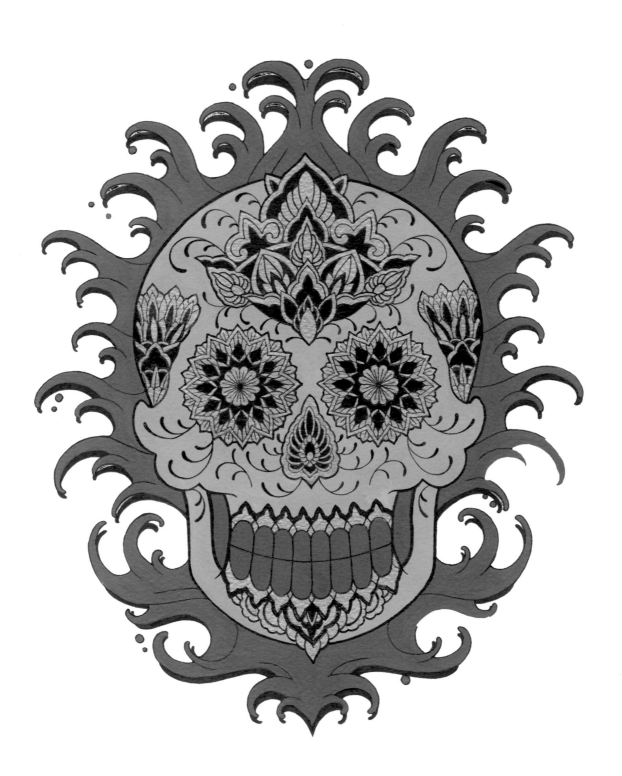

Step 1

Step 2

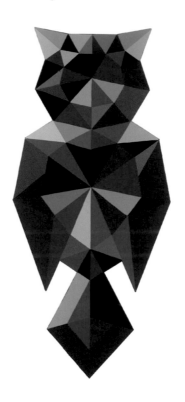

With today's new technology, I now also use an iPad to create artwork in the same basic steps, only digitally. With this method I don't need a light box or tracing paper. Instead, I just use multiple drawing layers, similar to Photoshop. The convenience of this method has really saved me a lot of time and hassle in creating artwork. Whereas I used to have to carry heavy sketchbooks and tons of art supplies to create as I travel around the world or even from home to work, now I have all the same products in one simple digital pad and stylus.

Step 1: Create the outline.

Step 2: On a separate layer on top, I like to color in the base colors of my art.

Step 3: Now using multiple top layers, I create all the shading and color blends.

Step 4: On a final top layer, I like to add the highlights.

Step 4

Step 3

part two

TATTOOING

Chapter
four

The Tattoo process

These days there are so many different ways to go about designing a tattoo, and many different processes to tattoo it. Here I am going to share my personal processes. Keep in mind I am not teaching you how to tattoo, but rather giving you a visual overview of the process so as a client you know what to expect, as a novice tattooer you see how much work goes into it, and as an experienced artist you get a peek into my world.

Tattoo artists book their appointments in many different ways. Some tattoo artists accept walk-ins, meaning you can just walk into their shop and get a tattoo should the artist of your choice be available, or if you're comfortable enough, you can get tattooed by whoever is available. Other artists like to book their appointments and discuss concepts ahead of time, discussing things with clients by phone or email. Some will actually schedule a preliminary in-person consultation with you. At this point, research is key in making sure you have the right artist for the job, which I will get into later. Also, be patient if your artist is booked out for a bit, because many of them will be.

The first step is to figure out how to go about putting your design together. I tattoo many different styles, and while the process changes for each, they share the same basic design steps. I determine where the tattoo is going on the body, how big it will be, and the shape of the space to be tattooed. Once that is decided, there are a couple of different ways I go about beginning the drawing. Sometimes I take a photo of the area on the body and draw directly over that photo, drawing on a digital tablet. If I'm working by hand, I'll trace the area of the body with tracing paper. If the area wraps around a spot on the body, making it difficult to photograph, but I still want to draw digitally, I will use tracing paper to trace the shape I am going to tattoo in and photograph that to draw on my tablet.

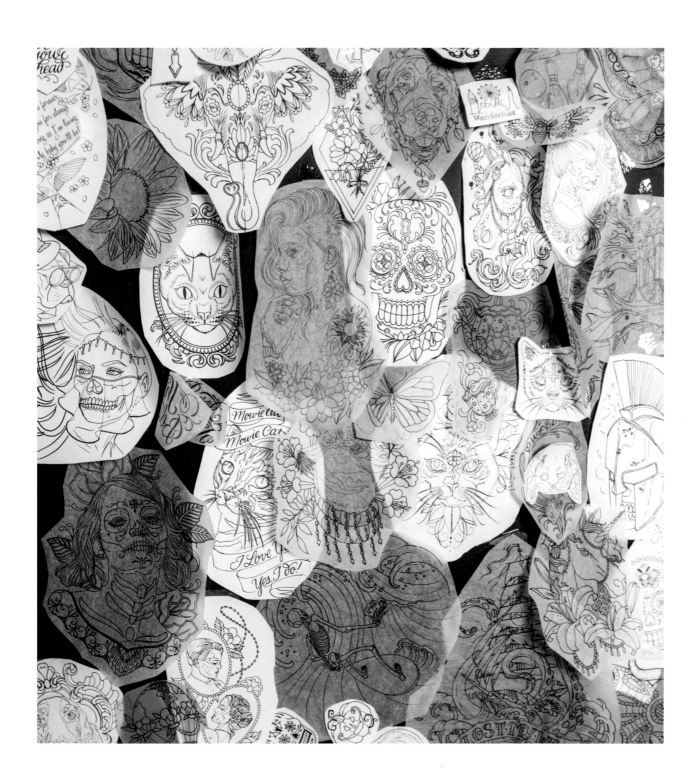

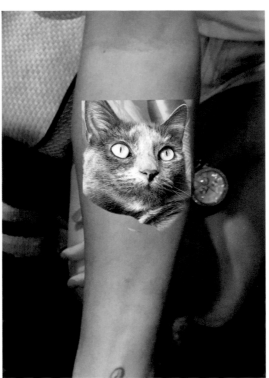

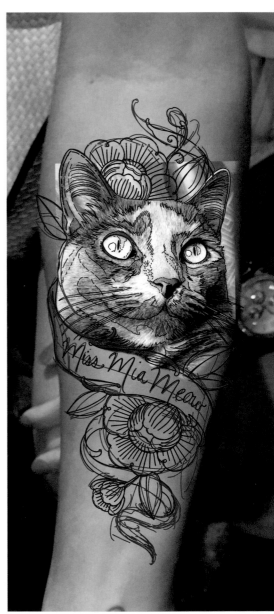

Once I have that space mapped out, I start drawing a rough shape of the design in red pencil, either digitally on a second drawing layer, or by hand on a separate piece of drawing paper in case I want to try something different or start over.

Using red pencil as opposed to graphite frees your eyes up to see different shapes in your sketch and freely make changes. I personally like drawing onto photos or tracings of the body because I want the artwork to flow with the natural shapes of the body. Working on a 3-D canvas can be tough, and this will help the tattoo look as if it was always meant to be in that spot. In the case of this example, I added in another digital layer for my photo reference, which I traced directly in order to get the most precise likeness possible.

Once I've hashed out my design in red, I make a sharp, clean trace of this design in black. If it's digital, I just create a new layer in my tablet; if it's by hand, I use a new sheet of tracing paper and a pen such as a Micron.

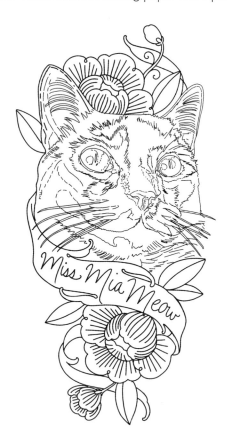

Unlike the process I just described, some artists have a different method for mapping out their tattoos called freehanding. This method can sometimes mean just going straight onto skin without any sort of guideline or stencil at all. For others, freehanding means they draw their designs directly onto the skin with markers for their stencil. Usually in order to do this, the artist's style has to be particularly tailored to this method. I know a few artists who excel at this and it's very impressive. However, I am personally way too neurotic to tattoo this way. I prefer having my stencil safety net.

Some designs are drawings that come right out of the artist's head, while other designs sometimes call for reference material. When doing a realistic-style tattoo, it is common to use photo reference. I use photos for a few different reasons—sometimes to make sure I am keeping proportions correct, sometimes to maintain where light and shadows lay. Other times I trace a photo directly to ensure that an image is perfect. In the case of portraiture tattooing, it is absolutely necessary to have a good, clear photo of your subject in order to get the best possible likeness. Sometimes reference material isn't so much for exactness as it is for drawing inspiration. Reference material can be sourced from the Internet, books of photos and

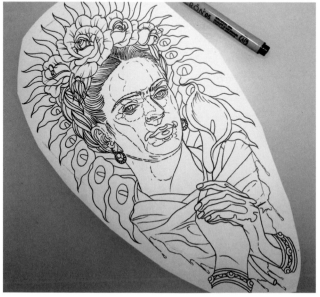

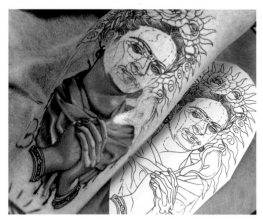

drawings, or even your own photos, as we've discussed. Sometimes when I am working on a piece and I'd like to add arms or hands, I'll actually take photos of myself in the mirror or my friends and use them as the reference, as I did for this Frida Kahlo tattoo.

The final, sharp design that was created with a marker will be the one used to create the stencil. This is done by making a copy of the design in a copier and inserting the drawing into stencil transfer paper and running it through a Thermo-Fax machine. Or the stencil can be traced by hand onto the stencil paper. Now these drawings don't usually reflect what the finished product of the tattoo will look like. The more complicated the tattoo is, the crazier the stencil usually looks. The stencil is more like the skeleton of a tattoo. It is used merely to provide guidelines for the tattooer. If the tattoo is more of a traditional style, the stencil will just look like the outline of your tattoo. The artist will then add shading and color after they complete the outline. However, if your tattoo is a more realistic-style tattoo with areas that don't require outlines, or areas with complicated shading, there may be a lot more lines and shapes included in the stencil that won't actually be in the finished product. These lines and shapes are merely reminders for the artist to know where to put certain shades and colors.

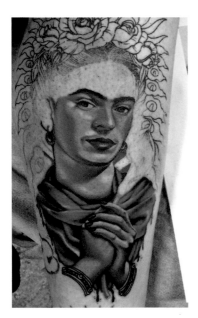
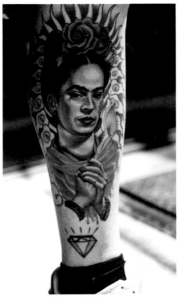
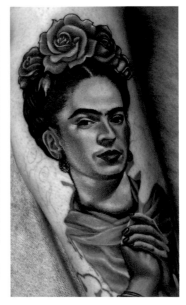

Here is a more traditional-style stencil and tattoo:

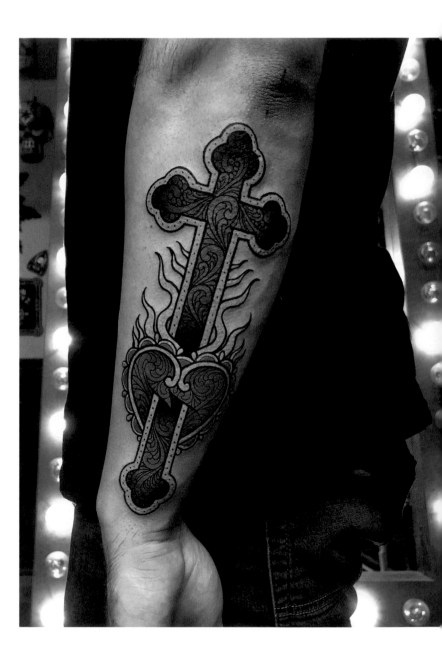

And here is a more realistic-style stencil and tattoo:

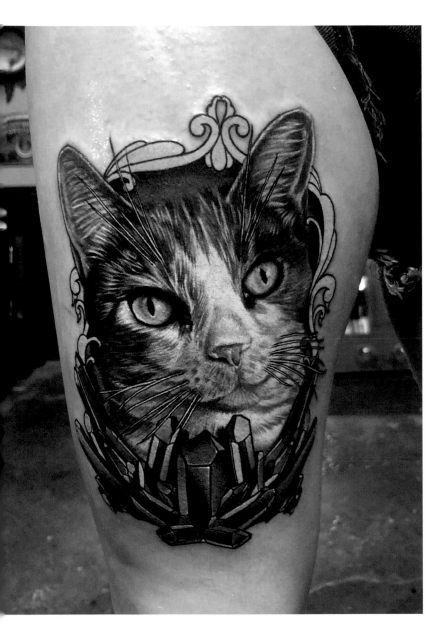

SPELL CHECK!

A little warning for those getting lettering tattoos: when presenting the idea to your artist, it is important to make sure your tattoo is spelled correctly. If you write the phrase, name, or dates you'd like tattooed on a piece of paper, it is likely the artist will tattoo it exactly the way you write it. The artist is focused mostly on the design of the tattoo, looking at each letter and word as more of a design than an actual piece of text. Also, if you're planning on getting a tattoo written in a different language, which is pretty trendy, understand your artist may not have any idea what your tattoo says, so it's up to you as the client to make sure it's right. That being said, *always*

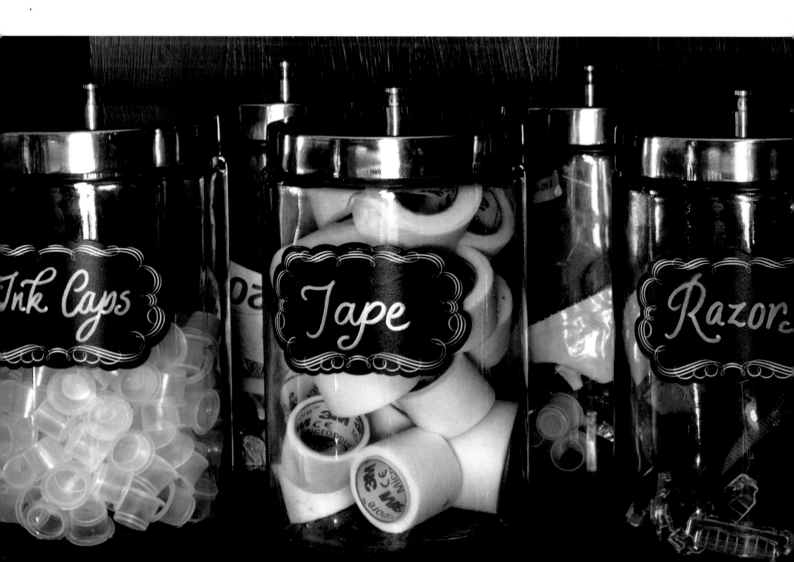

double-check the drawing before the stencil is applied. If you wait until you're looking at the stencil on your body in the mirror, you're going to be looking at it backward, which makes it way harder to spot misspellings. It may sound silly or common sense to some, but I can't tell you how many tattoos I've seen misspelled for these exact reasons. I myself experienced this very issue in the beginning of my career with a client who wanted *Only the Weak Die Hungary* across his stomach, not realizing his spelling referred to the country instead of the word meaning famished.

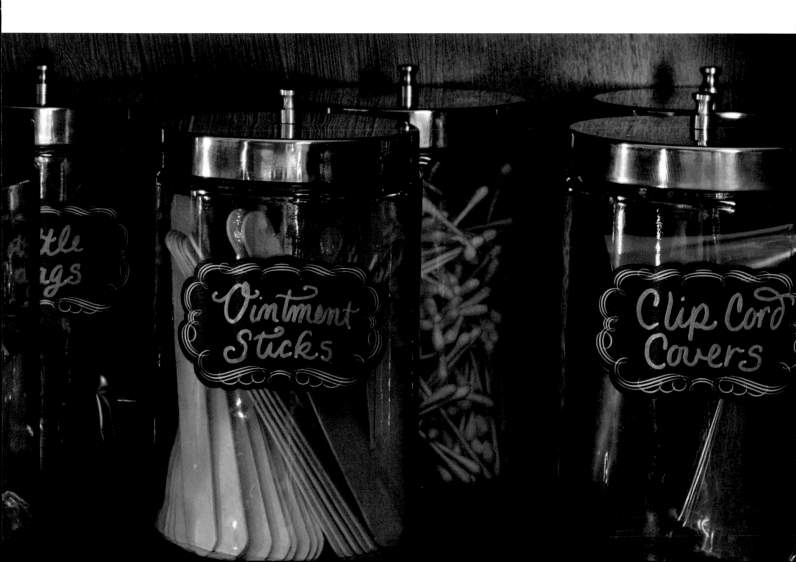

DOS AND DON'TS

It usually takes a certain kind of experience for me to create a tattoo that truly becomes one of my favorites. First, it takes a customer coming to me wanting a tattoo because they like my particular style. Most clients want to get a tattoo from someone because they know they are a good artist, but they may not always consider that what they want is outside of the artist's usual aesthetic. Sometimes artists welcome new ideas, but sometimes they prefer to stick to either what they know they're best at or what they love to do the most. It's also important to pay attention to the kinds of artwork the artist is currently doing and interested in. If you ask an artist to tattoo like they did years prior, and their style has since evolved, they might not be so thrilled. In my personal experience, when a client comes to me with a request that I'm not entirely excited about, I try to talk them into getting something more in my own style, and most of the time they are happy to. If not, I usually refer them to another artist who better fits what they're looking for.

Also, a good tattoo takes interesting subject matter, that isn't overcrowded, with the right amount of space. A good rule of thumb is to limit a tattoo to between one and three elements, one or two being more complicated with the other one or two being simpler and more complementary. Sometimes clients will come in asking for way too many elements in one tattoo. We artists like to call this "ten pounds of sh*t in a two-pound bag," and it doesn't look good. For example, a client came in once asking for a tree of life, with the roots turning into a dream catcher, and in the center of a dream catcher a portrait, all within a few inches on their leg. This is three very detailed and complicated subject matters that each deserve their own individual tattoo in order to get the right amount of detail. Not to mention, in order to do that many detailed tattoos, you would probably end up with an upper-thigh sleeve. Your tattoos should be clear enough that people standing five feet away from you can make

out what they are. If you have a ton of tiny squished-together tattoos, it just sort of looks like you're dirty.

Try to keep your ideas relatively simple and clear. I've had a client ask for six different flowers, each coordinating with the birth month of a family member, and each in the color of their birthstone, and each family member's initials inside each flower. This might sound cute to some of you, but to an artist it sounds like an aesthetically unpleasing and over-controlling headache. Relinquish control a little bit. Instead, tell us the meaning and messages you're trying to convey with your tattoo, and let us help you come up with a design that is perfect for you and aestheti-cally pleasing. In this example, I would suggest simply getting the flowers as they are, as they carry the desired meaning all on their own. The flowers could still be done in the specific birthstone colors, but you want to keep the color palette in mind and opt for colors that complement one another and aren't forced together to reestablish meaning. I would personally do without the initials inside the flowers because at this point one or two other elements already convey the message. However, if the client felt compelled to keep them, I would try putting them outside of

the flowers, perhaps in a banner so they are clear and legible and flow with the flowers instead of complicating them.

Yes, as artists we understand it is your tattoo, but you're also coming to us for our expertise and we want to give you the best tattoo possible. You just need to trust us to do that. Also, trying to hide something inside another tattoo usually doesn't look good and overcrowds the piece.

Once you and your artist have agreed on a concept, and you've spoken thoroughly about your ideas, the artist will make a concept drawing of your tattoo for you. It isn't unusual for clients to see the first drawing and sometimes want to make some minor changes. Sometimes clients can be more indecisive and continue to make many changes over many drawings. It's important to keep in mind that the more changes you make to a tattoo an artist has drawn for you, the worse it's going to look. It's often that the very first way they drew it was the best way, because it's coming straight from the heart. It's important to trust your artist and believe in their ability. Most people don't go to the doctor and put in their two cents about the diagnosis, because the doctor is the expert and went to school for many years to be able to give you the information you need. While we are definitely not doctors or doing something as important as saving lives, it's still the same principle of trusting the educated and talented people you're paying to help you. Also, the more your artist enjoys the piece they're working on, the more epic it will turn out.

This brings us to the actual tattooing process. You know what you want, the design is perfect, and the stencil is ready to go. The next step is to apply the stencil. There are a few different ways to do this, but in general you can expect that the artist will wipe your skin clean with a cleanser or soap and shave the area before applying the stencil. This is done for a few reasons: hair can prevent the stencil from lying flush against the skin or it can cloud the artist's vision as they are tattooing. Shaving also helps prevent ingrown hairs occurring during the healing process. After this, the artist will apply the stencil, usually using a cream or soap (back in the day it was with a stick of deodorant!), making sure it's made full contact with your skin before removing it.

This is the last time to make changes before the image becomes permanent, so it's important to make sure everything is perfect. Look to make sure the stencil is placed in the desired spot; for example, if it's meant to be centered in an area, make sure it lines up. If it's proving to be a difficult spot, the artist may make some guidelines on the person's skin with skin markers or pens to help ensure the tattoo is centered.

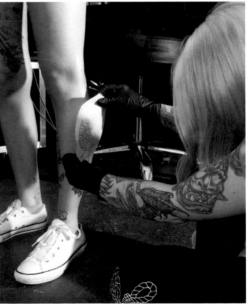

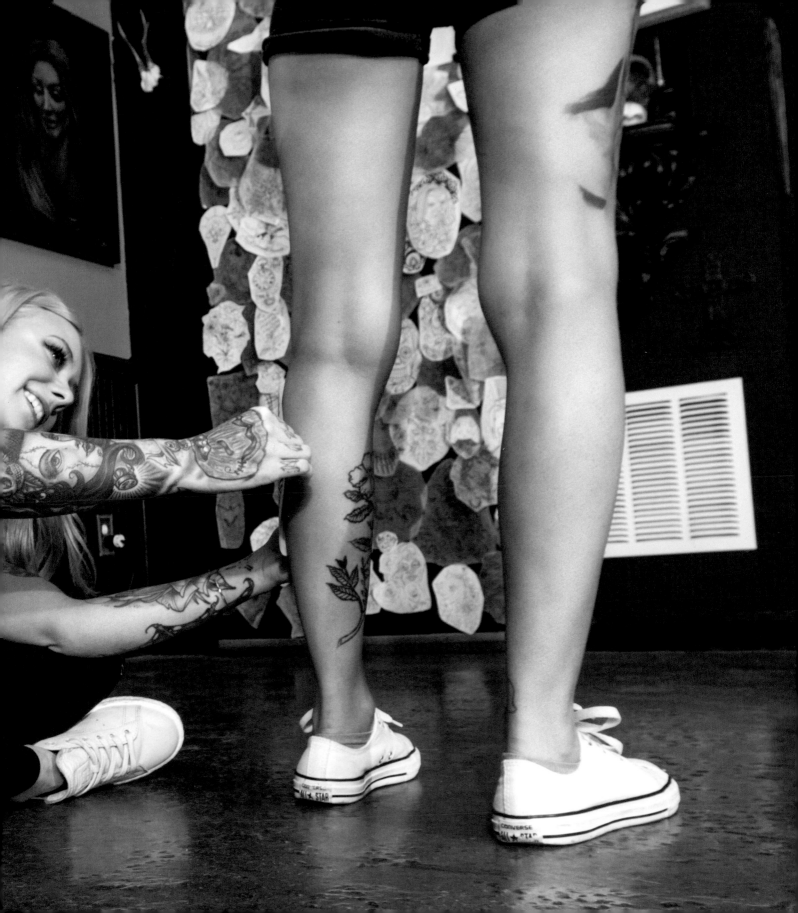

This is the time to speak up if you would like the tattoo to be moved up, down, left, right, or tilted at all. Clients shouldn't feel bad about asking an artist to move a stencil, and artists, it's much better to move a stencil ten times than always be annoyed that the tattoo was slightly off. This being said, it's important to remember that this stencil is going on a 3-D, moving surface. Your tattoo is always going to change shape as you move your body. The main objective is for the tattoo to look its best in your most natural, normal position. It's important to trust that your artist knows the best, most realistic placement options, as they have the experience.

A general rule of thumb for placing a stencil is that every tattoo should face your center. This means if your tattoo is on your left arm, it should face right, and if it's on your right arm, it should face left.

After your stencil is ready to rock, your tattoo artist will place you in the best possible position for them to reach your tattoo well. While they will want you to be as comfortable as possible, the positions you might be stuck in for the next few hours can become rather uncomfortable after a while. There's not too much that can be done about that other than to just prepare to keep yourself comfortable. Make sure you

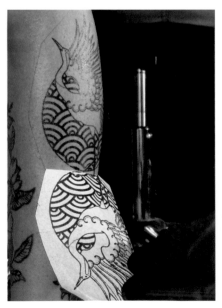
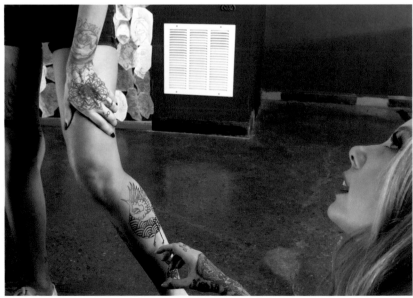

wear comfortable, loose-fitting clothing that also helps your tattoo artist easily get to the area on your body that they are tattooing. Also, don't wear anything that you'll lament getting stained, because once tattoo ink gets on your clothes, it rarely comes out. Also bring some water, snacks, headphones, something to read, or anything that can distract you from the pain but won't cause you to move. Staying still is key during your tattoo process. Even moving other body parts that aren't being tattooed can affect your tattoo. For example, if your ankle is getting tattooed, moving your arms and head around is still moving your whole body—everything is attached! I need to remind customers of this almost every time I tattoo. Also, while bringing a friend for moral support isn't unusual and typically okay with your artist, bringing your whole posse is a little excessive. Having lots of friends around usually causes a client to be a little too distracted and move around a lot, and it can be very disruptive to the artist and anyone else tattooing in the shop. Remember there are probably other people being tattooed at the same time. It's actually a great opportunity to make friends with the other tattoo clients as well and share in your painful yet positive experience. At my studio, we all tattoo in the same large open room so that we can all converse with each other throughout the day. (It's great for keeping our clients entertained.) Also, it's up to you whether you'd like to strike up a conversation with your artist—whatever helps you deal with the pain best. Either way, the artist is usually content, but everyone is different. Personally, I love to chat, but if I'm working on a certain section that may be harder or require more concentration, I tune out.

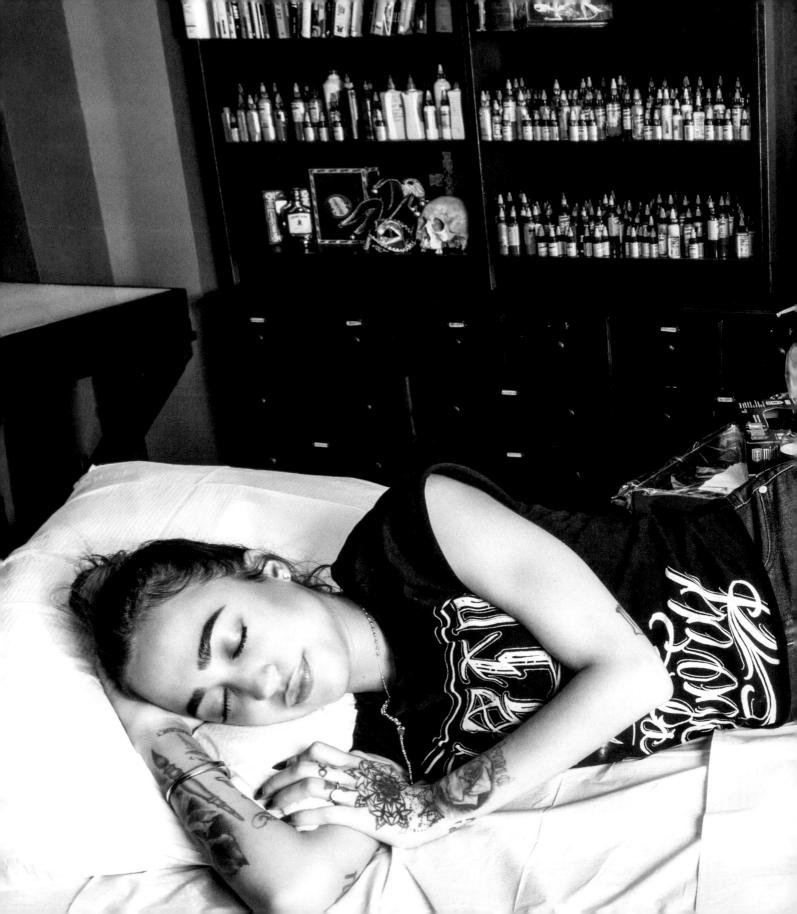

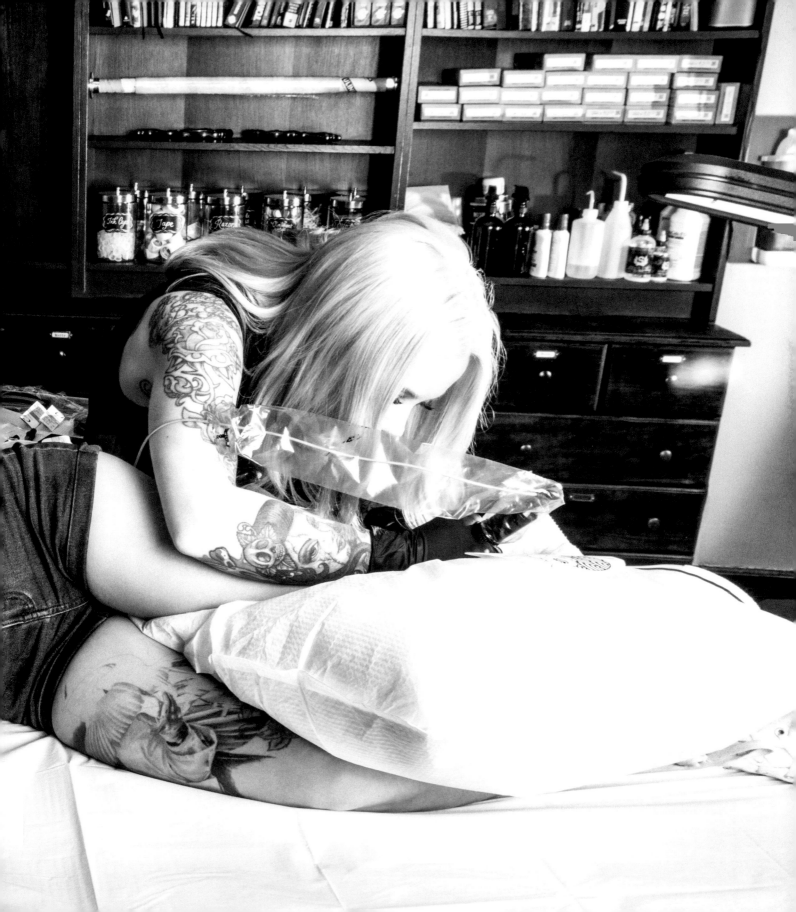

TATTOO EQUIPMENT ●━━━━━━━━━━●

1. Cartridge needle: A type of tattoo needle housed in a cartridge casing.

2. Lining needle: The needle used to make line work.

3. Shading needle: The needle used to shade and color in a tattoo. Often called mags.

4, 5, 6. Tip, tube, and grip: The pieces that make up the part attached to the tattoo machine that the artist holds on to and that encase the needle during the tattoo process.

7. Ink: The pigmented substance used to make the black and colors of a tattoo.

8. Power supply: The machine that powers and regulates the voltage of a tattoo machine.

9. Foot pedal: A pedal that is plugged into your power supply that allows you to turn your tattoo machine on and off.

10. Clip cord: The cord running power from the power supply to the tattoo machine.

11. Autoclave: The device used to sterilize tattoo equipment.

12. Ultrasonic: A device used to aid in cleaning tattoo equipment.

13. Rotary tattoo machine: A quiet-running tattoo machine powered by a rotary motor.

14. Coil tattoo machine: A traditional electric tattoo machine, powered by magnetic coils. (Note: never refer to a tattoo machine as a tattoo gun!)

15. Thermo-Fax machine: The machine used to create tattoo stencils.

16. Ink caps: Small containers that hold ink.

NOT PICTURED

Disposable: Single-use tattoo equipment that is discarded after use.

Green soap: A soap tattoo artists commonly use during the tattooing process.

Tegaderm: A medical adhesive wrap used to care for wounds and tattoos.

Light table or light box: An illuminated drawing surface that makes drawings or photos visible under a piece of paper, enabling tracing.

Now that you're all prepared, it's time to take that final plunge of permanence. The first line can be a little scary, but most clients are happy to discover that they built it up in their minds to be way more painful than it is. Actually, many times the first tattoo is the easiest tattoo a person will get. This is because clients are usually both very nervous and very excited, which releases adrenaline and endorphins, which make getting tattooed feel way less painful. Unfortunately, despite what some may assume, you do not build a pain tolerance to tattoos. It seems that the more tattoos you get, and the longer time goes on, the more they hurt each time. I have a personal theory that because we're not as excited and nervous about getting tattooed as we used to be, the less our hormones help us out. So enjoy it while it lasts!

You may notice your artist using a few different products. First and foremost, artists should always be wearing gloves and have protective covers on the items they're using, such as their cords and bottles.

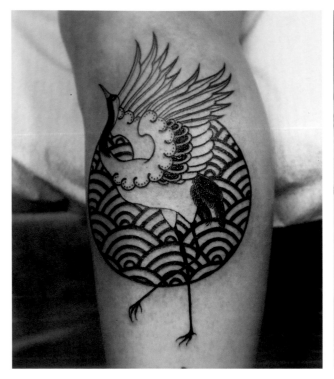
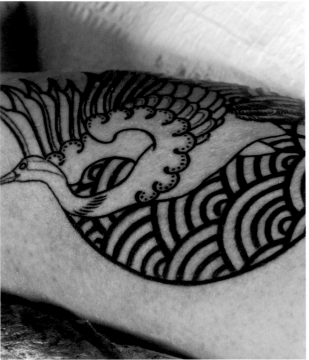

All blood and ink should be treated as biohazardous material. You'll notice as the artist does the outline, they are wiping an ointment onto the area they are tattooing, which controls the spread of the ink as they tattoo so they can better see what they are doing. It also helps clear the ink away, as they cannot use soap to wipe the tattoo down until the stencil is no longer needed. The soap would take off the stencil.

After that stage, the artist will begin wiping your tattoo with paper towels and soap to keep it clean and clearly visible. At first this will feel pleasant and cooling, but unfortunately after many hours the wiping becomes more painful than the tattoo itself.

All tattoos hurt—don't let anyone tell you otherwise—but different spots range in degree of pain from annoying to excruciating. Also, everyone's individual pain tolerance is different. The easiest spot on your whole body is your upper, outer arm. To me, getting tattooed in that area feels similar to deep scratching or massage. A few other areas that are generally easier are the forearms, thighs, and calves, all avoiding the joint

and bone areas. Most people seem to feel the ribs are the most painful area. A few other pretty painful spots are the feet, hands (in particular the palms), most of the joints such as wrists, and underneath the upper arm. In general, bonier areas tend to yield a sharper pain, but it also has to do with your nerves. The more nerve endings in an area, the more it hurts. If you're someone who doesn't handle pain very well, there are a wide array of numbing sprays that can be used both before and during the tattoo process to help take the edge off.

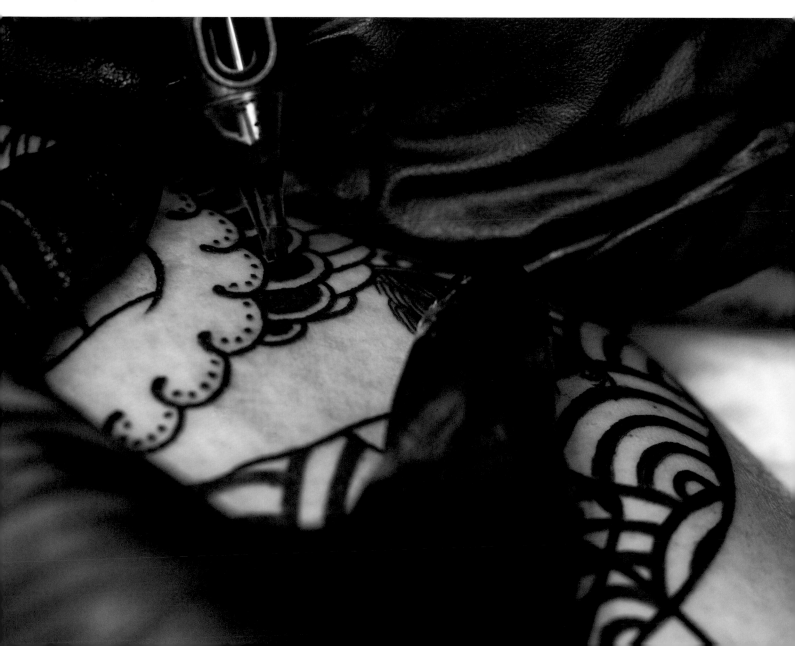

The style of your tattoo will dictate how your artist will go about tattooing it. If your tattoo has an outline, this step will be completed first before the shading and coloring are added. In general, artists start the tattoo at the bottom right side of the tattoo (if they are right-handed, or the left side if they are left-handed) and slowly work their way across the bottom until it's complete and continue all the way up. The reason they do it this way is to avoid rubbing the stencil away with their hand before that section of the tattoo outline is complete. Tattoos that are more realistic in style and don't have an outline are sometimes done with this same method, only instead of completing just the outline, the artist will complete the shading and color as well, leaving the highlights for the end. Sometimes if the tattoo has a very difficult section, such as the details

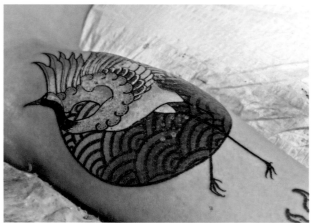

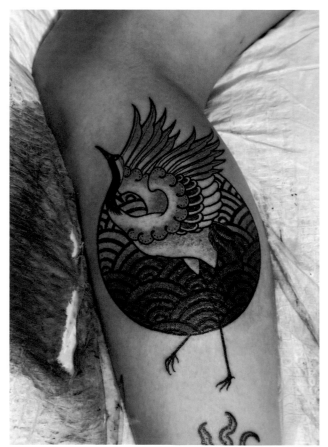

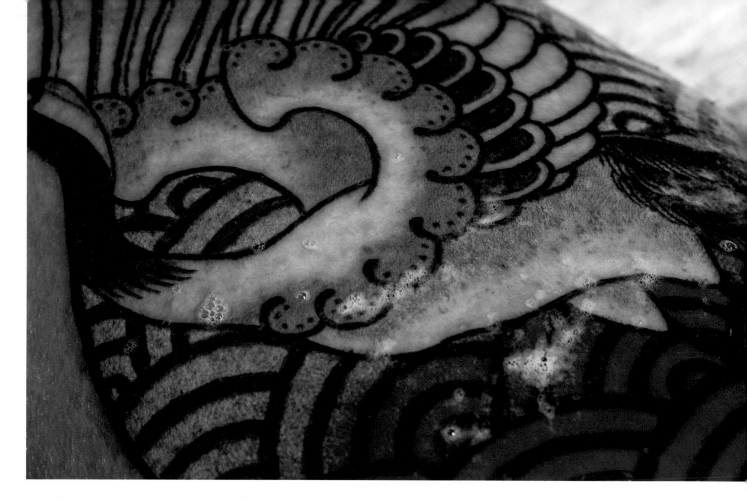

of the face in a portrait, the artist may choose to start there, as it's the most important place to have the stencil intact.

If your tattoo is in color, the artist will generally complete the darker tones before lighter ones. This is because sometimes certain colors can "stain" others, and in most cases it's a dark color staining a lighter one. This isn't always the case, though; even I jump around my color palette, as sometimes toward the end of a tattoo I decide I want to add or blend colors together more.

The last step for most tattoos, if the tattoo calls for it, is the addition of white. White is usually used mostly for highlights, as it's so light it has a tendency not to stay vibrant if done in large areas. White is a pretty tricky color, and some skin holds on to it better than others. A common myth that white ink hurts worse than other colors probably stems from the fact that it's the last color used, so the client is at their sorest point, and it's also usually done with smaller needles, which hurt more than larger ones.

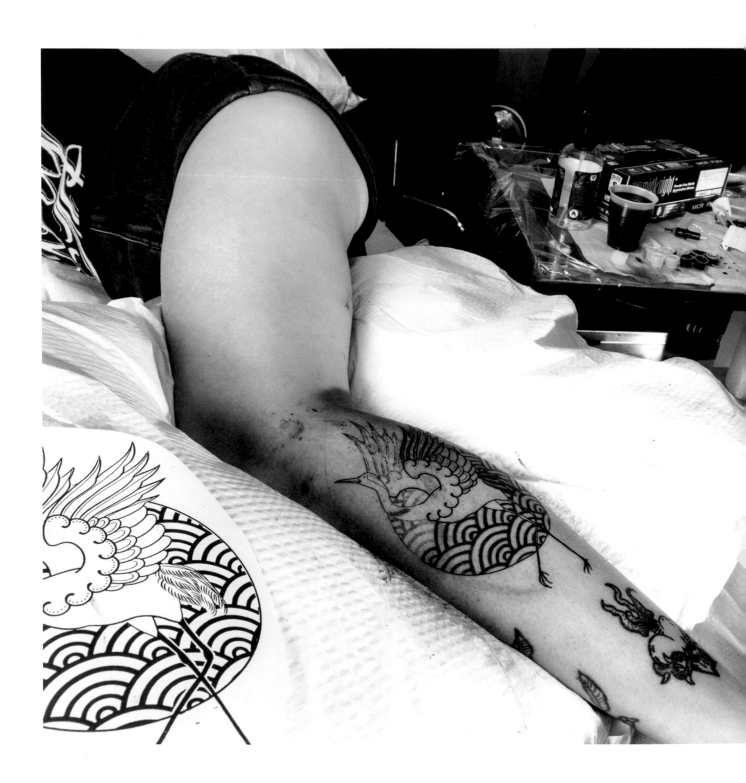

That may seem hard to believe, but it's a matter of distribution. Not to be gross, but think about it like this: You know how some people lay on a bed of nails without piercing their skin? Well, that's because their weight was evenly distributed over a larger area. If you were to step on a nail, though, a much smaller area, it would be a different story.

Another tip concerning ink is that red seems to be the one color that some people have an allergy to. I've heard about a few ingredients possibly contained in some red inks, like cadmium, nickel, and mercury, being culprits. Whatever may be the exact reason, the reactions can range from mild to severe. It can cause the red area to take longer to heal, or to heal inconsistently, become bumpy, or feel itchy for an extended time. I've even seen it completely vanish from tattoos, though that's very uncommon. As a little test, I ask clients if their skin turns black or green or develops an allergic reaction when they wear cheap jewelry, which is usually nickel-plated. If so, I usually play it safe and avoid red.

Tattoos can take anywhere from a few minutes to many hours and even multiple sessions to complete. At the end of your session comes one of the most important parts of the tattoo process, the aftercare. There are many different ways out there to heal a tattoo. Everyone heals a little differently and it's important to find the method that works best for you. For my clients, I prefer to use a medical-grade bandage called Tegaderm. It is a clear second skin–like sticker that goes over the tattoo, and I recommend my clients leave it on for four days. This helps protect the tattoo from any outside irritants and allows the tattoo to heal in your own natural bodily fluid. When using this, I let my clients know that their tattoo isn't going to look very cute for a few days. The clear wrap fills up with a bubble of the fluid that normally seeps out of your tattoo for the first couple of days. This fluid is blood plasma and leftover tattoo ink. After two days of looking a bit gooey, it starts to dry and look crusty inside the wrap, all of which is completely normal. Taking the wrap off can be a little scary, as it is usually pretty stuck on, but it won't hurt you to peel it off as long as you're not taking it off before day four. You can take the wrap off in the shower to make it a little easier. That being said, sometimes the wrap falls off on its own before the fourth day, commonly because of an

excessive amount of fluid under the bandage. If this happens, it isn't a big deal; just continue with the same steps as if the wrap came off on day four. If Tegaderm isn't readily available to you, I would bandage the tattoo with cling film and ointment overnight, taking the wrap off the following morning and cleaning it with antibacterial hand soap. Wash the tattoo often the next four days, morning, night, and a few times throughout the day. Use an ointment for just the first two days (I usually recommend bacitracin or A&D ointment). It's important to use the ointment very sparingly, as it is very heavy and can clog pores. Oversaturating with ointment can lead to a bad heal. It is also important to avoid products with zinc and petroleum jelly.

Now that your Tegaderm is off, or you just finished using the ointment, clean the tattoo with antibacterial hand soap, and continue to do so mornings, nights, and any time the tattoo may become dirty for the next two weeks. You're also going to start moisturizing your tattoo with an unscented hand lotion for the next two weeks. I say two weeks because after that amount of time there's nothing you can really do to mess up your tattoo, but in reality after the first two weeks your tattoo will remain shiny for another couple of weeks. It takes about a full month before your tattoo is 100 percent healed. Four to six days after you get your tattoo, the whole tattoo will start peeling dead skin, like when a sunburn heals. The skin will come off in the colors of the tattoo, which is totally normal.

While these are the ways I've determined work for me and my tattoos, it is important to take the advice from your personal artist, as they know best how their type of tattoos heal. How well you heal your tattoo will determine how good your tattoo is going to look. However, it isn't uncommon to need a little touch-up, or sometimes unfortunately we experience bad heals. In these cases, consult your tattoo artist. Even after your tattoo is healed there are a few things you can do to keep your tattoo looking nice for longer. One piece of advice I give to all my clients is to moisturize your tattoo every day, even long after your tattoo is healed. Also be sure to use sunblock on your tattoo after it's healed, as tanning and sunburns can accelerate your tattoo's aging and fading.

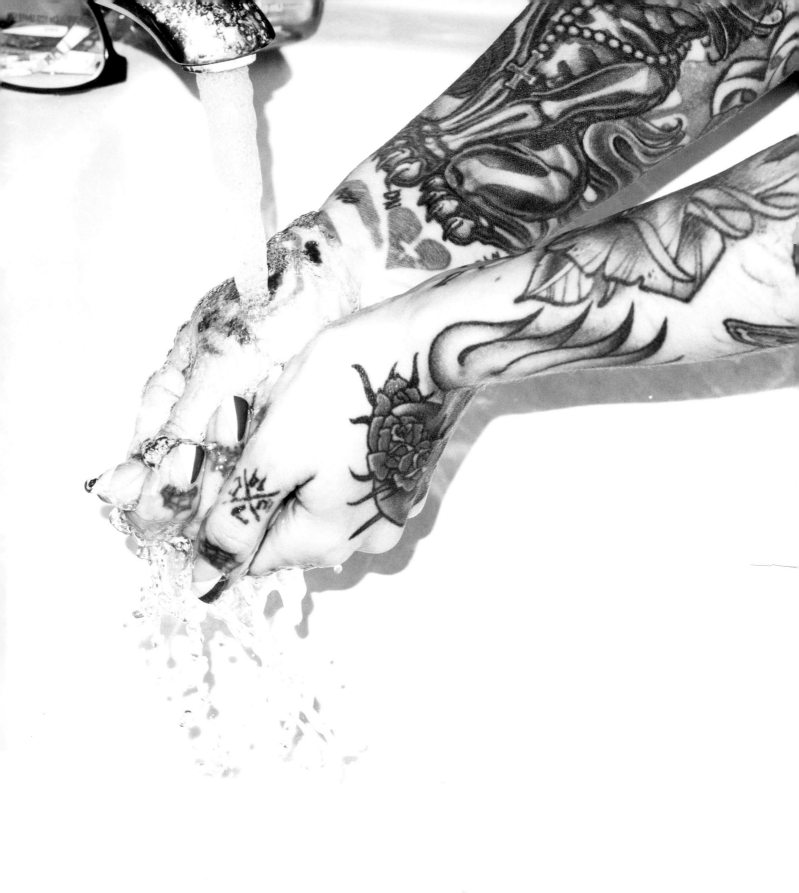

Chapter 5

Hall

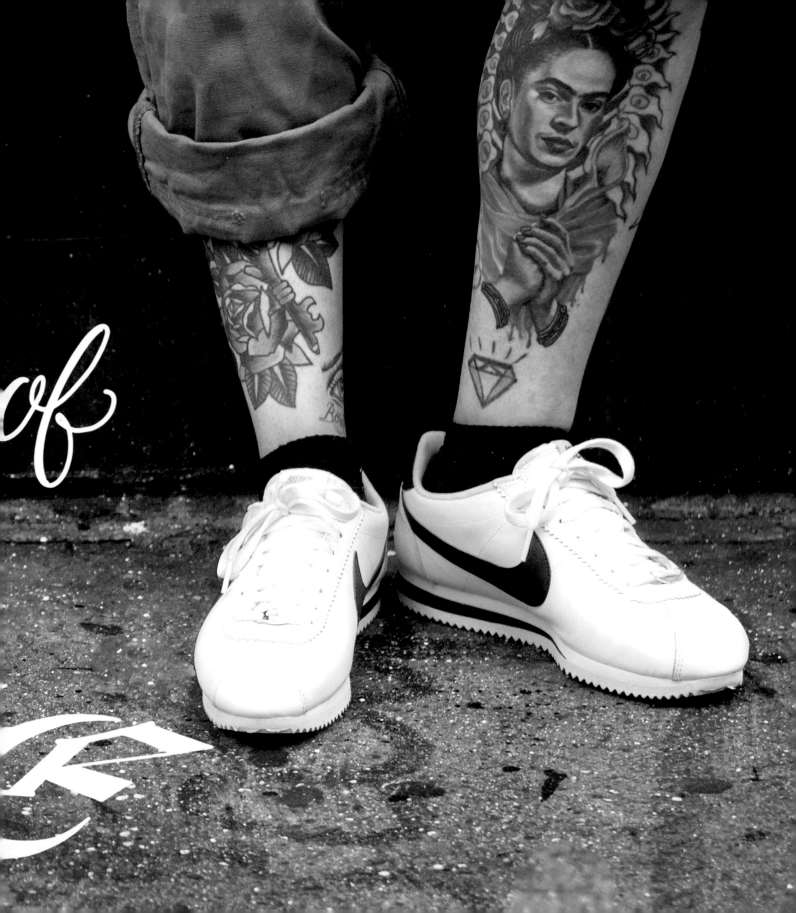

I never keep track of how many tattoos I've done; I've always been bad at things like that. But I figure if I did at least one tattoo a day, five days a week for the last fourteen years, that puts me at around 3,360 tattoos. There are days I went without tattooing, of course, and plenty of days I've done multiple tattoos, up to twenty. So that estimation is not at all accurate, but at least it gives you an idea.

Out of all the many tattoos I've done, here are just a few of them that are my favorites, and why.

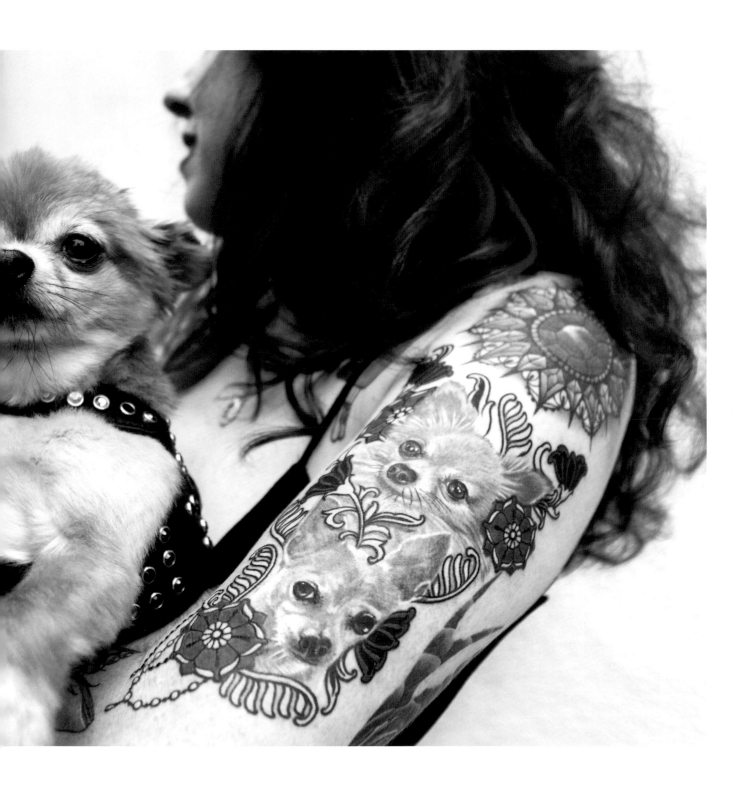

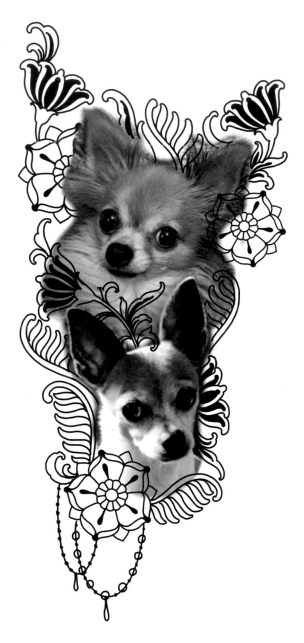

SPIKE AND CHEWY

Leila Listo is one of Grit N Glory's best clients. When she started coming in to get tattooed, she had only a few smaller, older tattoos. Now she is almost covered. I've done a few cover-ups and redos for her, as well as a bunch of fresh pieces.

Out of her collection, my favorite is of her pet Chihuahuas, Spike and Chewy. As her therapy dogs, they are always close by her side every time she gets tattooed, whether waiting patiently in their cute carrier bag or huddled around her neck cuddling her. They both have such cute personalities and it was so much fun to try to reflect those personalities in the tattoo. They are now like the shop's mascots. I tattoo a lot of people's pets on them, particularly dogs and cats. Sometimes it's a commemoration tattoo for a furry best friend that has passed, or just sheer appreciation of their love while they're still with us. It's clear to me through the eyes of my clients just how much these animals mean to them.

In this design I chose to keep the dog faces realistic in style, and surround them with more traditional-style foliage. I do this juxtaposition of styles often in my tattoos. I feel the one-dimensional details of the flowers really help create the illusion that the realistic portraits are popping right out at you.

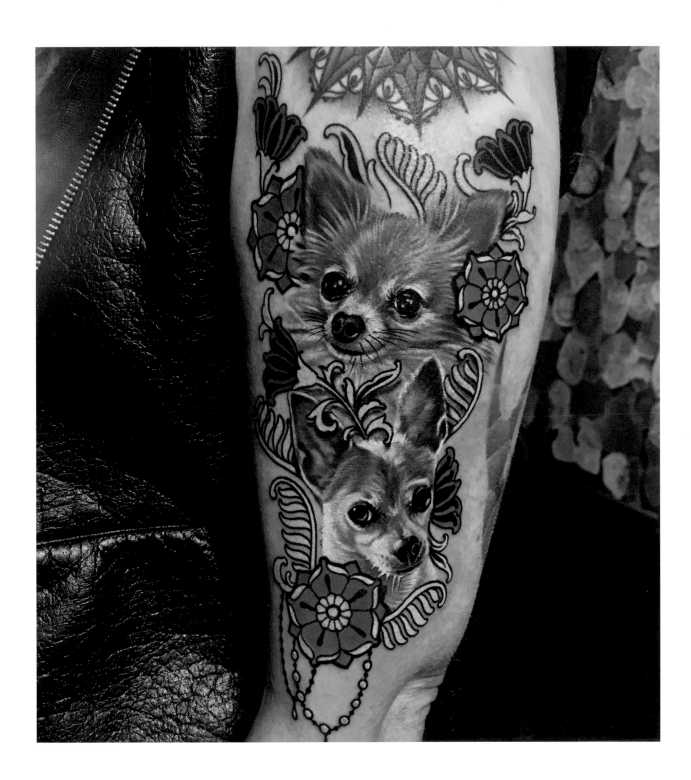

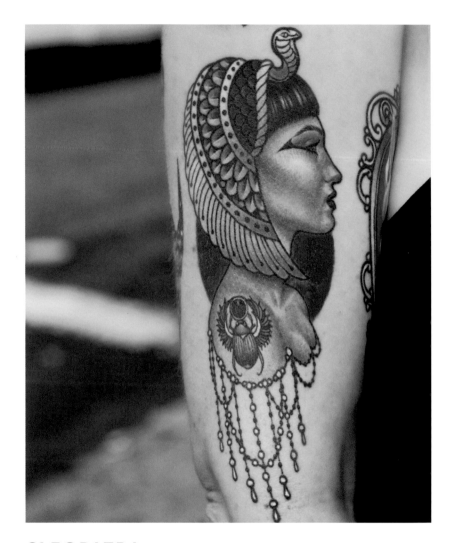

CLEOPATRA

Another tattoo I did for Leila and really enjoyed was this Cleopatra on her arm. This tattoo came about pretty randomly. We set up some time for her to get tattooed but for this particular appointment didn't have anything specific in mind. She mentioned Cleopatra, and I have wanted to do more tattoos of strong female figures. I drew the tattoo to fit the area on her arm between other tattoos, and she left the design entirely up to me. I drew this completely out of my head.

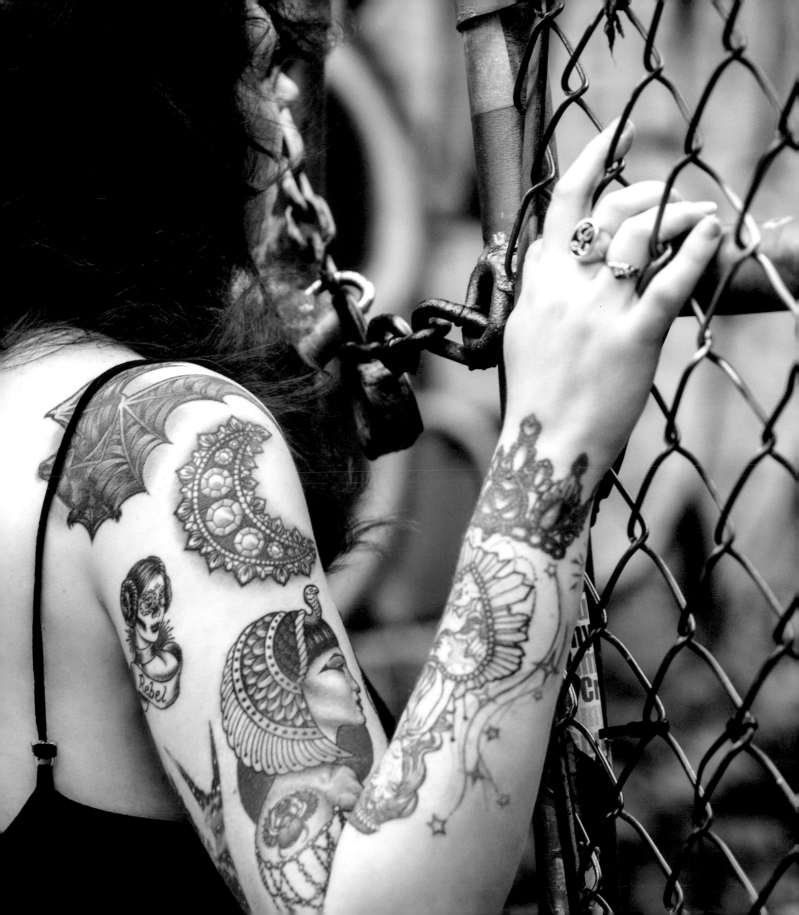

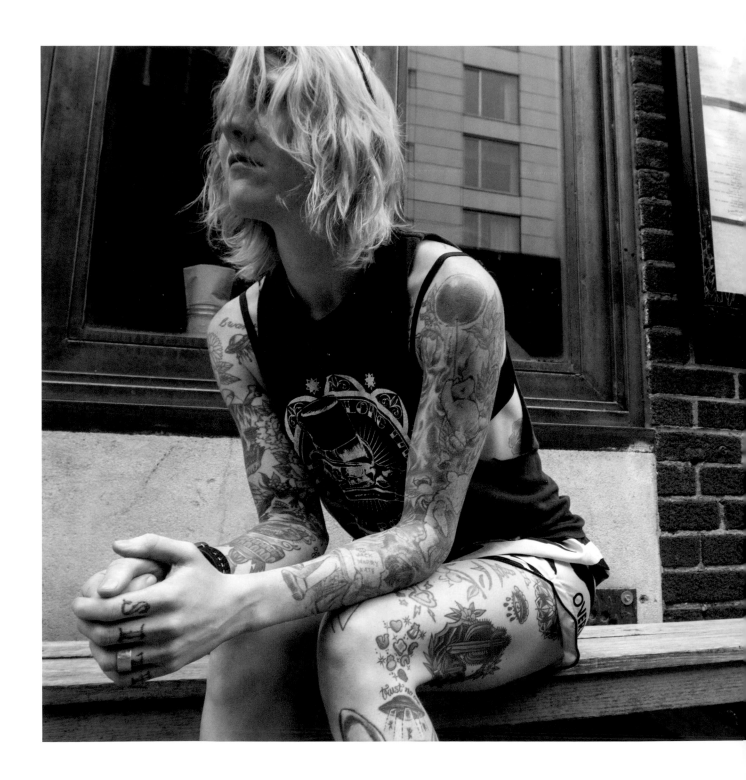

BONETHROWER

The original artwork for this tattoo is by a very cool painter named David Cook (a.k.a. Bonethrower), whom both my client (who happens to be my business partner Emily) and I are fans of.

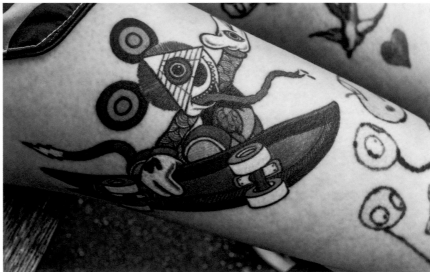

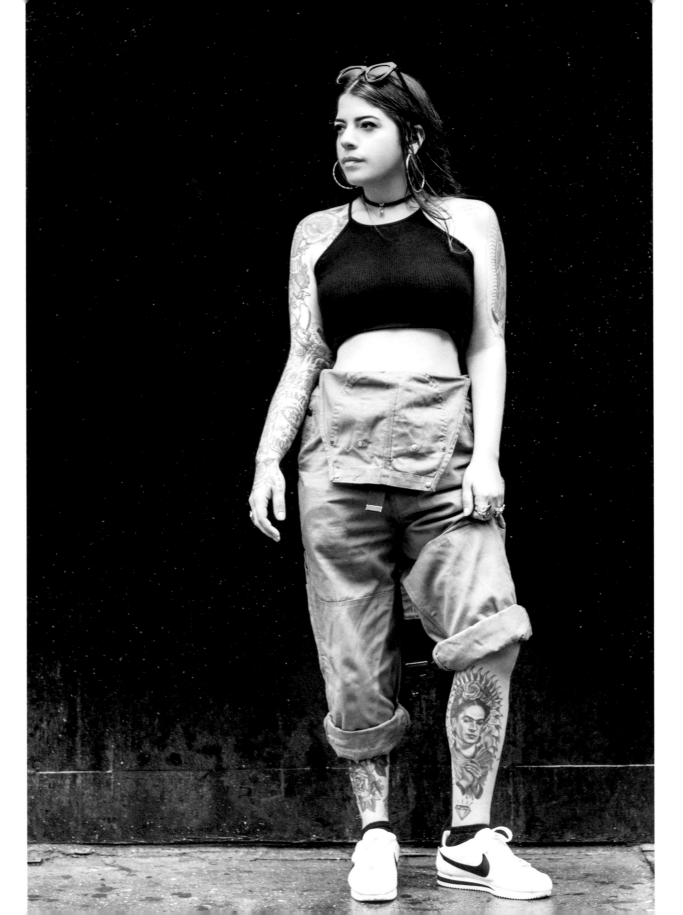

FRIDA

Frida Kahlo was a strong woman and artist whom I've always looked up to. In this design, I fashioned the calla lilies to look like the ones painted by her husband, Diego Rivera. I also placed them in the background to mimic the rays behind the Virgin of Guadalupe. I was happy to give this tattoo to my business partner Veronica. (You might remember from earlier in the book that I used my own hands to model these.)

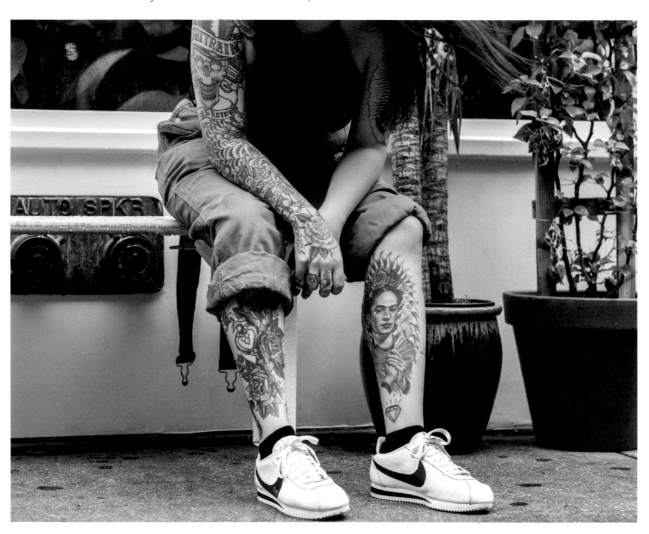

FOX AND SUNFLOWERS

My client was inspired by images of a very cute fox named Juniper.
We added some sunflowers and may add some more someday.

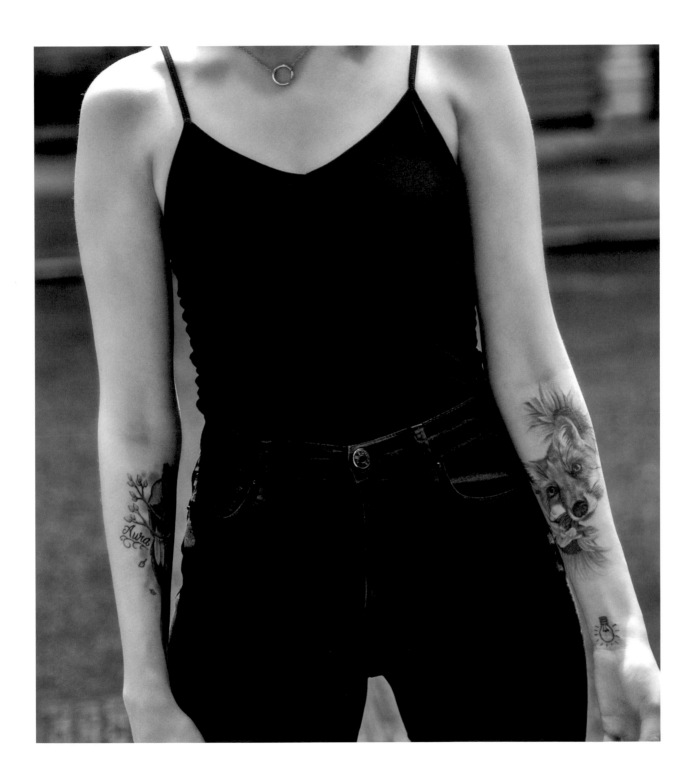

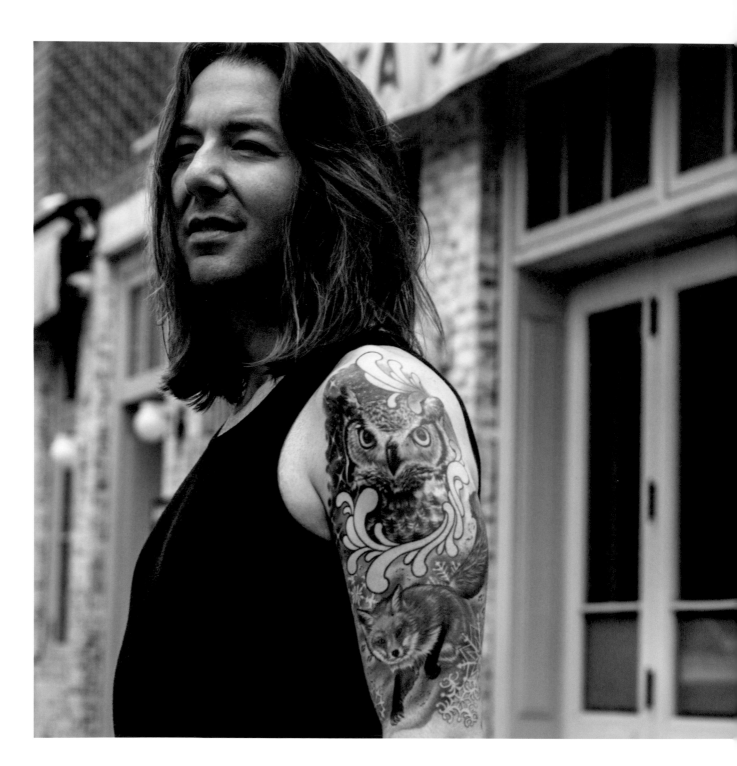

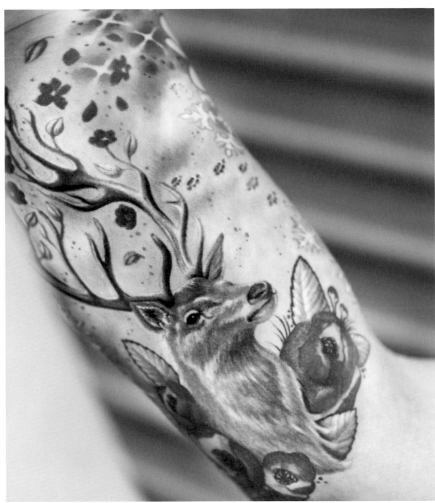

ANIMAL SLEEVE

John first came to me with a request to cover an older star with a hummingbird. We then decided to do another cover-up on the top of his arm with an owl. John was then hooked and got a snowy fox and flowery deer to complete a half sleeve.

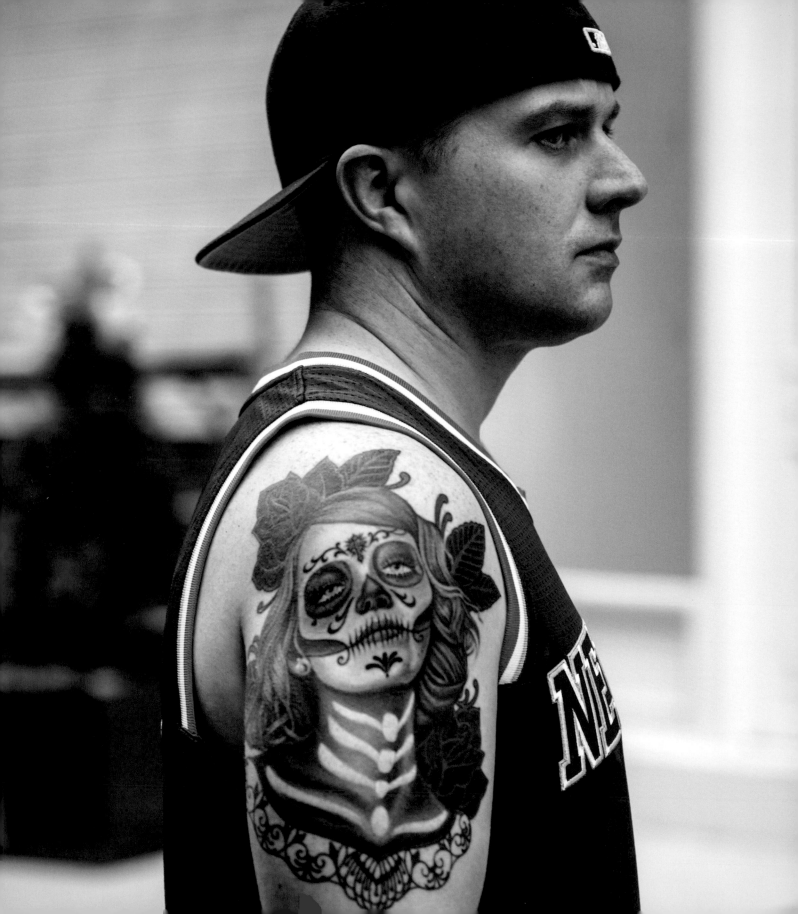

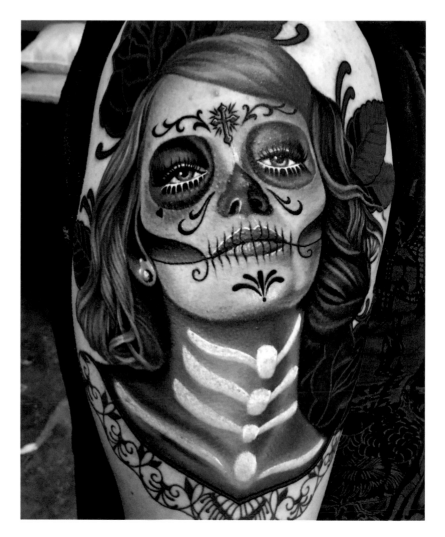

DAY OF THE DEAD GIRL WITH FLOWERS

This is one of my favorite Day of the Dead–style girls I've done, modeled after a reference of actress Emma Stone. Here I chose to do a very dark, graphic-style version of traditional roses for the background.

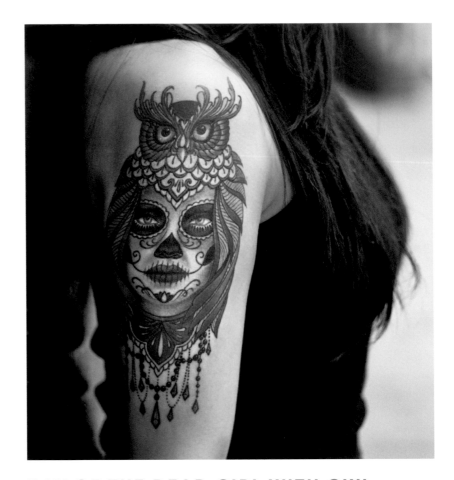

DAY OF THE DEAD GIRL WITH OWL

Day of the Dead–style girls are a trend that I have been tattooing for
years now. Their makeup is inspired by the Day of the Dead celebration
in Mexico. I've had the opportunity to experiment with different color
patterns and colors to make each one unique. In this case, we combined
a girl's face with an owl that almost acts like hair and makes for a really
uniquely styled tattoo.

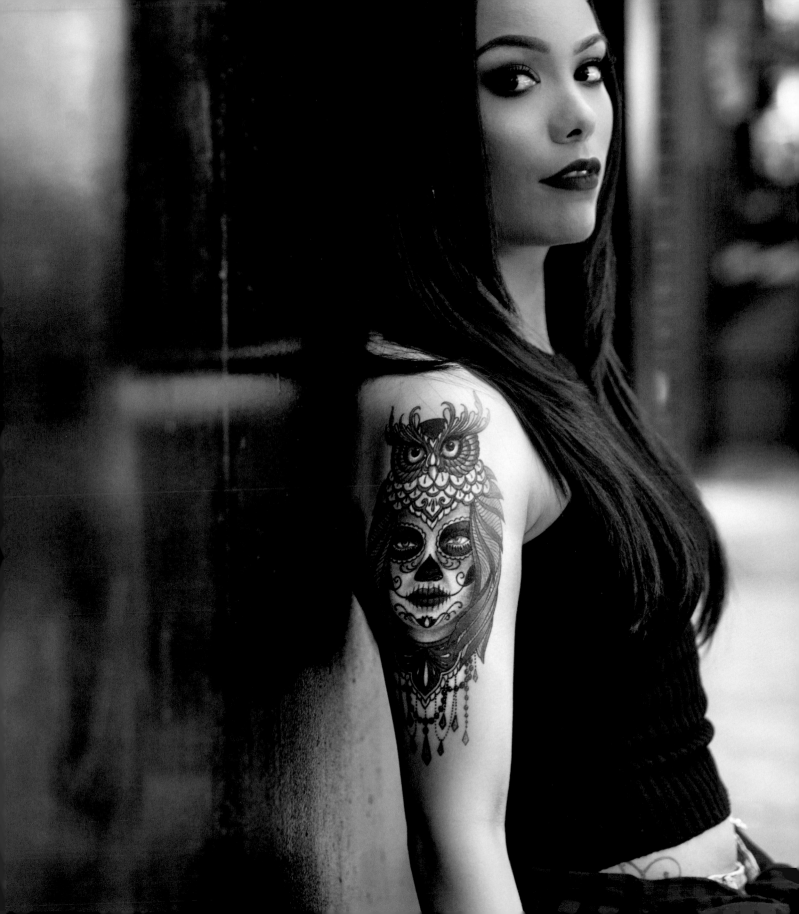

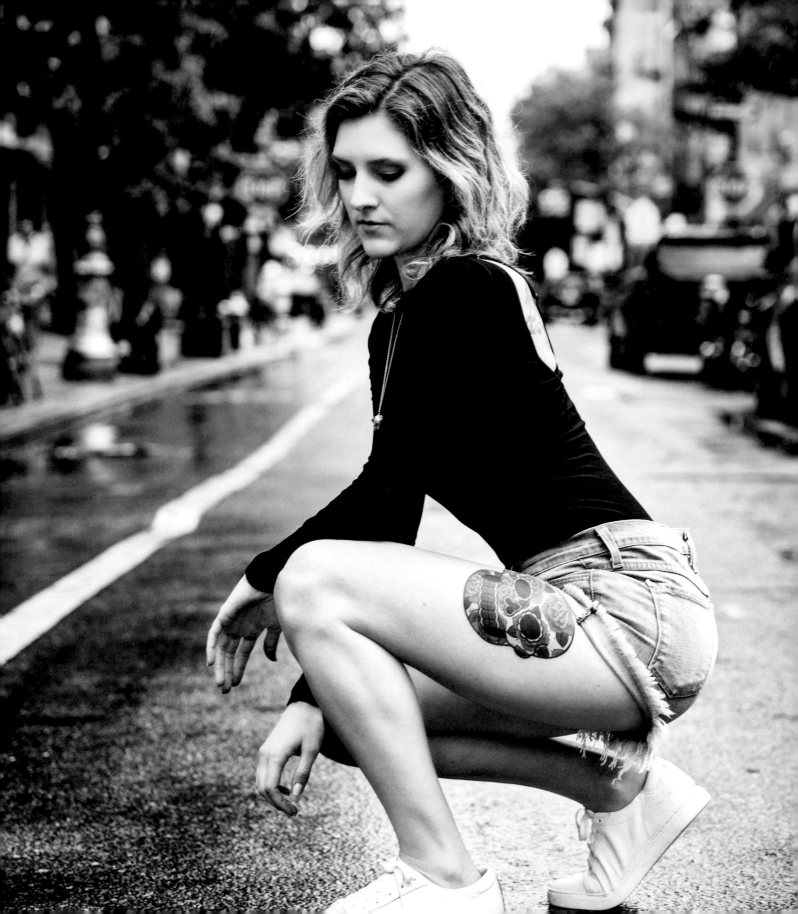

ROSES SUGAR SKULL

Also related to the Day of the Dead celebration, sugar skulls have become another subject many of my clients have requested. Over the years, the designs evolved and changed. Most sugar skulls have different elements inside them. Some clients pick specific images to put inside the skull to mean different things. I tattoo many sugar skulls and always try to make each different and special. In this case, I chose to go with a pattern of traditional roses in the background instead of the more usual decorations.

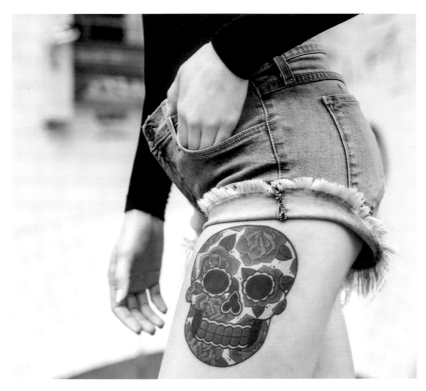

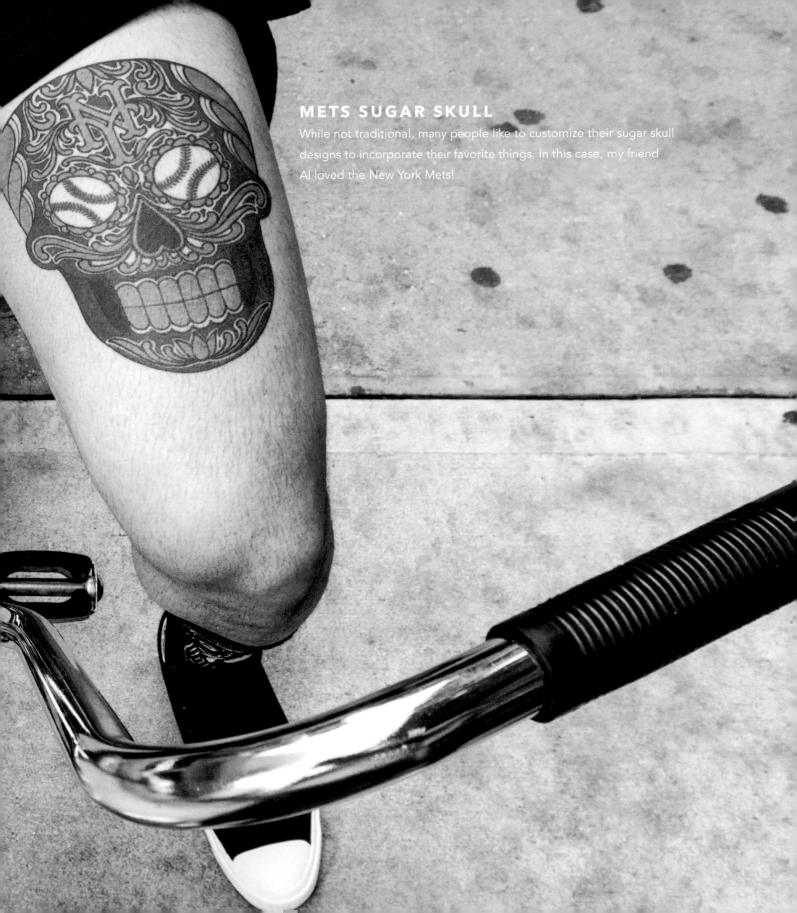

METS SUGAR SKULL

While not traditional, many people like to customize their sugar skull designs to incorporate their favorite things. In this case, my friend Al loved the New York Mets!

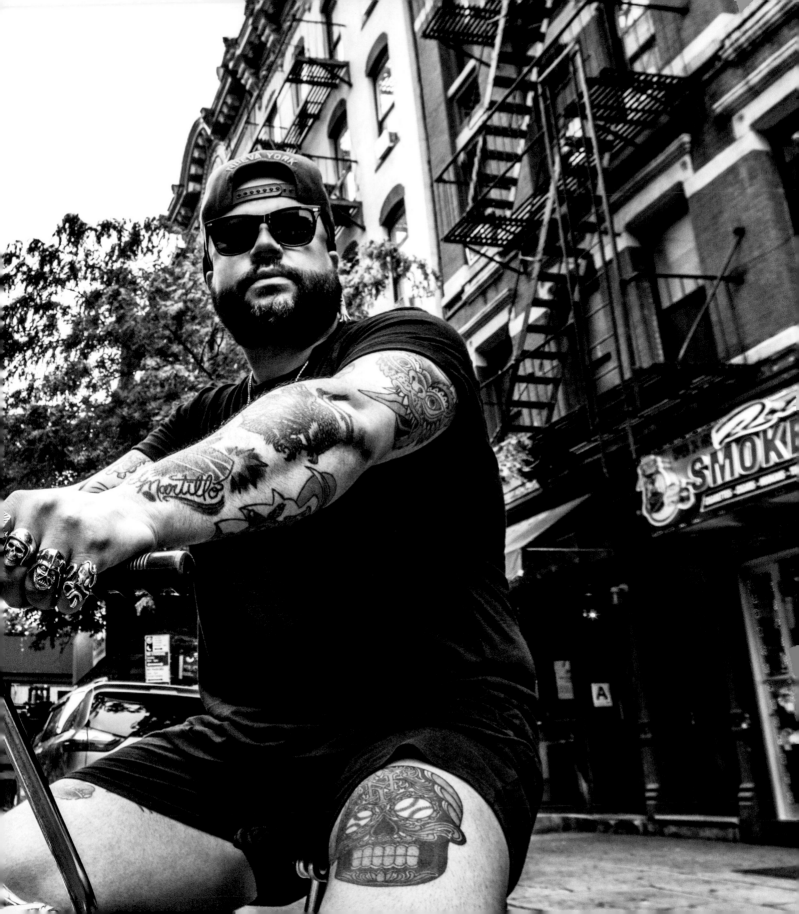

LYDIA

For Halloween 2016 I made a flash sheet titled "Scream Queens." As one of my top favorite spooky ladies, Lydia from Beetlejuice had to be on the sheet. I was very happy to give this tattoo to my friend Katie. As with most of my flash tattoo designs, this tattoo took twenty to thirty minutes to complete.

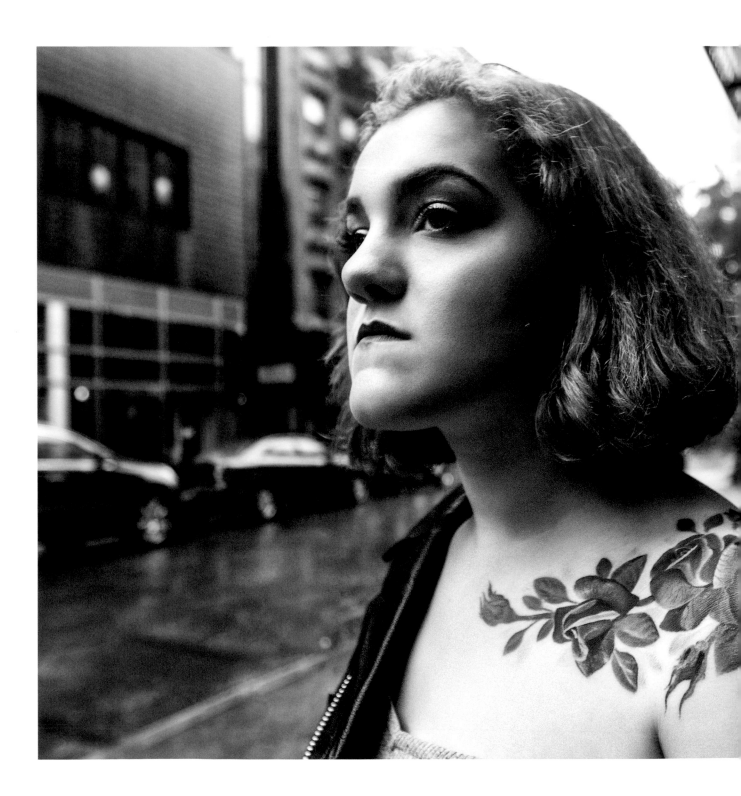

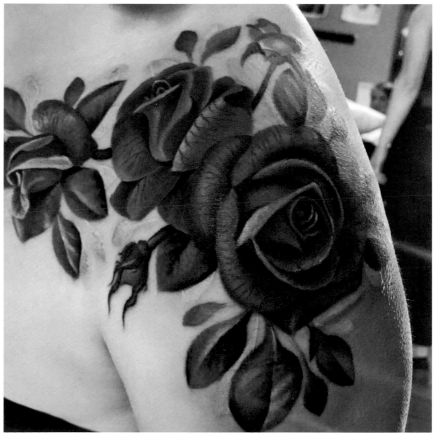

ROSE SHOULDER

Samantha chose a super-daring and cool spot for her very first tattoo. She also sat like a champ!

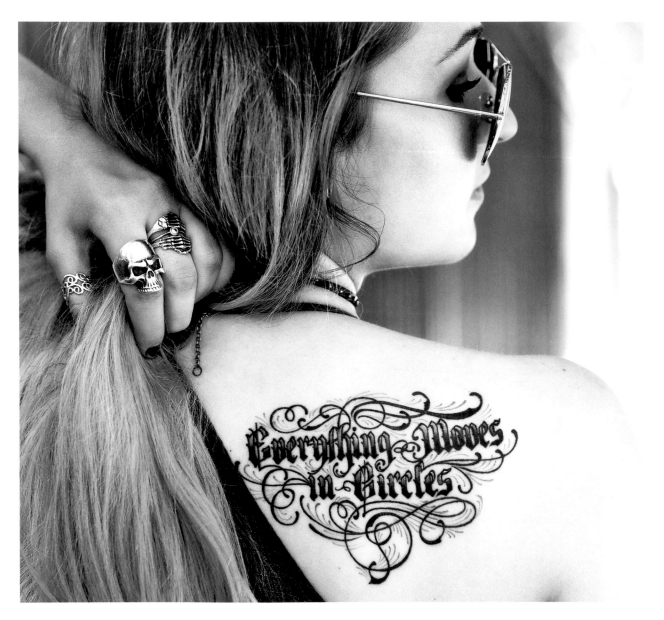

EVERYTHING MOVES IN CIRCLES

I don't do script tattoos often, but in this case when my friend Christie Blickley—who happens to be the graphic designer and the appointment booking manager at Grit—asks me for script, she gets it.

SANTA

This is on a client who absolutely loves vintage holiday tattoos. This was the first tattoo of a whole vintage holiday forearm sleeve we're working on, the second of which is the reindeer tattoo.

CHIHUAHUA

I think it is a well-known fact that I love to do tattoos of animals, particularly people's pets. I have been lucky to dedicate a lot of furry friends to their owners' bodies. It all started on the first season of *NY Ink*, when, as I mentioned earlier, I tattooed my friend Taylor's pet Chihuahua on her, dressed in Victorian clothing. From then on, it started a trend of people coming to me for dog tattoos. At first, many people asked for their pets to also be dressed in clothes, but as the years went on, the requests became simpler.

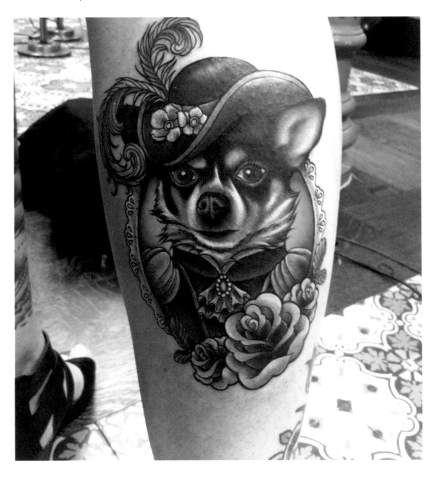

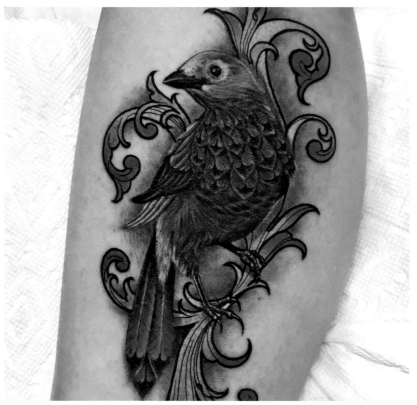

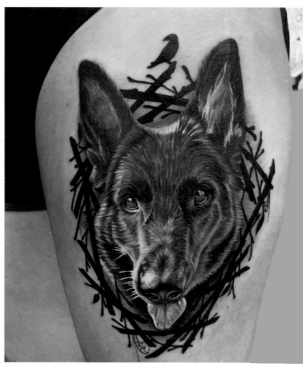

COLORFUL BIRD

In this case, my client simply asked for a colorful bird tattoo. After researching so many different kinds, I couldn't make up my mind on which to tattoo, so instead I added a few elements from different birds I liked and came up with my own species.

TIBBY

With every dog tattoo, I try to do something a little different. For this piece, I decided to go with a much darker color palette than most of my other pet tattoos. This black German shepherd loved playing with sticks, so we went for a wreath made out of sticks for the background. It took about five hours in total.

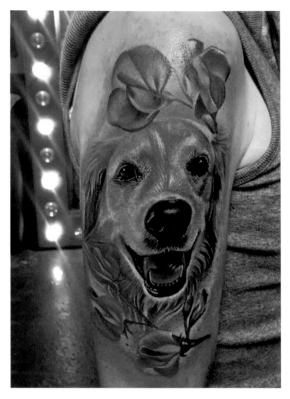

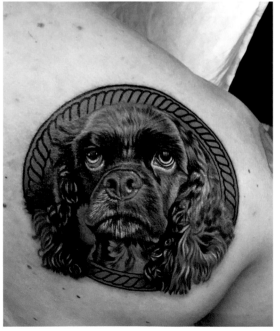

GOLDEN RETRIEVER

This client flew in from very far away to dedicate her love for her super-cute pup.

LEIA

This super-cute cocker spaniel was so fun to tattoo. (She also looks a little like William H. Macy!) The very curly ears were particularly detailed and time-consuming to tattoo.

PANTHER

I really love combining different styles of tattooing together in one tattoo. In this case, I made the panther more realistic and the roses more traditional.

NALA

This is one of my favorite cattoos to date. Nala is a very beautiful Siamese cat.

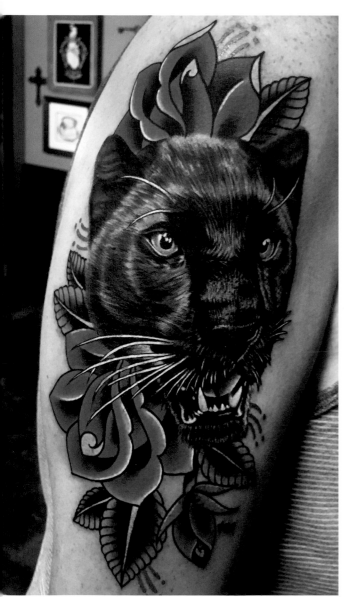
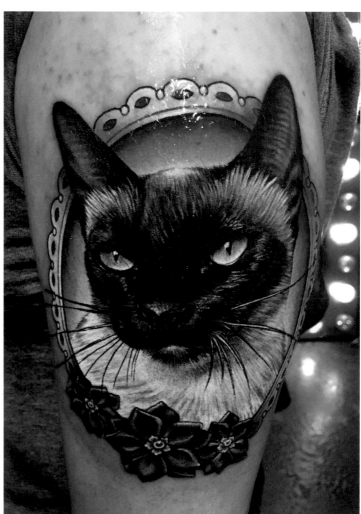

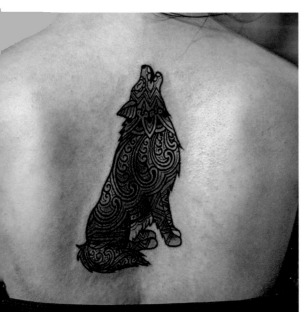

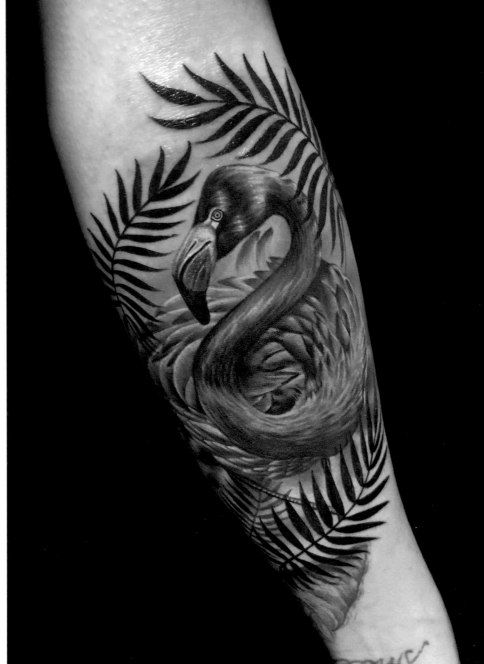

ORNAMENTAL WOLF

I chose the colors of this ornamental design to give an iridescent vibe to this tattoo.

FLAMINGO

I really love tattooing animals in general. I recently realized I had never tattooed a flamingo and jumped at the chance to tattoo this beauty.

CROSS

This tattoo is more of an ornamental style on a very dedicated client of mine from England whom I've tattooed many times.

SKULL WITH FLOWERS

This is another example of how I mix styles in one tattoo. Here we have a black and gray, more realistic-style skull mixed with color, and more graphic flowers.

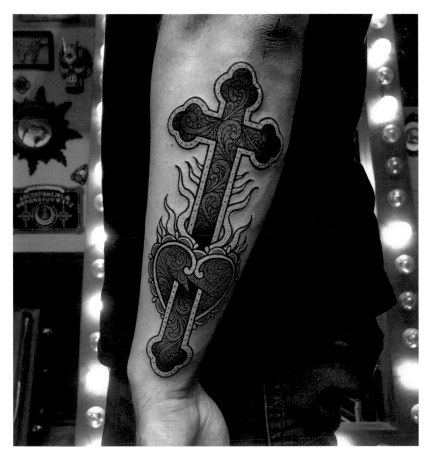

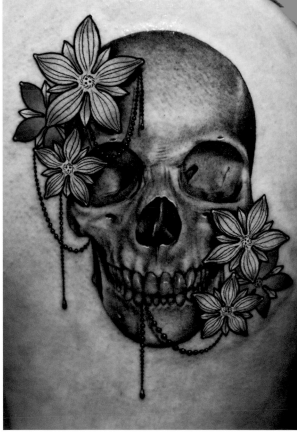

SKULL TURNTABLE

My client was a DJ and wanted a tattoo to symbolize that while also being just a bit different and unique.

PITBULL PORTRAIT

What a cutie! How unique are the eyes on this super-cute pitbull named Mr. Meats?

FLOWER TWINS

In this case, two best friends got the same exact tattoo, only in two different places and way different sizes. One woman got the flowers huge, wrapping all the way around her back calf. The other woman got it much smaller and used it as a cover-up of a small, older tattoo on her lower back.

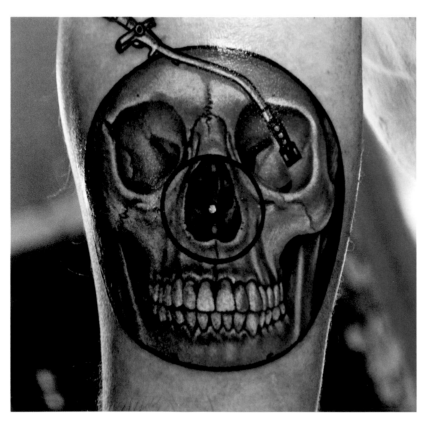

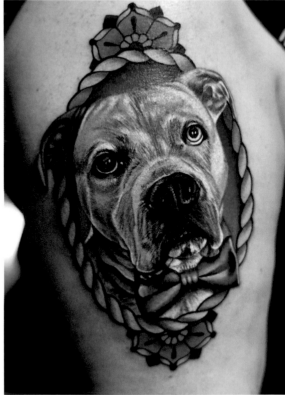

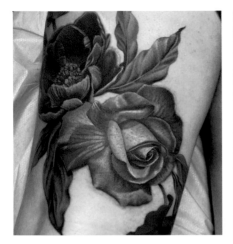

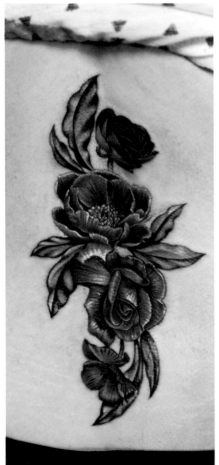

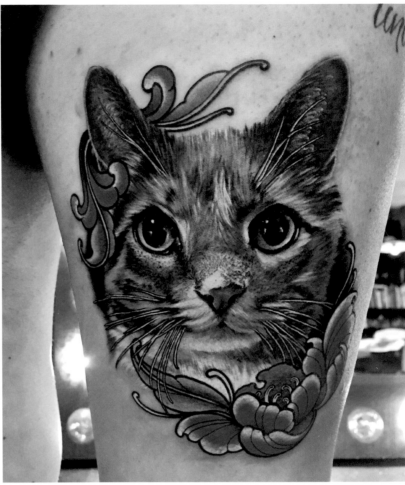

GRAY CAT

This lovely cat's name is Sweet Pea and is a favorite cattoo of mine. You'll notice here I added some black shading to the background. When I'm tattooing portrait-style animals, I always opt for very dark backgrounds if the animal's colors are on the lighter side in order to help them pop visually. In the case of a darker animal, I use a lighter background to do the same.

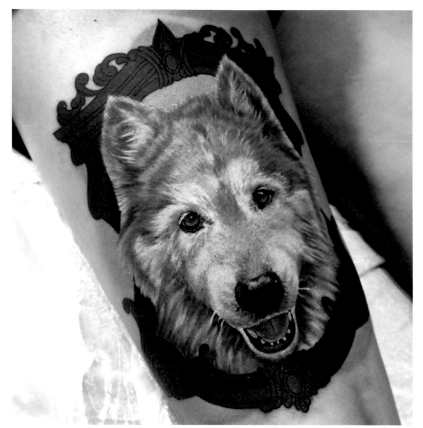
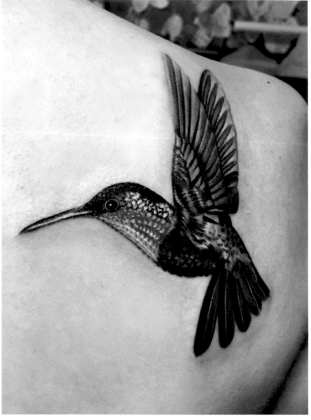

HUSKY

This is a super-fun portrait of a husky I tattooed in Fullerton, California, during a guest spot at Captured Tattoo studio.

HUMMINGBIRD

Tattoos come in all sizes. In this case, this tiny hummingbird tattoo is about the size they are in real life.

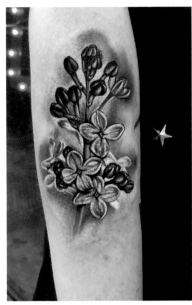

LILACS

Flowers are such a pretty, classic tattoo. These lilacs are done uniquely, with a colored background that reflects out-of-focus foliage behind the image.

POMERANIAN TATTOO

This is one of my earlier dog tattoos, in the era when I was still dressing them up as people. This little pup's name was Chai Tea Latte, so it was only fitting to have him drinking one!

TATTOO MACHINE

I did this tattoo on another tattoo artist, Anahi, during her visit to NYC from Peru.

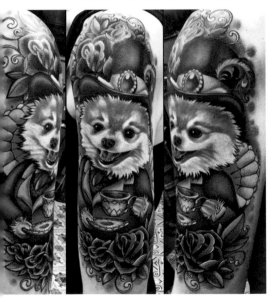

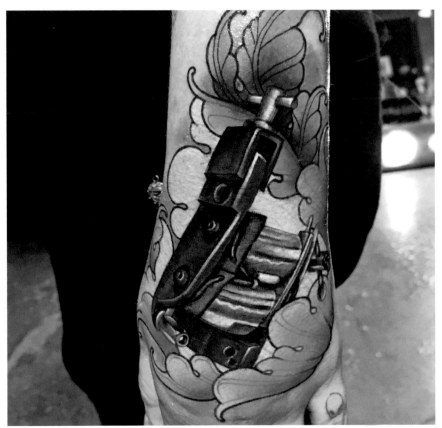

SISTER TATTOO

This tattoo is dear to me because of who it's on, my dear little sister Melissa! Tattooing is so much more than art to me; it's about connecting with other people. I'm always so happy when I'm able to share this with my family.

SELF-PORTRAIT WITH DAY OF THE DEAD MAKEUP

This tattoo's subject might look familiar: it's me! It's not often I get people asking for pictures of me, and I'm not going to lie, it felt a little funny tattooing an image of my own face. However, I feel like it worked great for this tattoo, which I did at the Cezanne tattoo convention in Aix-en-Provence, France.

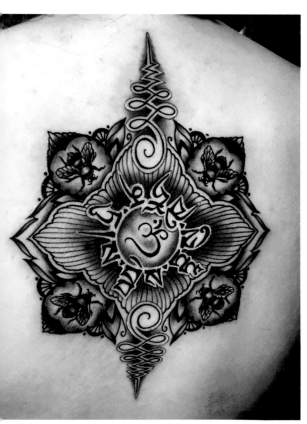

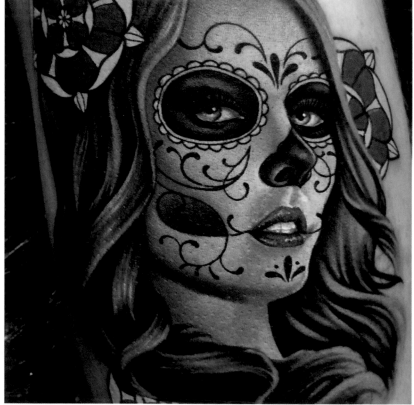

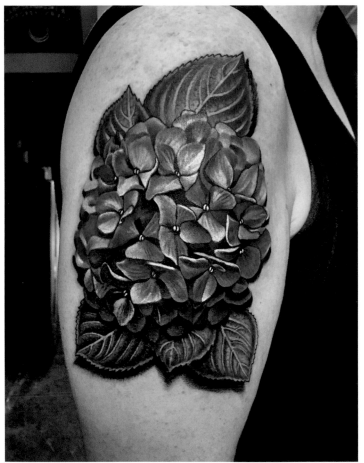

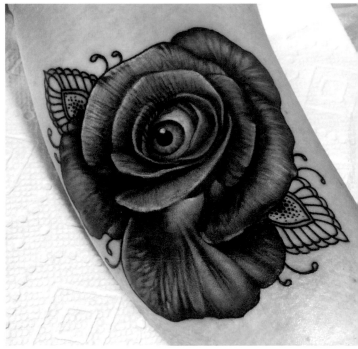

HYDRANGEA

This tattoo was very complicated with all its petals. It was still super fun, and I love how the drop shadow really makes this tattoo pop out.

EYEBALL ROSE

I went through a period of time where I really enjoyed putting eyes in tattoos. A few of those tattoos were flowers like this rose.

CHRYSANTHEMUM EYE

Here is another example of adding eyes into tattoos, only this flower is a chrysanthemum.

ECUADOR WOLF

I tattooed this wolf on my trip to the Mitad del Mundo tattoo convention in Quito, Ecuador. The black designs framing it were inspired by my recent visit to Angkor Wat in Cambodia.

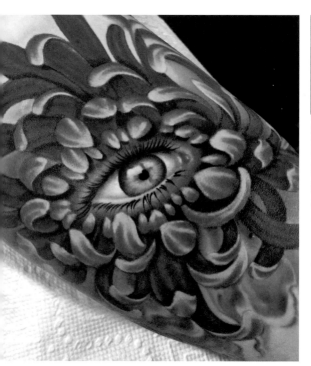

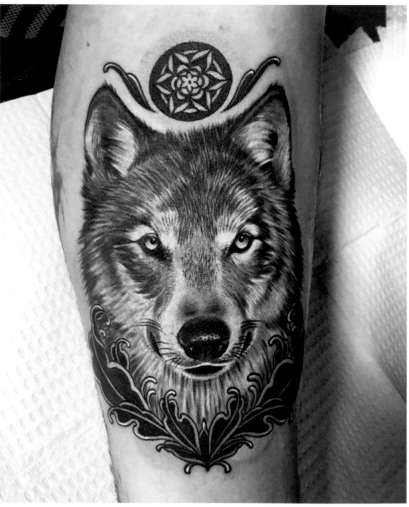

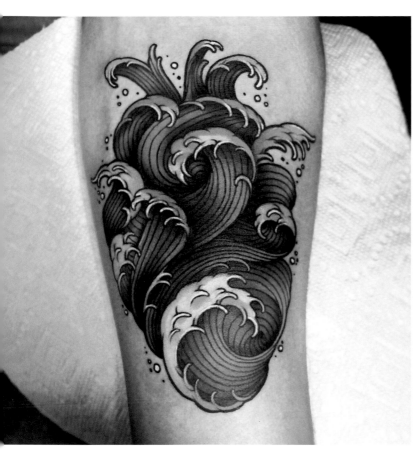

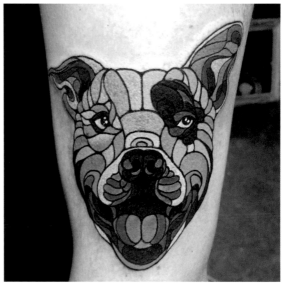

WATER HEART

I tattooed this heart made of waves on a friend of mine with a passion
for surfing.

MOSAIC DOG

I did this mosaic-style dog tattoo of a lovely pup named Santiago
on his owner.

CHEST COMPASS

I am really happy with the depth and dimension in this compass tattoo.

TITANIC

This *Titanic* tattoo was quite a treat, as I loved that movie growing up.
It was also really fun figuring out how to tattoo cameos.

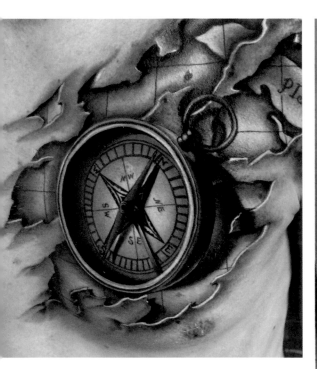

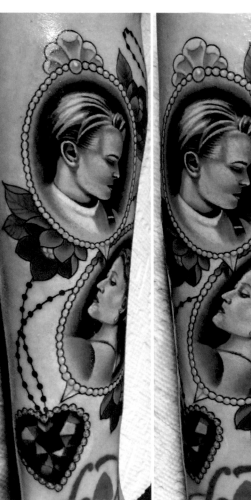

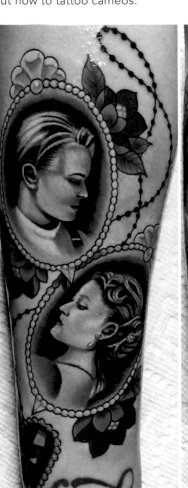

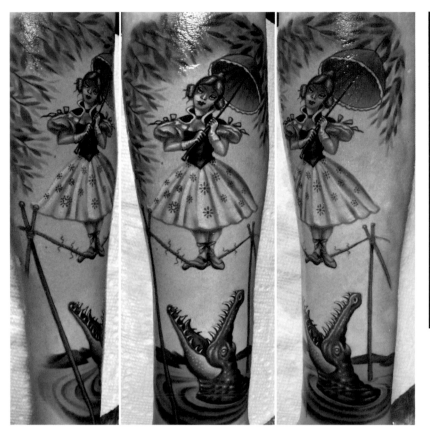

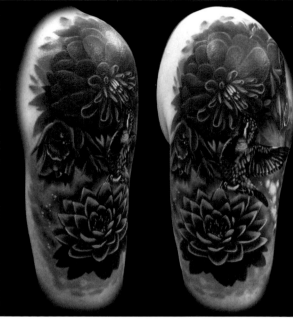

HAUNTED MANSION

This image is from Disneyland's Haunted Mansion. This was a very long, very intricate tattoo. I am very pleased with how it came out.

FLOWERS WITH HUMMINGBIRD

This is probably one of my most colorful tattoos. I particularly loved tattooing the hummingbird and intricate details.

RIBBON WITH POCKET WATCH

This tattoo is another one that symbolizes a milestone for me in tattooing. I finished this tattoo and was completely satisfied with how it came out. This is a feeling I rarely have. Artists are their own biggest critics. When you look at a piece of art you probably recognize everything you like about it. However, when I look at my own work, I see everything wrong with it and what I will improve next time. It has nothing to do with disliking the tattoo; it's simply that I'm striving for perfection. I've never done a perfect tattoo, but I've done a lot of tattoos that I'm happy with.

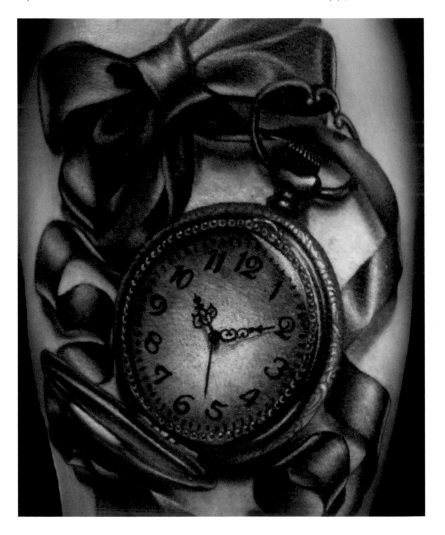

SKULL WITH CANDLES

I was always very pleased with how this older tattoo of mine, made in 2011, came out. It was a milestone for me; upon completing this tattoo I felt I was really starting to understand realistic color tattooing.

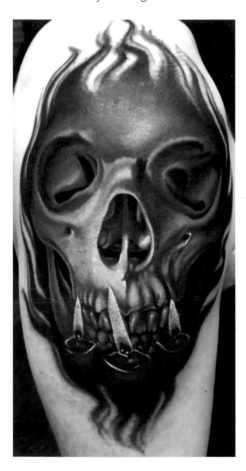

STYLES OF TATTOOING

The tattoo industry has developed many styles over the years, and with increasing speed. By the time this book is out, I'm sure more styles will have developed. As most artists specialize in a particular style, it's important to know what style of tattoo you are looking for so that you can find the right artist.

Biomechanical

This style combines both organic and mechanical elements to make the person wearing it appear as if they are partially made from machine parts.

Black and Gray

This means any style of tattoo done without color, and with black and gray shading. The gray can be done with an opaque gray-colored ink, but is more commonly done with what we call a gray wash, which is black ink cut with tattoo-safe thinning agents at different levels to make it lighter. In this case, the client's skin tone is used as the highlight tone. Some artists will use white ink to bring out smaller extreme highlights such as the gleam in an eye or something that is supposed to be wet and reflective.

Blackout

Blackout tattoos mean a large area of the body is colored in completely with solid black.

Black Work

As the name suggests, black work tattoos are done entirely in black line work, without gray shading.

Chicano

A form of black and gray style, Chicano tattoos are a West Coast style characterized by specific subject matter like roses, skulls, women, money, religious symbols, and gangster themes.

Color

Many different styles of tattooing can be in color, but in general, color simply means any style of tattoo done in color. I'm personally very drawn to color tattoos because I love having such a wide range of color options to choose from to help create depth, dimension, pattern, and texture. These things can still be achieved in black and gray; with color, you just have more variety.

Combination Styles

Different styles of tattooing can be combined or juxtaposed in the same tattoo.

Dot Work

Tattoos that are shaded with or are completely made up of dots instead of smooth shading are known as dot work. Some will occasionally be combined with areas of smooth shading as an accent.

Fine Line

Fine line tattoos have delicate, thin lines made by very fine needle sizes, such as 1 and 3.

Geometric

Geometric-style tattoos feature geometric lines and patterns.

Japanese

This traditional style of tattooing, originating in Japan, has very strict rules, color patterns, and specific meanings. Dragons, koi fish, cherry blossoms, chrysanthemums, Japanese maple leaves, water, wind bars, samurais, geishas, and Fu dogs are some popular subjects. The traditional, nonelectric way of Japanese tattooing is called Tebori.

Neo-Traditional

The neo-traditional style is an extension of traditional, retaining aspects such as two-dimensionality, bold lines, and black shading. However, it experiments with a more diverse color palette and more detailed designs done outside of the usual rules.

New School

These tattoos are specifically known for their cartoony appearance, made up of warped, exaggerated characters and scenes, commonly done in color.

Ornamental

Ornamental tattoos are made up of flowing lines and patterns and include mandalas, henna-inspired tattoos, and filigree.

Portraits

Realistic portraits that replicate the likenesses of people or animals are a form of realism and are usually created from photo reference.

Realism

Artists working in realism usually use photo reference for their realistically accurate tattoos.

Script

Script is the art of tattooing lettering. There are many styles that range from simple cursive to very ornate typography.

Surrealism

Surrealistic tattoos look 3-D and like they could be real but feature elements that don't exist in real life.

Traditional

Traditional tattoos are a classic and two-dimensional with specific rules about how subject matter should look. It's usually defined by clean and simple black line work, black shading, and a bold color palette. There are many themes in traditional tattooing, such as nautical and military motifs, flowers (particularly roses), women, good luck/bad luck symbols, and religious iconography.

Trash Polka

Trash polka tattoos are done in black and red. They are usually a combination of many elements, graphic patterns, and shaded 2-D or 3-D objects, usually over a large part of the body, sporadically placed and overlapping one another.

Tribal

Usually done in black, tribal tattoos come from many ancient cultures, such as Polynesian. These designs can range from simple to complex and have specific meanings based on the design. The modern-day tribal tattoo consists of thick black line designs that follow muscle shapes, ending in points that are more decorative and don't usually have a specific meaning.

Watercolor

In these color tattoos, the subject matter is tattooed to mimic the affect of a watercolor painting, with or without line work, often characterized by paint drips and splatters.

Chapter 6

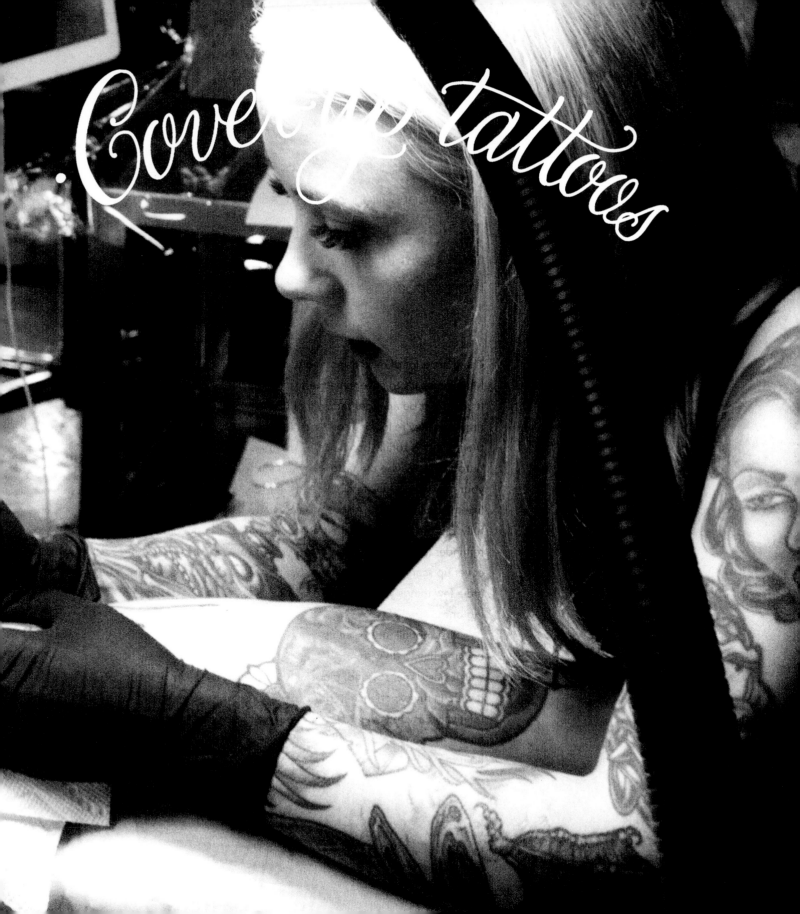

Coverage tattoos

Cover-up tattoos have recently become a very popular topic in the tattoo world, perhaps because of the rise of TV shows on the topic, so clients are starting to now understand better what a good tattoo *really* is. It could also be that as the popularity of tattoos has grown over the last couple of decades, there are a lot more tattoos out there aging along with it.

There are a *lot* of reasons someone may want to get a cover-up tattoo. Many times it's to cover an already existing tattoo they are unhappy with. It could just be an older tattoo that has naturally faded and aged with time and they're looking to spruce it up. It could be a newer tattoo, but the artwork is totally botched due to an inexperienced artist or a bad tattoo heal. Maybe the tattoo was technically done well, and you thought your fairy would look feminine and whimsical but instead it looks more like the bearded lady. Also, sometimes a tattoo could be done beautifully, but the meaning of the tattoo has changed or become a negative reminder (a common result of relationship tattoos). People use tattoos to cover up scars as well. Whatever the reason behind the cover-up, there are a few things you need to know before jumping into getting or tattooing one.

First, not all tattoos can be covered up. Whether a tattoo can be covered has to do with a few factors: age of the tattoo, how technically well it was done, scarring, placement, and what the client wants to cover it with. In my experience, tattoos that are ten or more years old are relatively easy to cover, whereas anything three years or less can be a lot harder. If you're unhappy with your artwork, and your tattoo healed very light or partially fell out, it is a blessing, because that makes it a lot easier to cover. Sometimes a tattoo can look terrible artistically but the artist technically put the tattoo in well, which would make it harder.

Chances are, if you're looking to cover a tattoo, the artist who did it may have been inexperienced. While some novice artists may not put a tattoo in deep enough, causing it to fall out, others can put the ink in too deep. When they do that, it can cause something called a blowout. A blowout is when a line is put in too deep and the ink spreads instead of staying in its intended spot, causing blobby-looking lines instead of crisp ones. This can also cause keloid scarring, which is raised scar tissue. When doing a cover-up, it can be difficult to get new ink to stay in scarred skin. In my experience, it's harder to get ink to stay in raised scars than in indented scars, but it isn't impossible.

In general, cover-ups usually need to be a little bigger than the original tattoo, not only to make sure that you have plenty of room to cover the tattoo well, but also to add other elements to distract from the cover-up part of the tattoo. If the tattoo is surrounded by other tattoos, or in a small area of the body without much extra space around it (for example, the neck, face, hands, feet), it can make it very difficult if not impossible to cover.

Another obstacle when dealing with a cover-up is what subject matter to put over the previous tattoo. Some tattoos can be covered with a multitude of options if they're on the older, lighter side, but a lot of tattoos can be covered with only a few things. I usually always prefer to do cover-ups in color as opposed to black and gray. This is because color offers fuller skin coverage than the black and gray style, which uses the skin tone as the lightest value, or highlight. In my experience, subjects with a lot of texture, areas of shading, and shapes that can be moved around easily tend to work best. A couple of things I usually suggest in these cases are flowers such as roses, because with their many petals there are lots of shaded areas and you can move the petals around to work with the shapes of the underlying tattoo. I also think animals tend to work well for cover-ups, as the texture of fur and feathers can be great for covering. Ultimately, there isn't one magic thing that works great for any cover-up, as each situation is unique. As a client, the best option for your cover-up is to not have many or any restrictions and just leave it up to the artist what is going to work best artistically.

If your tattoo can't be covered, it isn't the end of the world! There are options out there to lighten your tattoo to make it possible to cover. I recommend laser tattoo removal as a good solution to this problem. I myself have had a few tattoos laser-lightened and covered up.

Now that you know how to determine if a cover-up is doable, here's some advice about how to make it the best cover-up possible. It's important to research a good artist to do the work. Cover-ups are difficult tattoos to make, and it's important to go to someone who knows what they're doing. While researching, look for examples of other tattoos and cover-ups the artists have done. Once you find an experienced artist, don't be surprised by how much money and time goes into cover-ups. Difficult cover-ups can take many hours and sessions to complete, which is going to add up. The important thing to remember here is to not make the same mistake twice. Your cover-up is worth it!

My advice to novice tattooers is that cover-ups can be really hard, so it's best to start with easy cover-ups, and as you gain experience with how ink at different stages covers up, slowly work up to harder cover-ups. I have done cover-ups of cover-ups of cover-ups more than once, and I'm not exaggerating. Every time you cover a tattoo with another bad tattoo, it only makes it more complicated, time-consuming, and expensive to fix again. The best piece of advice is to do it right the first time, but if not, at least do it right the second time.

It is also important to manage your expectations with your cover-up. Keep in mind that while a cover-up can look great, it will almost never be as good as if it were an original, fresh piece of art. Something I also tell my clients and I think is a realistic expectation is that sometimes little spots in cover-ups could keep popping through the new ink, even after a few sessions. Remember that the only people who know it's a cover-up are the client and their artist, and they will be able to see certain things no one else can. The goal is to have it cover enough so that when other people look it at it, they cannot tell.

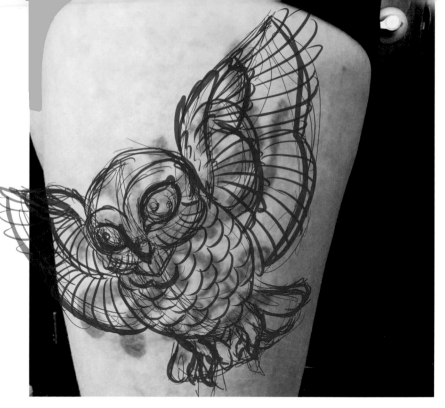

Here are my personal, general steps for the artist of the cover-up process:

Step 1: Assess the tattoo to be covered.

In this case, my client had some lettering that was relatively new, meaning less than three years old. My advice to her was to get some laser tattoo removal so that she could have more versatility with her new tattoo. She agreed and this was the result.

Step 2: Sketch a design that masks the old design underneath.

Here I was working digitally on my tablet, so I drew directly over the photo. By hand, I would trace the old design on tracing paper, and then draw on another piece of tracing paper over that drawing on a light table. I always start my sketches in red, as I've mentioned, because it allows my eye to see more shape options. The idea is to fit the underlying tattoo inside the new image without compromising the impact of the new design. In this case, I am very lucky the client got the laser removal and the older tattoo is light enough for me to cover with most things. Had the older tattoo been darker, I would have avoided putting the cover-up area in the head, which is the focal point of the new tattoo.

Step 3: Make the black line drawing.

I now do a hard, black line drawing over my red sketch. These lines will be the actual lines of the tattoo and what I will use for my stencil.

Step 4: Make and place the stencil.

Stencil placement is very important in the cover-up process to ensure everything can be covered properly.

Step 5: Begin the first stage of the tattoo process.

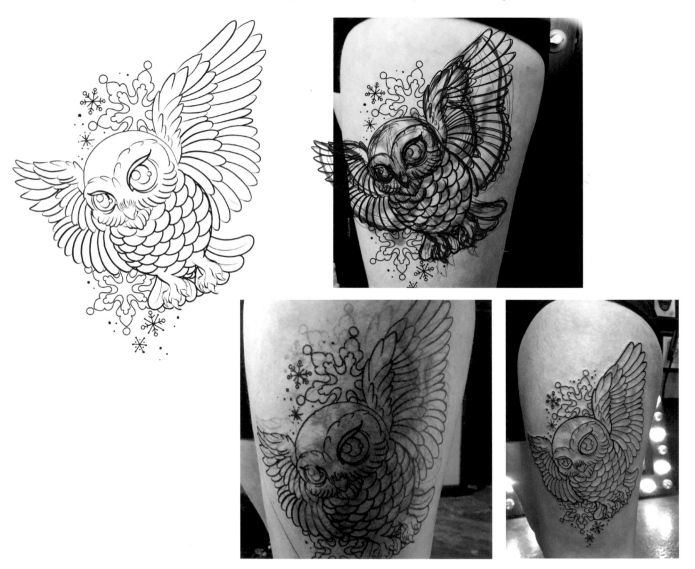

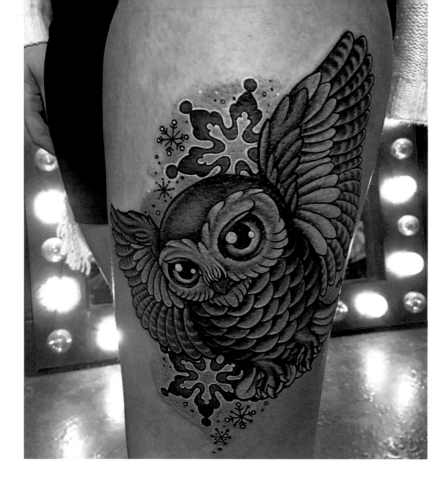

Notice how now with the fresh line work, the old tattoo seems to disappear. Although an older tattoo may look very dark, compared to the new tattoo it is actually very light. Again, this highly depends on the age of the older tattoo. The older a tattoo is, the lighter it will be in comparison.

Step 6: Complete the new tattoo.

The steps for tattooing a cover-up are basically the same as the general tattoo process, except my advice for artists would be to not go in and make a cover-up super dark right off the bat. Medium tones usually easily cover tattoos that are ten or more years old. This is usually true of tattoos five-plus years old as well; while you may need some darker color tones, you still shouldn't need straight black. Tattoos three years old and younger, if technically well executed, usually require the darkest tones and black. It is not uncommon, after the tattoo heals and the ink settles, to go back and do a touch-up session if the cover-up pieces become more noticeable.

Now that you know the guidelines, following are a few examples of cover-ups I've done, and why I chose the direction I went in.

HUMMINGBIRD COVER-UP

In this cover-up, the star was very old, so the client and I had a lot of options for what we chose to cover it with. I decided to make the hummingbird's belly very dark for high contrast and to aid in the three-dimensional feel, but that level of darkness wasn't necessarily required to cover the star. As you can see, there are parts of the star in lighter sections of the new tattoo. However, I did try to minimize where I overlapped the old tattoo with lighter sections, as there's a chance after healing they may become more notice-able (although because they are such small sections, it's likely no one will notice). There is so much else going on in the tattoo that it distracts from these areas.

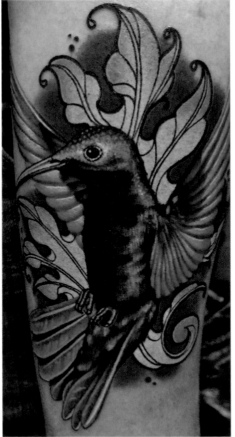

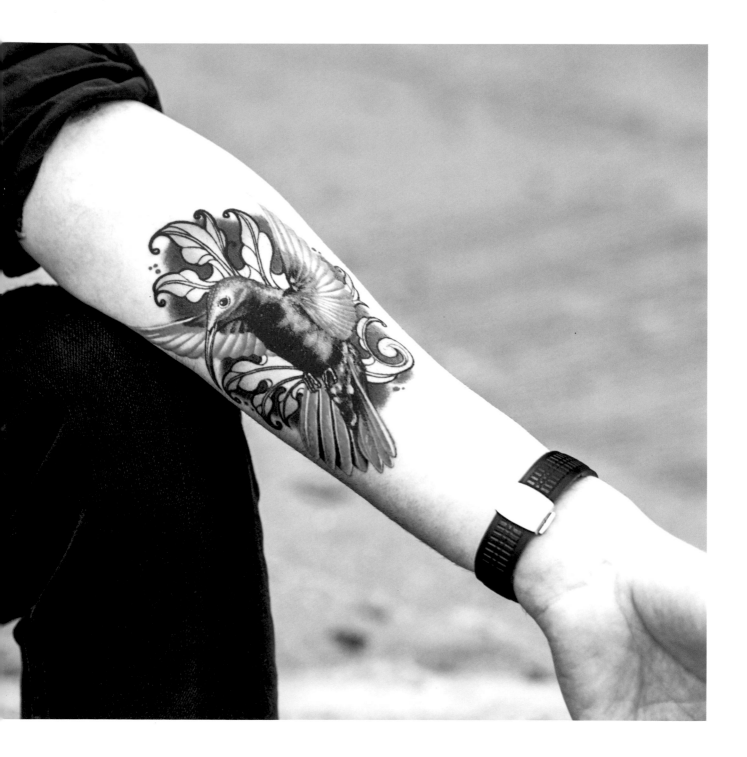

BRACELET COVER-UP

This is a cover-up of a very old tattoo, probably close to twenty years old, which made it pretty easy. Here I wanted to keep the delicacy of the bracelet but also embrace my client's very bold and colorful personality.

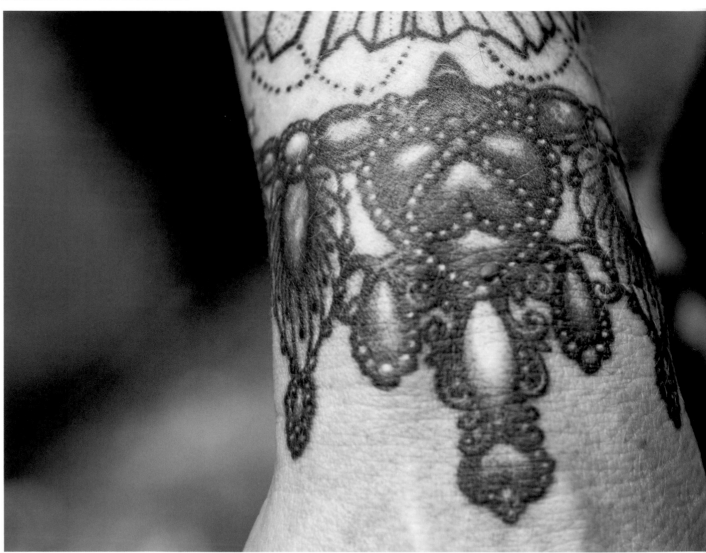

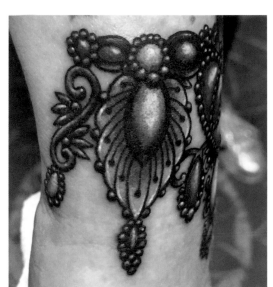
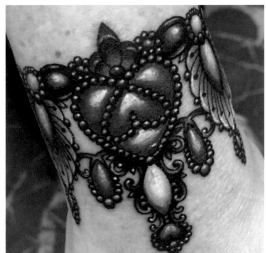

ELEPHANT

This tattoo cover-up was a bit more of a challenge. The tattoo was younger, probably less than five years, and on a stomach, which is a tougher spot to tattoo. As you can see from the first image, behind the elephant outline there was some older tribal designs around my client's belly button. The elephant was what my client requested; I decided to add some extra filigree designs in order to help cover up the tribal elements. I felt filigree was a pretty addition that didn't add too much more bulkiness to the tattoo.

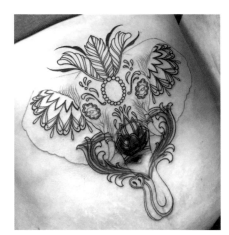

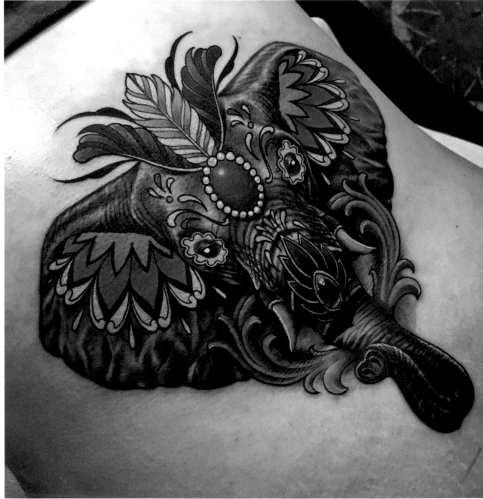

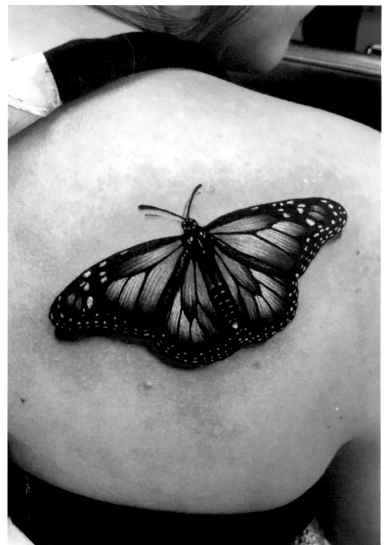

BUTTERFLY

Talk about a transformation! This little butterfly morphed into a much more spectacular version after I was through with it. Some may have seen this cover-up on the TV series *Bondi Ink Tattoo*.

OWL

My client decided to update his old phoenix tattoo with a brand-new bird. This owl definitely has a lot more wow factor and matches his personality much better.

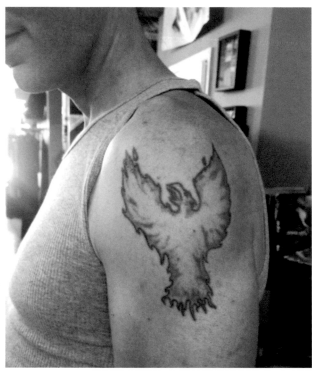

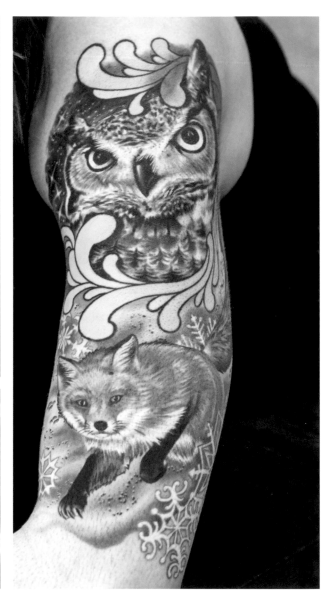

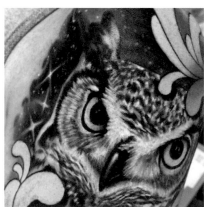

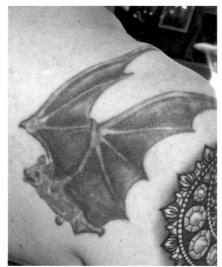

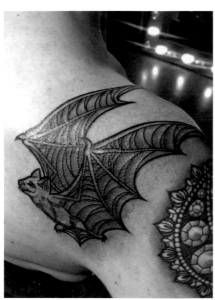

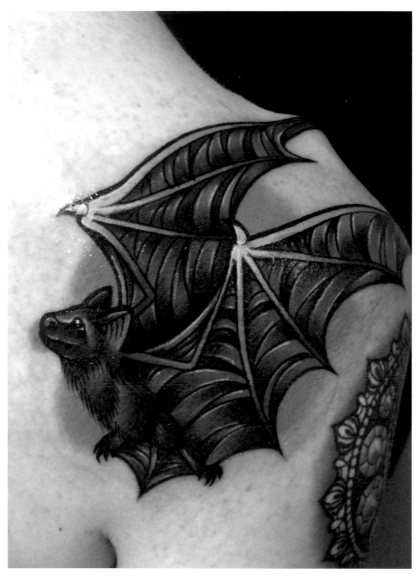

BAT

This would be considered more of a tattoo redo than a cover-up, but it's still the same process. Here we took my client's old bat tattoo, ten-plus years old, and gave it some new life.

FLOWER

Here my client wanted to transform his arm into a glorious flower sleeve.
However, first things first, we needed to get rid of this pesky old tribal
armband. Good-bye, 1980s!

DAGGER

We really brought this old dagger tattoo out of the dark ages and into the modern world.

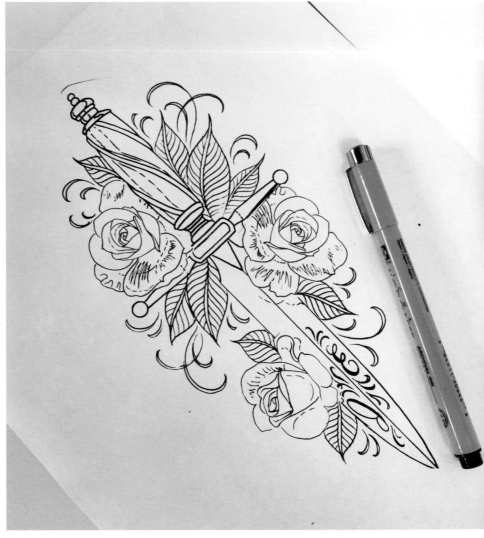

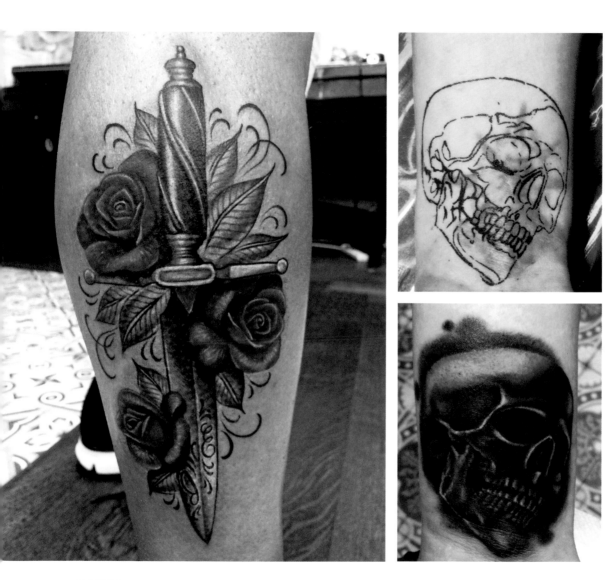

SKULL

Here is one of my older cover-up tattoos. It was super easy to cover my client's very old, light, and almost indiscernible wrist tattoo. However, the tiny little details of the skull made it challenging.

ROSE

The original rose tattoo had a bad heal that left it very light, which made it pretty easy to cover. My client still loved the idea of having roses, so I gave her something that fit the shape of that area of her body better. As with most cover-ups, it will most likely require a second session, as there's still some bits that show through in the leaves. I like to do one main pass not super dark and give it a chance to heal before deciding to make areas darker.

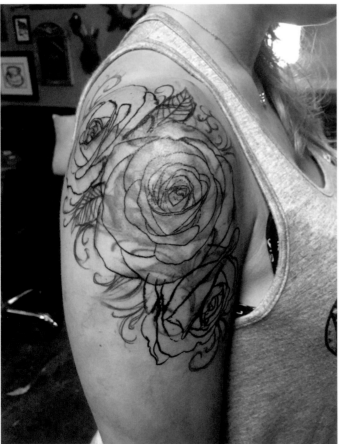

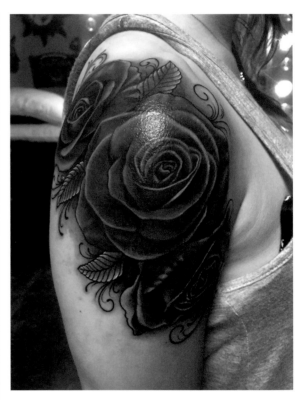

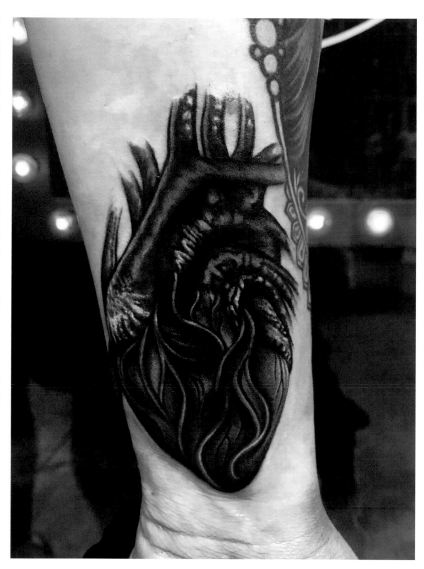

HEART

This is another example of a tattoo redo. Here I had done almost a full sleeve on my client, starting at the top of his arm and working my way down. Once we got to the forearm, it was time to address the old heart that didn't match the rest of his new work. I looked at photo reference of a human heart and freehanded some of the important cover-up areas with a skin marker before starting the tattoo.

TRENDS IN TATTOOING

Just like fashion and music, tattooing goes through trends. As I mentioned earlier, the trend when I started tattooing in 2004 was new school. However, there were a lot of other popular tattoo ideas running around at the time. Working at a street shop, I did some of the same things you still see getting done today: names, flowers, butterflies, skulls, religious and good luck symbols all seem to never go out of fashion, but they have definitely evolved aesthetically over the years. This is both because of changes in trends and tattoo equipment technology. Some other common tattoos of the time were tribal, barbed-wire armbands, nautical stars, flames, kanji, fairies, dolphins, wizards, and Looney Tunes characters. I probably tattooed one hundred Godsmack suns and Tupac crosses. I also needed to stock every Amy Brown fairy book because for a while it's what every woman wanted. Most of these subsequently dropped out of style, and tattoos such as the tribal armband and floral "tramp stamp" were then branded as uncool. Keep this in mind when getting a tattoo: if you're getting something that's all the rage, it's important to keep in mind that in ten years' time it will be the epitome of uncool. The next trends in tattoo styles to come about were neo-traditional, and then color realism.

I'm not knocking trends—without them, we artists wouldn't make the living that we do. Also, trends are inspiring for my own tattoo work. I'm always looking to evolve my own work and learn new things. Experimenting with new styles and techniques is a great way to do that. I currently incorporate little aspects of lots of different trends in my tattoos. It's less about conforming to a trend than it is about being inspired by it and figuring out how to incorporate it into your particular style.

Some of the current trends in tattoo styles are very intricate, such as dot work, geometric, and ornamental styles. However, for the ultra mainstream, having a collection of tiny, dainty outline tattoos randomly

placed on different parts of your body seems to be the it thing at the moment.

Honestly, some trends come and go so fast it's hard to keep up. Especially with the Internet, I believe everything is speeding up. That doesn't mean that trends don't come back around, though; they often do. Funnily enough, today there's a resurgence of '80s lookalike tattoos, bearing both tribal and barbed-wire aspects. Also stick-and-poke tattoos are in, which are made to mimic the handmade look of India ink tattoos that kids would make for themselves decades prior. Here are examples of the galaxy, watercolor, Day of the Dead, and owl trends.

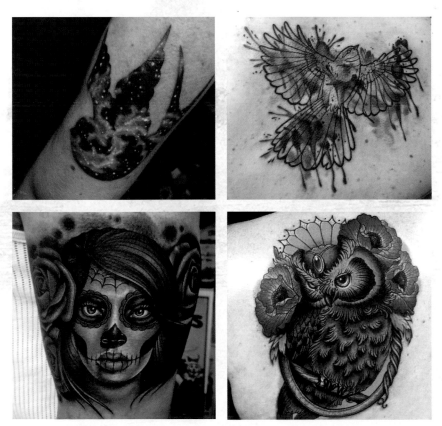

APPENDIX: FAN ART

Throughout these years of pursuing my dreams and achieving success as a tattoo artist, I know I could not have done any of it without the love and support of my clients and fans. From the bottom of my heart, I thank each and every one of you for helping make my dreams possible. One of the biggest rewards for me is that my artwork brings joy to other people.

A really cool thing about my fans and friends is that they sometimes return the favor and make artwork for me! Whether it's artwork created by another artist peer or by fans who mail it to my studio or give it to me at tattoo conventions, I'm always overwhelmed by the love. It's a great feeling seeing that in some small way I have inspired other people to create. Now I have *a ton* of fan artwork I've collected over the years, and I save everything that I can. Here is some of my collection.

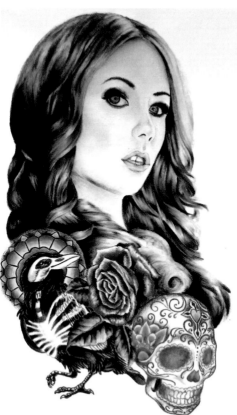

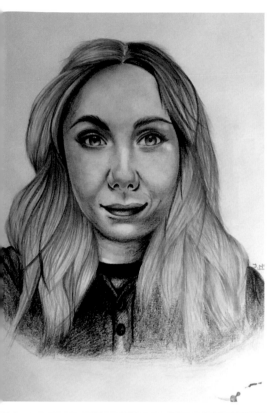

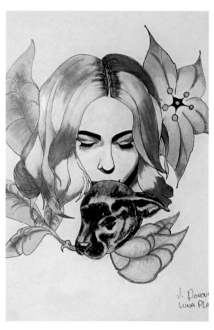

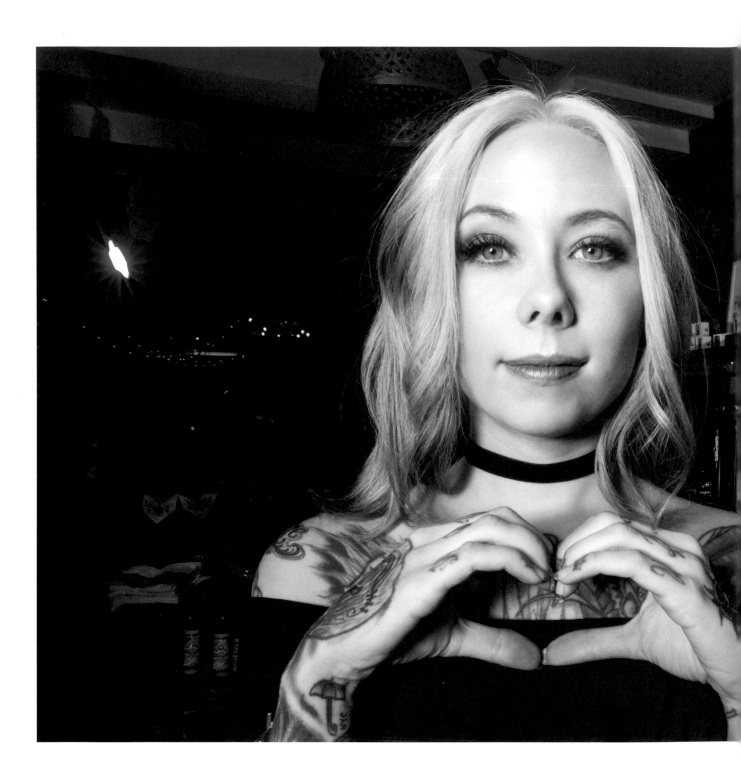

ACKNOWLEDGMENTS

A big thank-you to my editor, Lisa Westmoreland; designer La Tricia Watford; publicist Daniel Wikey; and production manager Serena Sigona. Also to my agent Lydia Shamah; my manager Matt Fontana; my photographers Lani Lee, Christie Blickley, and Michelle Star; my business partners at Grit N Glory, Veronica Mallo and Emily Conley; and my mom, dad, and the rest of my family for making me who I am today. To all the artists who inspire me to be better every day; all the people who take their time, pain, and well-earned money to be tattooed by me; and all my fans, because you have made my dreams possible! Thank you from the bottom of my heart!

about the author

MEGAN MASSACRE has been a tattoo artist since 2004. She is the author of *Marked in Ink* and has appeared on TV's *NY Ink, America's Worst Tattoos,* and *Bondi Ink Tattoo.* Best known for her incredible attention to detail and vibrant use of color, Megan's artwork has been exhibited in galleries and publications both inside and outside the tattoo world. Megan resides in New York City, where she is a partner at Grit N Glory, the city's first rock 'n' roll lifestyle boutique and tattoo studio.

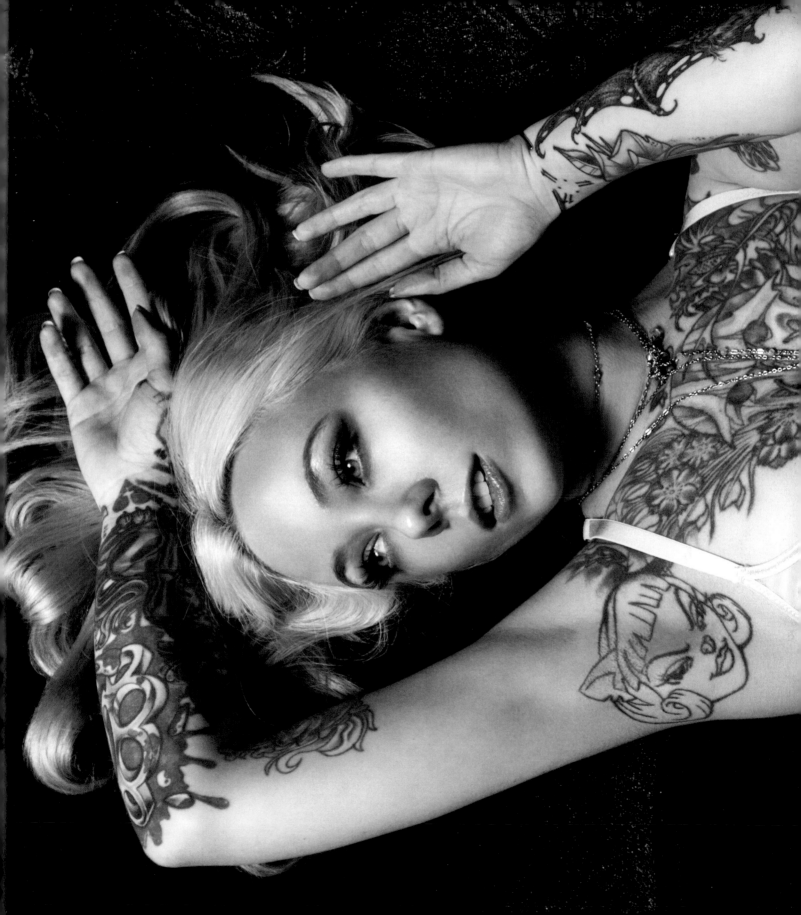

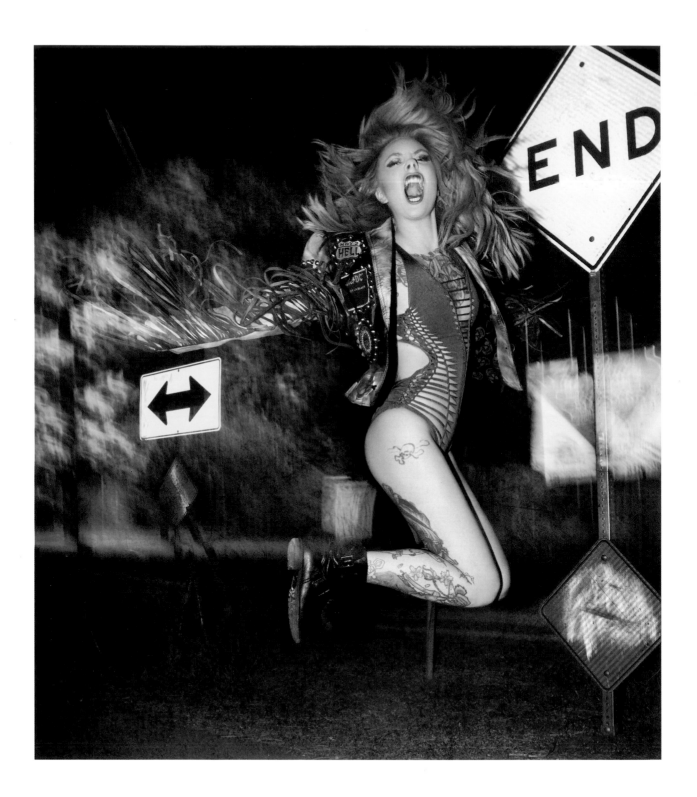

INDEX

A

Acker, Paul, 14, 38
America's Worst Tattoos, 1, 19, 20, 22, 42–43
Anahi, 197
Angkor Wat, 64, 200
animals
 sleeve, 170–71
 as source of inspiration, 74
 See also individual animals
artwork
 collaborations with other companies, 104–9
 in controlled mediums, 100
 early, 98–100
 process of creating, 110–12, 114, 118–19
ASPCA, 87
Australia, 61

B

bat, 225
biomechanical tattoos, 206
bird, colorful, 189
black and gray tattoos, 206, 207, 213
blackout tattoos, 206
black work tattoos, 206
Blickley, Christie, 186
blowouts, 34, 213
Bolonski, Justin, 35
Bondi Ink Tattoo, 1, 19, 22, 61, 223
Bonethrower, 165
bracelet cover-up, 220–21
Brazil, 56
Brown, Amy, 232
butterfly, 223

C

Cadic, Jasin, 81
Cambodia, 64
candles, skull with, 205
Captured Tattoo, 196
Casas del Bosque, 57
cattoos, 126–27, 131, 190–91, 195
Cezanne tattoo convention, 44, 63, 198
Chicano tattoos, 207
Chihuahuas, 19, 160–61, 188
Chile, 57
chrysanthemum eye, 200
Cleopatra, 162–63
cocker spaniel, 190
color, as source of inspiration, 70
color tattoos, 207
Colorwheel Tattoos, 36
combination styles, 19, 207
compass, 202
Conley, Emily, 78, 165
Cook, David, 165
Costa Rica, 60
cover-up tattoos
 difficulty of, 20, 22, 214
 examples of, 218–31
 expectations for, 214
 obstacles for, 212–14
 process for, 215–17
 reasons for, 212
 researching, 214
 size of, 213
 subject matter for, 213
cross, 193
cruelty-free products, 87

D

dagger, 228–29
Day of the Dead, 54
 girls, 110–11, 113, 172–75, 233
 makeup, self-portrait with, 198
DeCola, Billy, 42
Deep Six Laboratory, 14, 16, 38, 40
deer
 animal sleeve with, 170–71
 rein-, 187
design process, 124, 127–31, 134–36
Disneyland, 203
dogs
 Chihuahuas, 19, 160–61, 188
 cocker spaniel, 190
 German shepherd, 189
 golden retriever, 190
 husky, 196
 mosaic-style, 201
 pitbull, 194
 pomeranian, 197
dot work tattoos, 207

E

Ecuador, 58, 200
elephant, 222
"Everything Moves in Circles," 186
Expo Tattoo Guatemala, 55
eyes, 199, 200

F

fan art, 234–35
fine line tattoos, 207
flamingo, 193
flowers
 as cover-up tattoo, 226–27
 Day of the Dead girl with, 172–73
 eyes in, 199, 200
 hummingbird with, 203
 skulls with, 193
 twins with, 194–95
 See also individual flowers
Fox, Dave, 35
foxes
 animal sleeve with, 170–71
 sunflowers and, 168–69
France, 63
Frankenstein, bride of, 34, 35, 43
freehanding, 128

G

Galápagos Islands, 58
galaxy trend, 233
geometric-style tattoos, 207
German shepherd, 189
golden retriever, 190
Grit N Glory, 1, 43, 78–84, 87, 90, 93, 110
Guatemala, 55
Gunnar, 35

H

Harley-Davidson x Sailor Jerry project, 106–9
Haunted Mansion, 203
Hawaii, 65
hearts
 as cover-up tattoo, 231
 sacred, 44
 water, 201
Hendricks, Tim, 19, 43–44
home, as source of inspiration, 69
hummingbirds, 196
 as cover-up tattoo, 218–19
 flowers with, 203
husky, 196
hydrangea, 199

I

inspiration, sources of
 animals as, 74
 color as, 70
 favorite places as, 53–65
 home as, 69
 subject matter as, 72
 tattoo conventions as, 66–67
 travel as, 51, 53

J

James, Ami, 18, 19
Japanese tattooing, 208
Jeanchoir, 44

K

Kahlo, Frida, 128–29, 166–67
Kells, Rob, 36
keloid scarring, 213
Kern, Tim, 43

L

laser tattoo removal, 40, 213
Leia, 190
Letz, Joe, 40–41, 78
lilacs, 197
Listo, Leila, 160, 162
"lucky 13" tattoo, 40
Lydia, from Beetlejuice, 182–83

M

Machu Picchu, 59
Mallo, Veronica, 78, 167
"Man's Ruin" tattoo, 36
Maori culture, 62
McSorley's, 42

Mexico, 54
Miami Ink, 10
Mitad del Mundo tattoo convention, 58, 200
modeling, alternative, 12
Morton, Jack, 40
Motionless in White, 40

N

Nagle, Ross, 42
Nala, 190–91
Napoli, Teneile, 44
negative tattooing, 32
neo-traditional tattoos, 208
new school tattoos, 208
New York City, 1, 16, 19, 22, 36, 40, 44, 69, 72, 74, 81
New York Mets, 179
New Zealand, 62
NY Ink, 1, 16–20, 42, 43, 78, 188

O

ornamental tattoos, 208
owls
 animal sleeve with, 170–71
 as cover-up tattoo, 224
 Day of the Dead girl with, 174–75
 as trend, 233

P

Pacific Ink and Art Expo, 65
Pagoda City tattoo convention, 43
pain, 147, 148–49, 151
Pangburn, Tim, 43
panther, 190–91
Pastor, 38
Peru, 59
Peta2, 87
pets, 19, 74, 188–91. *See also* cattoos; dogs

photos, as reference, 70, 128–29
pitbull, 194
pocket watch, ribbon with, 204
pomeranian, 197
portraits, 208

R

realism, 208
red ink, 153
reindeer, 187
relationship tattoos, 40–41
ribbon with pocket watch, 204
Rivera, Diego, 167
Rodriguez, Lee, 42
roses
 as cover-up tattoo, 230
 eye in, 199
 shoulder with, 184–85
 in sugar skulls, 176–77

S

Sacred Tattoo, 20
Santa, 187
scarring, keloid, 213
script tattoos, 132–33, 186, 208
Séance Tattoo Parlor, 14
self-portrait, 198
Shlak, 40
sister tattoo, 198
skulls
 candles with, 205
 as cover-up tattoo, 229
 flowers with, 193
 sugar, 176–81
 turntable with, 194
spell-checking, 132–33
Spike and Chewy, 160–61
Spotify, 56

stencils
 applying, 137
 creating, 129
 examples of, 130–31
 moving, 140
Stone, Emma, 173
Strunk, Jason, 36
styles, 206–9
sugar skulls, 176–81
Suicide, Davey, 40
Summer Ink tattoo convention, 57
sunflowers, fox and, 168–69
surrealism, 209

T

Tats N Tails, 87
tattoo artists
 apprenticeships for, 6, 8, 18–19, 27
 booking appointments with, 124
 choosing, 124, 134
 travel and, 51, 53
 walk-ins and, 84, 87, 124
tattoo conventions, 66–67. *See also individual conventions*
tattoo machines
 as tattoo, 197
 types of, 145
tattoo process
 aftercare for, 153–54
 body movement and, 141
 for color tattoos, 151
 conversation and, 141
 for cover-up tattoos, 215–17
 equipment for, 144–45
 length of, 153
 moral support and, 141
 ointment for, 148
 pain and, 147, 148–49, 151

position for, 140–41
for realistic tattoos, 150–51
red ink and, 153
stencils and, 137, 140
white ink and, 151
See also design process
tattoos
author's, 28–45
designing, 124, 127–31, 134–36
first, 29, 147
laser-lightening, 213
spell-checking, 132–33
styles of, 206–9
trends in, 232–33
See also cover-up tattoos; tattoo process;
individual designs
Tattoo Week tattoo convention, 56
Tebori, 208
Tegaderm, 153–54
Tevenal, Dave, 42
Titanic, 202
TLC, 16, 19, 22
traditional tattoos, 209
trash polka tattoos, 209
travel, 51, 53
trends, 232–33
tribal tattoos, 209, 232, 233
turntable, skull, 194

U

United Ink tattoo convention, 44

V

Viña Indómita, 57
Virgin Mary, 38–39

W

Waisman, Guy, 41
watercolor tattoos, 209, 233
water heart, 201
Weatherholtz, Justin, 36, 43
white ink, 151
wolves
Ecuador, 200
ornamental, 192
Wooster Street Social Club, 19, 20, 42, 78, 81

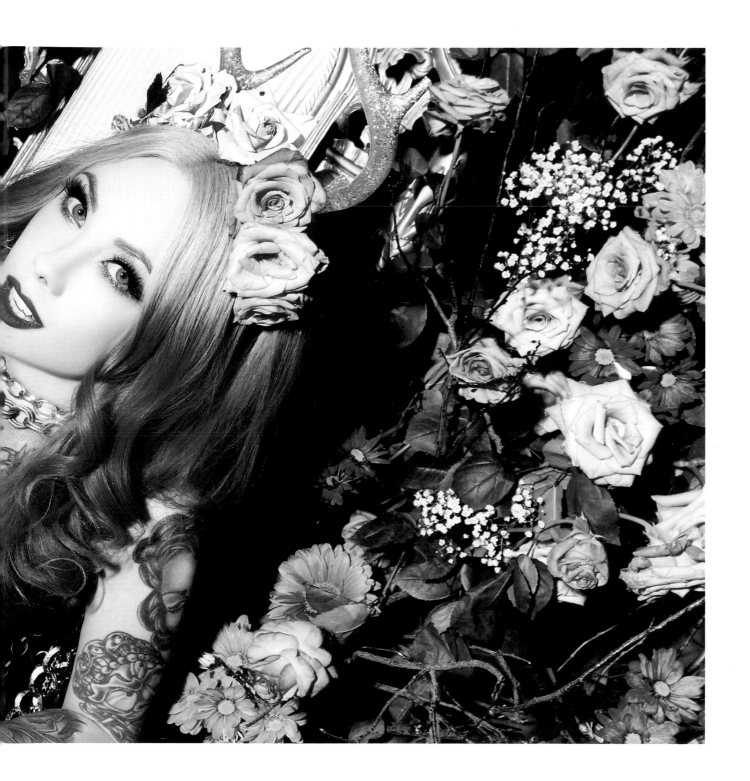

Photos on pages viii, 240, and 246 copyright © Michelle Star
Photo on page 12 (top left) copyright © Jason Ierace
Photo on page 12 (bottom left) copyright © Steve Prue
Photo on page 21 copyright © Jake Smith
Photos on pages 22, 70, 85, 95, 97, 99, 100, 101, 102, 103, 110 (left), 111 114, 115, 126,
128, 129, 130, 131, 160, 161, 173, 183, 185, 187, 188, 189, 190, 191, 192, 193, 194, 195,
196, 197, 198, 199, 200, 201, 202, 203, 204, 205, 215, 216, 217, 221, 222, 223, 224, 225,
226, 227, 228, 229, 230, 231, and 233 copyright © Megan Massacre
Photos on pages 90, 91, 94, and 192 (left) copyright © Christie Blickley
Photo on page 92 copyright © Warren Whitmore
Photo on page 105 copyright © Tania Gomez
Photos on pages 106, 108, and 109 copyright © Mel Stultz

Library of Congress Cataloging-in-Publication Data
 Names: Massacre, Megan author.
 Title: The art of tattoo : a tattoo artist's inspirations, designs, and hard-won advice
 / Megan Massacre.
 Description: First edition. | New York : Ten Speed Press, [2019] | "Published in the
 United States by Watson-Guptill Publications, an imprint of the Crown Publish-
 ing Group, a division of Penguin Random House LLC, New York"—T.p. verso. |
 Includes index.
 Identifiers: LCCN 2018006307
 Subjects: LCSH: Tattooing. | Tattooing—Pictorial works. | Massacre, Megan. | Tattoo
 artists—United States—Biography.
 Classification: LCC GT2345 .M365 2018 | DDC 391.6/5—dc23
 LC record available at https://lccn.loc.gov/2018006307

Hardcover ISBN: 978-0-399-57878-6
eBook ISBN: 978-0-399-57879-3

Design by La Tricia Watford

Printed in China

10 9 8 7 6 5 4 3 2 1

First Edition